Urban Waterways

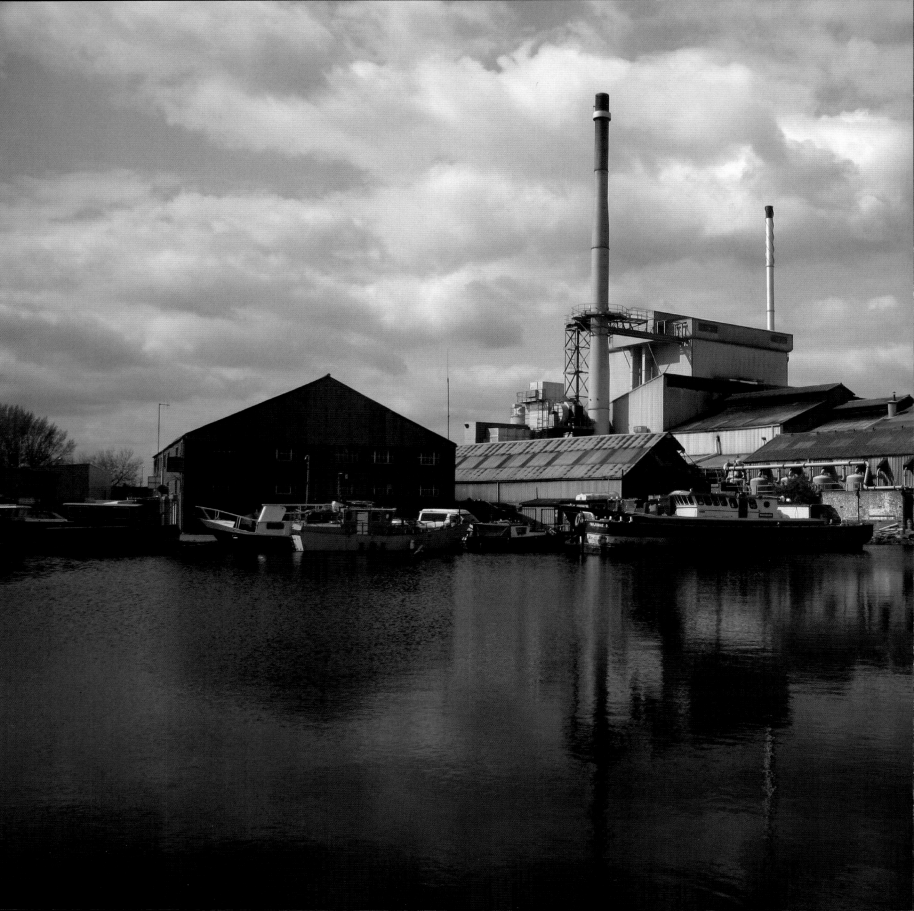

Urban Waterways

A window on to the waterways of England's towns and cities

Derek Pratt

Adlard Coles Nautical
London

◀ Factories reflected in the water of the Aire and Calder Navigation at Knottingley. The town became prosperous for its glassworks, chemical industry and boatbuilding. Kellingley colliery near Knottingley is the last working deep coal mine in Yorkshire.

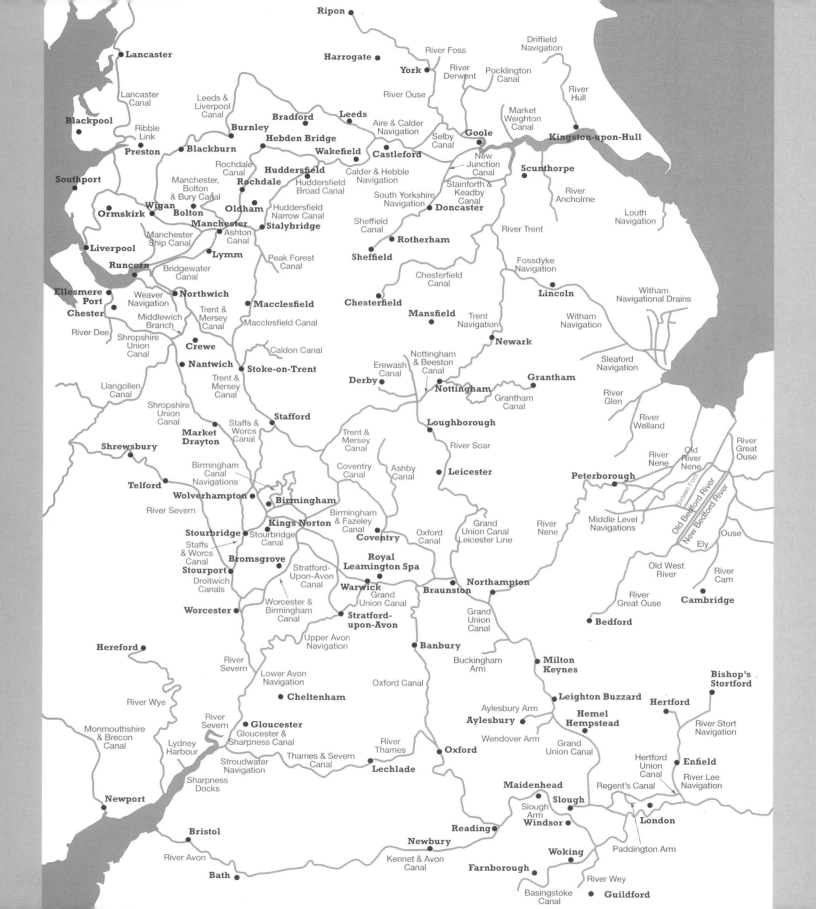

CONTENTS

Introduction

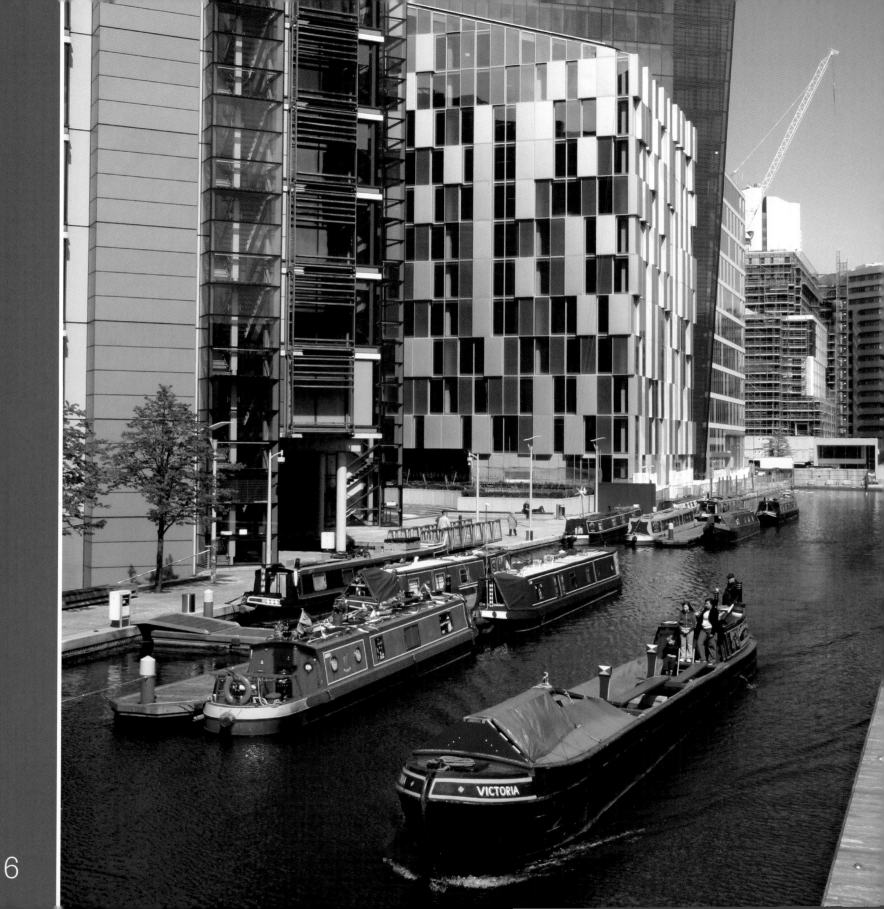

INTRODUCTION

The Industrial Revolution began in the mid-18th century and changed England from an agrarian to an industrial economy. While goods were transported by the country's major rivers, there remained large areas where they could only be moved by packhorses or horse-drawn wagons. Unfortunately, roads were difficult to build, expensive to maintain and usually impassable in winter.

Many of the new industries were in areas unconnected by navigable rivers. In the north the cotton industry in Lancashire and the woollen industry in Yorkshire were separated by the Pennine Hills. In Staffordshire the potteries established by Josiah Wedgwood were having difficulty bringing in coal and other necessary raw materials. Moving delicate and fragile produce was uneconomical because of breakages caused by the appalling road surfaces. England's largest industrial region developed around Birmingham because of the discovery of iron and coal deposits in that area. There are no navigable rivers around Birmingham, so manufactured goods had to be transported by road to the River Severn, where they were loaded into barges. In the south, London was separated from the Midlands by high ground, and the upper reach of the River Thames was cut off from the River Severn by the Cotswold Hills.

The solution to this problem was the building of canals to connect the new industry to rivers and ports. Some canals had been built earlier but these were either drainage channels or cuts to straighten out existing river navigations. The Canal Age really began at Worsley near Manchester in 1760. The third Duke of Bridgewater, frustrated by the exorbitant toll charges on the Mersey and Irwell Navigation, decided to bypass them and build his own navigation. The Duke's agent John Gilbert engaged the pioneering engineer James Brindley to build the canal, and the result was the Bridgewater Canal, which carried coal directly from the Duke's mines at Worsley to Manchester, halving the previous cost of coal. Inspired by the success of the Bridgewater Canal, most of the canals that followed were promoted by industrialists like Josiah Wedgwood and engineered by Brindley. Brindley went on to complete his vision of a Grand Cross of canals, which connected industrial areas to the major rivers and through them to the ports. The writer Thomas Carlyle wrote that Brindley 'chained seas together; the Mersey and the Thames, the Humber and the Severn, have shaken hands'. The hub of these early navigations was Birmingham and its industrial heartland known as the Black Country. Once the canal arrived, industry – in the shape of factories, foundries and mills – was built on its banks. Workers needed somewhere to live, so former villages expanded into towns. The urban waterway was born.

Most businesses had their own loading area where boats could pull in alongside the wharf, and in some cases bigger companies built their own private arm away from the main line of the canal. These arms can still be seen in urban areas, marked by the raised towpath over the entrance to the dock. In many cases the docks have now been filled in. Horse power was the driving force in those days and the towpath was

◀ Paddington waterside.

the workplace of the boat horse. Despite being in the centre of towns and cities urban canals were often private, enclosed places. Some waterside inns provided stabling for the horses while the boatman enjoyed a few hours of recreation. For a working boatman this was just an occasional luxury as he had collection and delivery times to meet.

The early canals were so successful that in the 1790s more and more were being constructed throughout the country; this period was known as 'Canal Mania'. New canals continued to be built for another 40 years until the advent of railways diverted business and speculators' money into a newer and faster form of transport. Many canals were bought by the new railway companies, who allowed them to deteriorate through lack of maintenance. Business on the canals slowly declined through the 19th century and continued into the 20th century when many canals fell into disuse. In some urban areas local authorities urged the infilling of derelict canals, which had become a dumping place for rubbish. Access to the towpaths was made difficult by bricking up entrances. In many cases this did not prevent children finding a way onto the canal but it did prevent adults coming to the aid of the children when they fell into the water.

Some canals still survived because carrying bulk cargoes by water is a cheap form of transport when time is not important. It was the advent of motorways and the severe winter of 1962–63 (when the canals froze and were unusable) that finally put an end to canal carrying as a commercial venture. The future of canals lay in the leisure industry.

In 1939 the author LTC Rolt made an epic voyage around the decaying waterways in his boat *Cressy* and wrote the bestselling book *Narrow Boat*, demonstrating and encouraging public interest in the canals. After the war Tom Rolt, together with

▲ Spon Lane Locks,
Birmingham Canal.

▼ Straight Mile, Leicester.

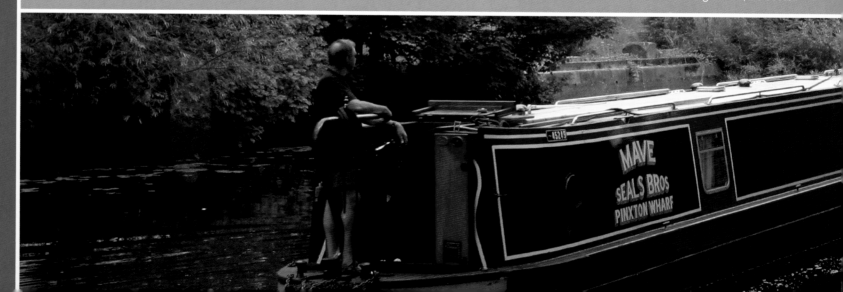

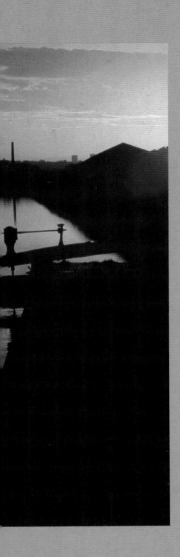

colleagues Robert Aickman and Charles Hadfield, met in London and as a result of that meeting formed the Inland Waterways Association. Relentless campaigning to change policies and attitudes saved many of today's popular cruising waterways from extinction. Other waterways which had fallen into dereliction were restored back to full navigation by voluntary labour with support from local councils and official bodies such as British Waterways.

Now there are around 60,000 boats registered on the waterways and thousands of people take their holidays on a hire boat. Towpaths in urban areas were opened up for public use and in some cases have become part of long distance footpaths. Many fine old buildings (such as the warehouses in Gloucester Docks) have found new uses as offices, recreational centres and museums. Disused factory sites have been cleared and the space used for commercial units or waterside housing. The old urban landscape, previously dominated by smoky factory chimneys, has completely changed. Estate agents are extolling the virtue of living next to water and some councils have landscaped run-down waterside areas and turned them into parks. Information boards about the waterway and its history are now a common sight by urban canals. What they can't impart are the mysterious smells wafting from food factories, the hiss of steam outlets and the hum and clatter of machinery.

The aim of this book is to show pictorially the English urban waterway in its contemporary setting, with occasional references to its past. All the locations in this book are on the connected 2,000-mile waterway system in England. Thanks to the restoration movement, it is now possible to travel by boat from Bristol to York or from London to Liverpool. Urban waterways have a large part to play in these journeys.

MANCHESTER
AND THE NORTH

The Bridgewater Canal was the first independent waterway in Britain. From 1760, it brought coal from the Duke of Bridgewater's mines at Worsley to the centre of Manchester and sparked off what became known as the Canal Age. Manchester and Liverpool were both towns that grew into thriving cities during the Industrial Revolution. They were linked by river, but river navigations were unreliable because of tidal conditions at one end and the effect of flooding or drought at the other. As a major port, much of Liverpool's trade was concerned with the manufacturing industries in and around the Manchester area, but it was not until 1894 that the Manchester Ship Canal eventually made a direct connection between the two cities. Until then the first connection was through the winding Leeds and Liverpool Canal, which linked with the Bridgewater Canal at Leigh. At 128 miles, the Leeds and Liverpool was the longest canal built in Britain. It connected Liverpool and the mill towns of Wigan, Burnley and Blackburn to Leeds and the Yorkshire coalfields. It was one of three trans-Pennine canals: the others were the Rochdale Canal and the Huddersfield Narrow Canal. All three of these waterways linked Manchester to Yorkshire's industry. The latter two waterways eventually closed through lack of business, but the Leeds and Liverpool stayed open throughout. Thanks to a huge restoration programme all three are navigable again.

To the south of Manchester, the 94-mile Trent and Mersey Canal linked with the Staffs and Worcester Canal to Birmingham and the River Severn. The canal also opened up a long road to London via the Coventry Canal and the Oxford Canal to the River Thames. Through the Trent it provided another route to Hull and the Humber as well as south to Nottingham. The Trent and Mersey also connected Stoke-on-Trent and the Potteries to the ports. The Peak Forest and Macclesfield Canals provided an alternative route from the Potteries to East Manchester via the mill towns of Macclesfield and Bollington.

The inland waterways in Yorkshire tend to be a mixture of river navigations linked by sections of canal. In this county coal was king and this was reflected by the huge tonnages once carried on its waterways. The canals were wider and deeper than the narrow gauge midland canals and special boats were designed to carry bigger

cargoes. Most famous of these were the 'Tom Pudding' coal compartment boats that worked the Aire and Calder, and the Sheffield and South Yorkshire Navigations. The only one left today is a floating exhibit at the Yorkshire Waterways Museum at Goole and very little coal is moved by water any more. Although the Yorkshire waterways lost most of their trade, none of them actually closed and some commercial traffic in oil, sand and gravel can still be seen on the Aire and Calder.

The canals around Manchester did not fare as well as their neighbours across the Pennines. Apart from the Bridgewater Canal and the Leeds and Liverpool, most of them were derelict by the middle of the 20th century. Some have been lost but the Ashton, Rochdale, Huddersfield and Peak Forest Canals have all been successfully restored.

In Manchester, the old dockland area closed in 1982 but has been reinvigorated as Salford Quays, home of the Lowry Centre. Castlefields, which is the terminus basin of the Bridgewater Canal, was designated as Britain's first Urban Heritage Park. It has become a trendy centre for Manchester's nightlife with restaurants, bars and nightclubs.

One of the most exciting things that has happened in this region is the construction of a new canal in Liverpool. This is an extension of the Leeds and Liverpool Canal at its previous terminus at Stanley Dock. New cuttings have linked old disused docks along the waterfront to a new canal in front of Pier Head, ending at Albert Dock. Now boaters can cruise right into the heart of Liverpool's new cultural centre.

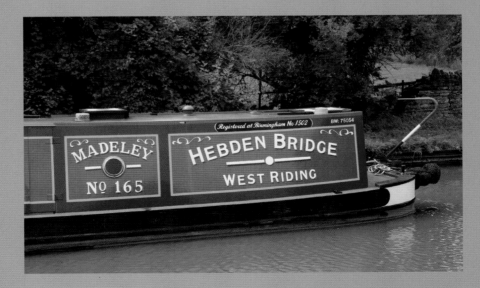

◀ Castlefield, Manchester.

11

◄ The Packet House at Worsley Delph, near Manchester. This was where the Bridgewater Canal left the Duke of Bridgewater's mines and carried coal to the centre of Manchester. The entrance to the Duke's mines is beyond the bridge to the right of the building. The orange staining in the water is due to iron ore deposits seeping from the mines. Inside the mine were 47 miles of underground canals on four different levels. A regular passenger boat service first operated from the Packet House to Manchester in 1781.

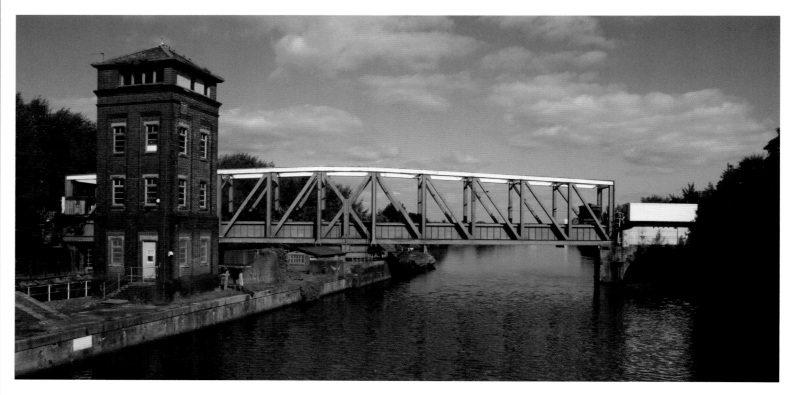

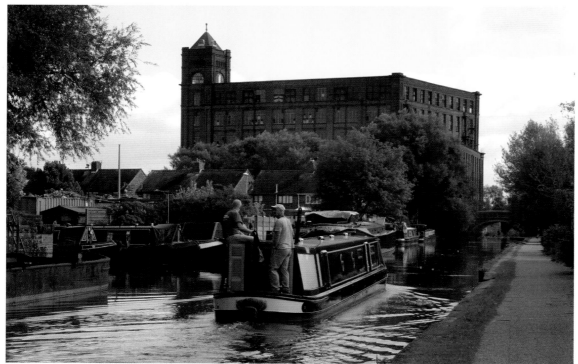

Barton Swing Aqueduct carries the Bridgewater Canal over the Manchester Ship Canal. The entire aqueduct (holding 800 tons of water) pivots to allow large vessels to pass along the Ship Canal. James Brindley's original aqueduct over the River Irwell was the largest construction of its type ever built in Britain and caused a sensation when it opened in 1761. It was replaced by the present aqueduct in 1893.

Leigh was an important centre in the textile industry and a number of cotton mills were built next to the canal. The mill in the picture was built in 1882.

Manchester

Castlefield, in the heart of Manchester, is the terminus of the Bridgewater Canal. Other than Roman occupation many hundreds of years ago, this area remained undeveloped until the canal arrived in 1765. Warehouses and other business premises were soon built to take advantage of the new safe and cheap method of transporting goods. The Rochdale Canal arrived in 1802 and made a connection with the Bridgewater at Castlefield. In recent years Castlefield has been transformed from a run-down derelict area into Britain's first Urban Heritage Park and has become one of the city's main visitor attractions.

▲ Merchants Bridge is symbolic of the regeneration of Castlefield. It spans the main canal at a watery junction where there are two short canal arms and the first lock of the Rochdale Canal. In the background is a splendid railway viaduct built in 1849. Apart from its many restaurants and clubs, Castlefield's other attractions include the Museum of Science and Industry and the Granada Studios.

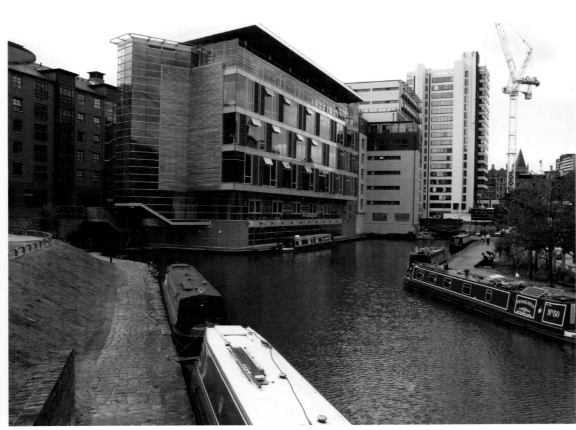

▲ Piccadilly Basin in central Manchester is the junction of the Rochdale and Ashton Canals. The Ashton Canal begins its journey by the bridge on the left of the picture while the Rochdale Canal plunges into a subterranean lock directly beneath a large office block. This is the first of a flight of nine locks that ends at Castlefield.

◀ Piccadilly Village is a modern housing estate by the Ashton Canal close to Manchester's Piccadilly railway station. Canal engineers Thomas Telford, William Jessop and James Brindley have basins and courtyards named after them within the village.

East Manchester

In 1972, under the banner 'Ashtac' ('Attack on the Ashton Canal'), thousands of volunteers descended on the canal in a mass restoration campaign. After years of dereliction, the canal was reopened in May 1974. The opening ceremony at Ancoats Locks was performed by Denis Howell (Minister for Sport and Recreation) and British Waterways chairman Sir Frank Price, whose boat *Telford* was the first craft through the restored locks.

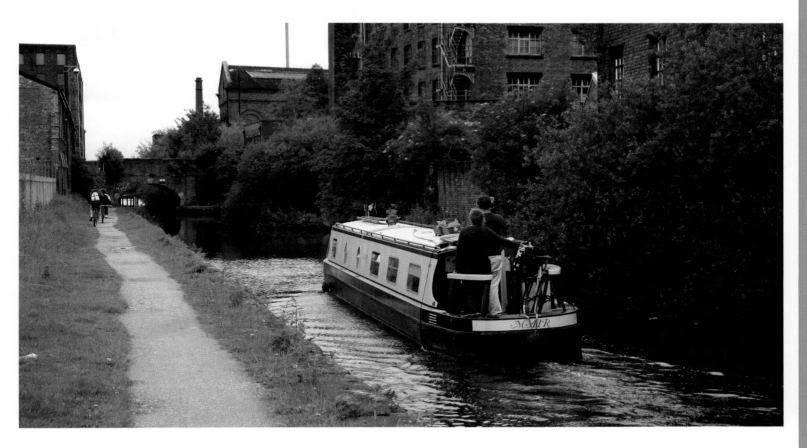

▲ Boating on the Ashton Canal in east Manchester, where trees and bushes soften the edges of redbrick mills and factories. An important trade on the Ashton Canal was supplying coal and raw materials to textile mills around Ashton-under-Lyne. The canal, which had become derelict by the mid-20th century, was restored in 1974, mainly by volunteer labour.

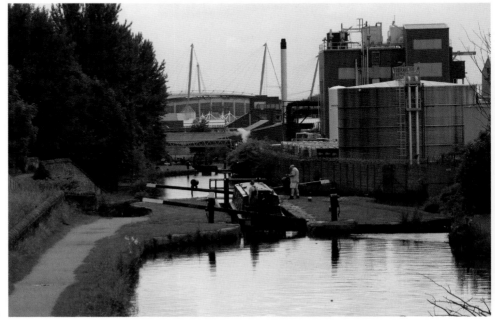

▶ The industrial landscape of Clayton Locks on the Ashton Canal in east Manchester. In the background is the City of Manchester Stadium (renamed the Etihad Stadium), which has been home to Manchester City football club since 2003.

A newly built lock in the centre of Stalybridge. When the Huddersfield Narrow Canal closed it became derelict and was an eyesore in the middle of the town. Restoration of the canal, along with an extensive landscaping programme, has transformed the centre of town. The waterway passes through Armentieres Square that, with its bars and bistros, has turned this part of Stalybridge into a continental-style piazza.

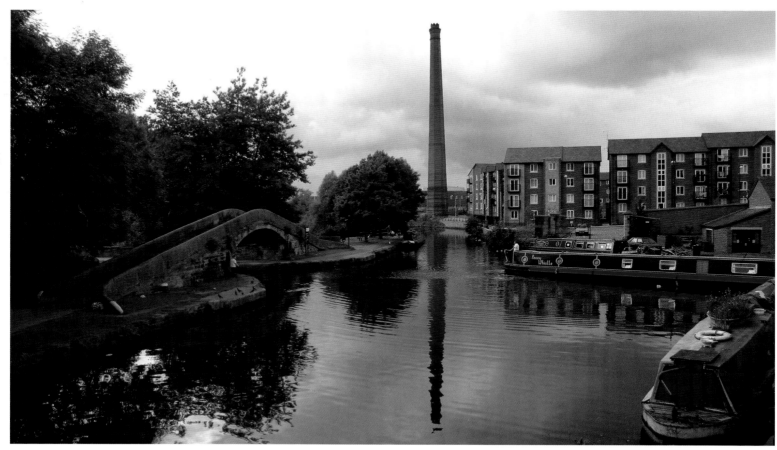

Boating at Tannersfield Lock, on the Rochdale Canal at Failsworth in East Manchester. Some textile mills still remain by the canal, although many of them have been converted to new purposes. In other places mills have been replaced by housing, parkland and light industry.

Dukinfield Junction marks the place where the Ashton Canal meets the Lower Peak Forest Canal and the Huddersfield Narrow Canal. The Ashton Canal warehouse, built in 1834, was destroyed by fire in 1972 and rebuilt as the Portland Basin Museum, where you can learn about local Tameside history and industry. In the 19th century this stretch of canal was lined with cotton mills.

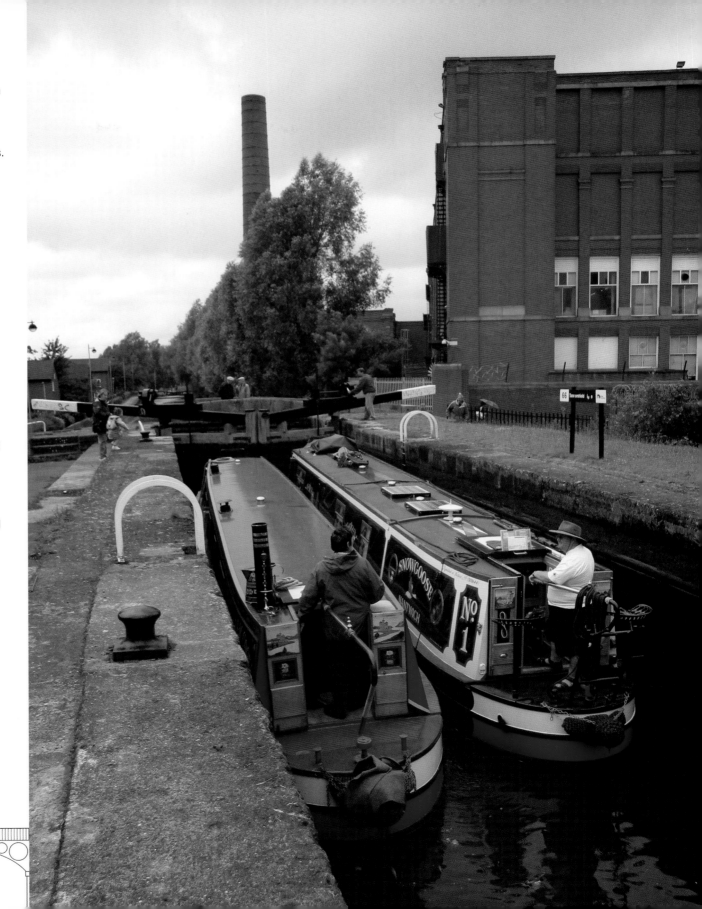

Salford Quays

The Manchester Ship Canal allowed ocean-going vessels to reach docks close to the centre of Manchester, making the city one of the largest ports in Britain. The 36-mile-long canal was opened by Queen Victoria in 1894. After almost a century of successful trading, the docks eventually closed due to containerisation competition in 1982. Manchester Docks was transformed into the present day Salford Quays, which has become a vibrant area with retail outlets, business, residential and cultural centres. The Lowry, named after the famous local artist LS Lowry, is an arts venue with two theatres, galleries and restaurants. Across the water on the opposite bank is the Imperial War Museum North and recently the BBC have relocated much of their programming to MediaCityUK at Salford Quays. The Docks' former trade with Canada is reflected in naming many of its quays and basins after Canadian cities and regions.

▶ The Lowry footbridge can be raised vertically to allow a large vessel to pass by. Behind the bridge is the Lowry Centre and the MediaCityUK. The passenger boat takes visitors on tours around Salford Quays and adjacent waterways.

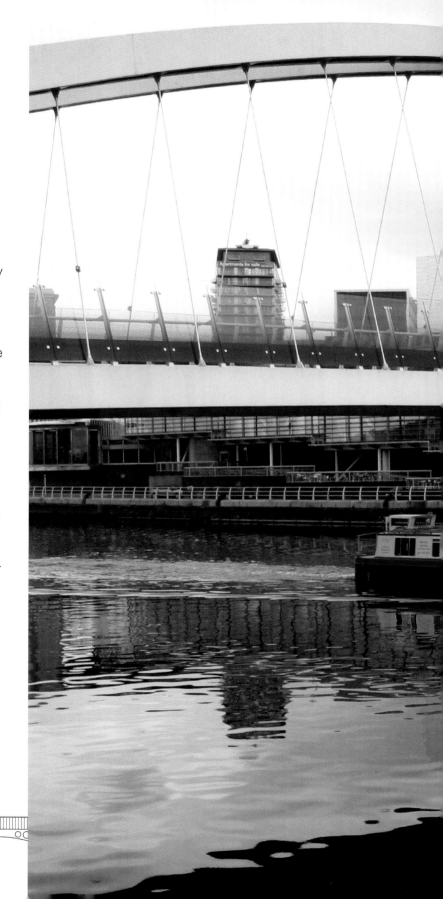

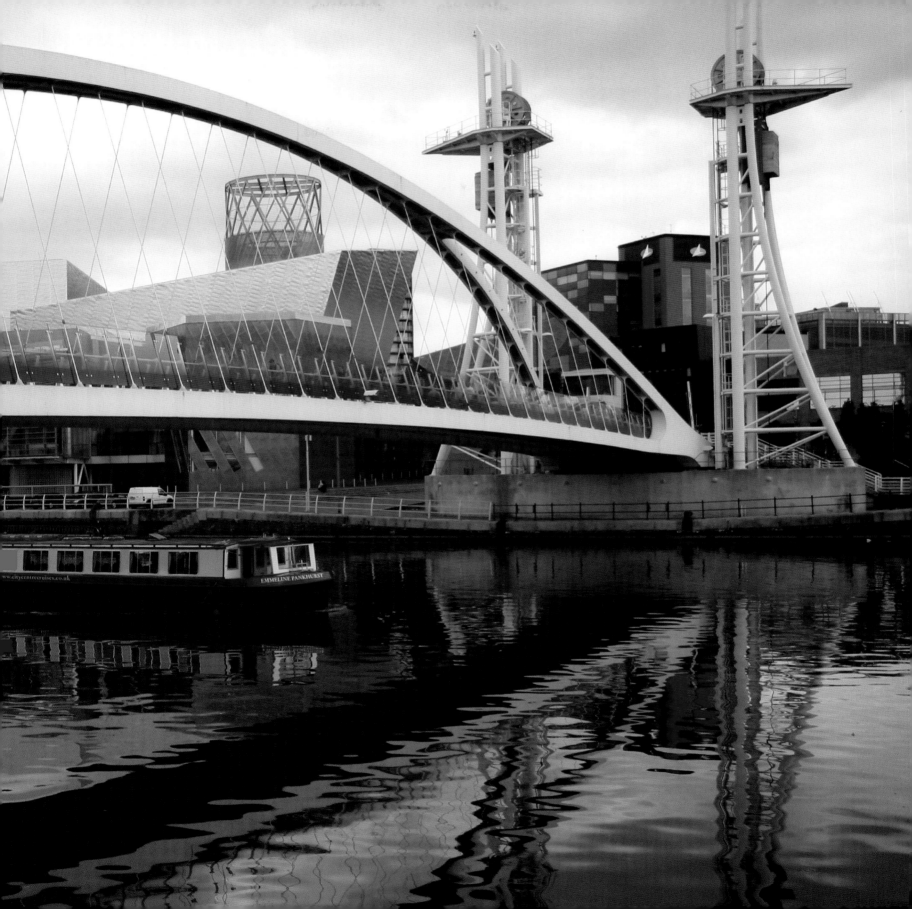

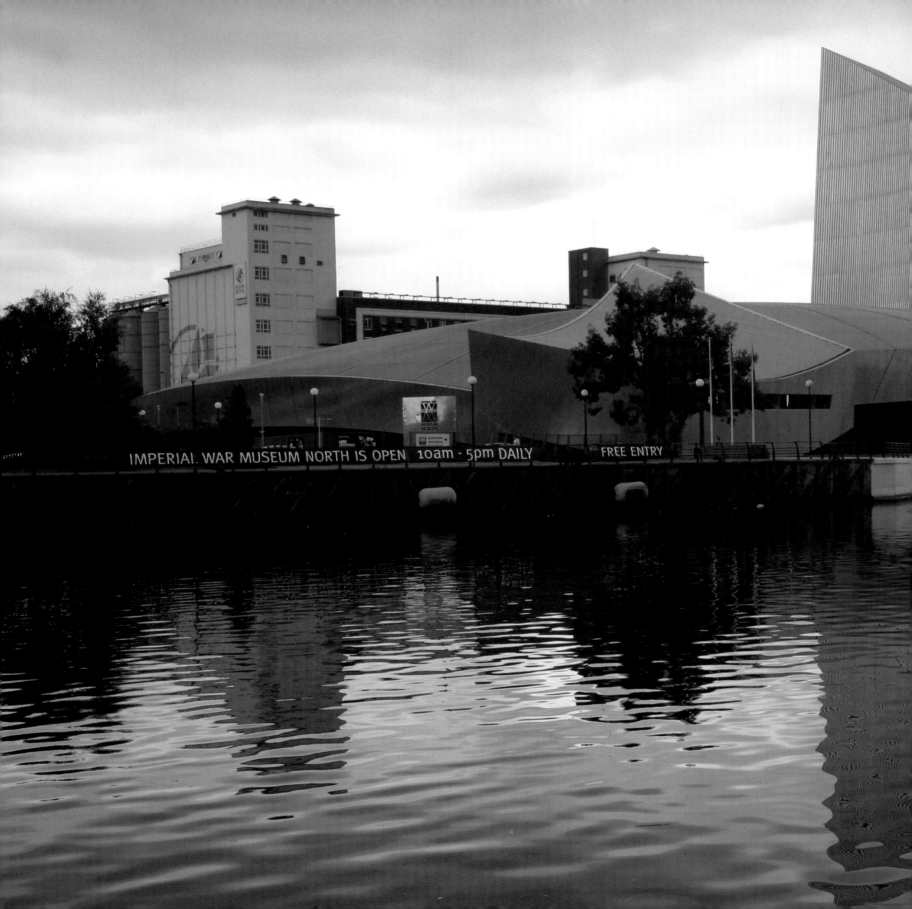

IMPERIAL WAR MUSEUM NORTH IS OPEN 10am - 5pm DAILY FREE ENTRY

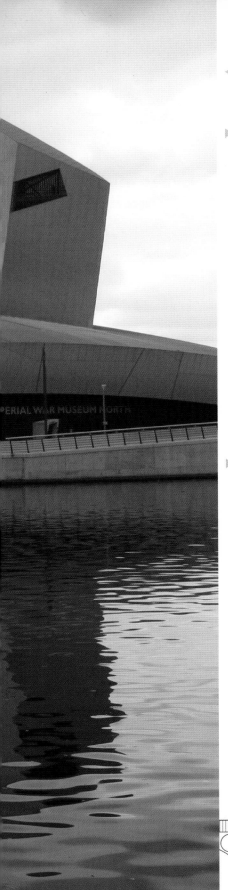

The Imperial War Museum North opened in 2002 and is situated on the bank of the Ship Canal.

Canoeists at the entrance of the Mariner's Canal which leads to the Victoria Harbour Building.

Ballerinas practise in front of the bridge outside the Lowry Centre. Ballet is just one of the arts that can be enjoyed in the Lowry Centre's two theatres.

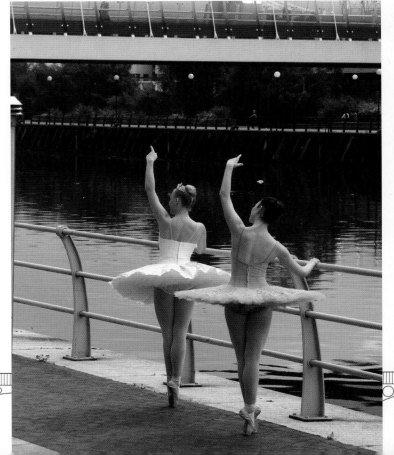

25

Liverpool Link

Until recently, the 128-mile Leeds and Liverpool Canal ended at the foot of Stanley Locks next to a huge tobacco warehouse at Stanley Dock. The Liverpool Link is a one-and-a-half-mile extension, which connects existing dock basins with new canals ending at the historic Albert Dock. Two new locks and three tunnels were built at a cost of around £22 million, and the Link opened in April 2009. Now canal boats can navigate through Pier Head, past a magnificent trio of buildings known as the 'Three Graces': the Royal Liver Building, the Cunard Building and the Port of Liverpool Building.

▼ The Liver Basin at Pier Head under construction in February 2008.

▶ The Liver Basin in April 2011. The boat in the background is emerging from the 200-yard-long St Nicholas Tunnel.

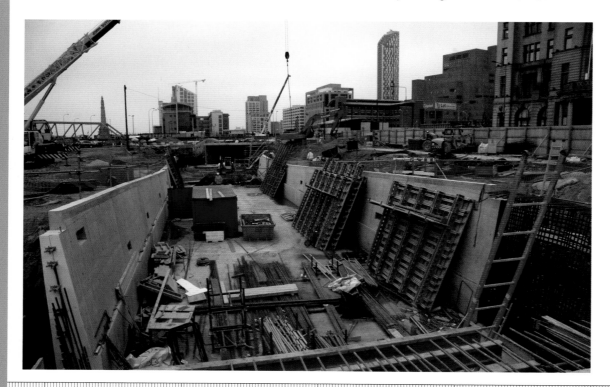

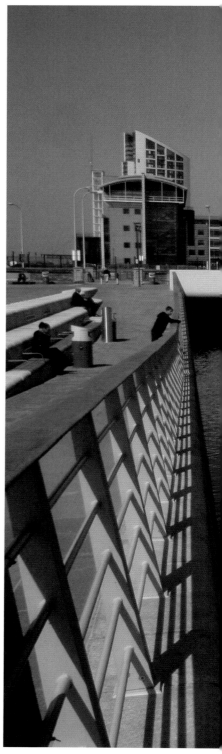

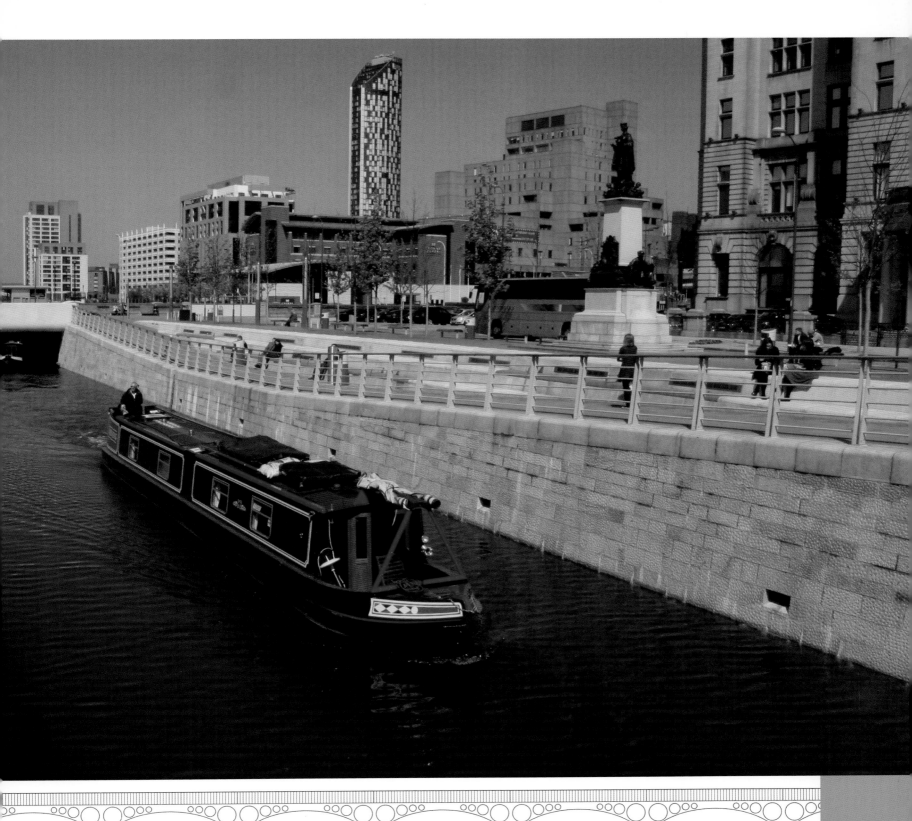

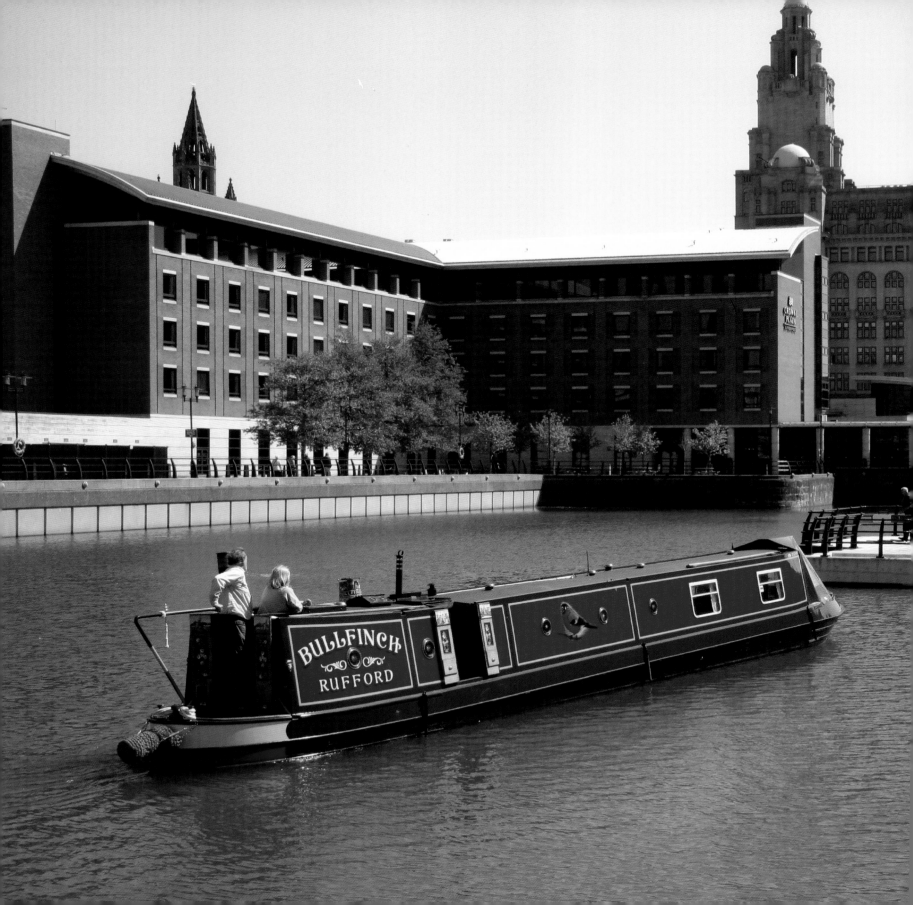

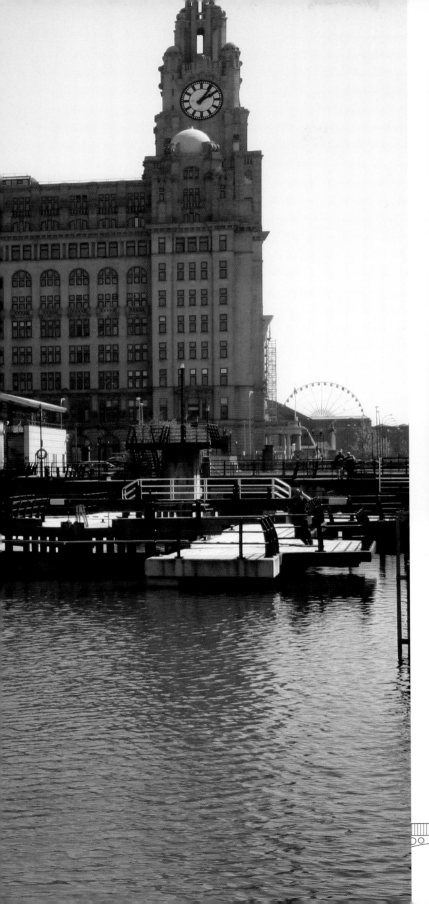

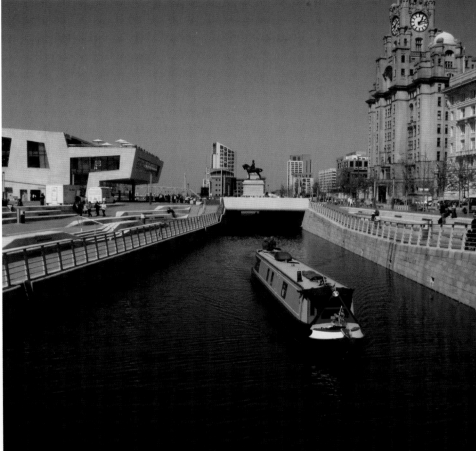

▲ The new canal at Pier Head with the Mersey Ferry Terminal on the left. The boat has just left the Cunard Tunnel.

◄ A boat approaches the lock at Prince's Dock with the Royal Liver Building in the background.

▶ The promenade at Albert Dock with the Mersey Ferry about to dock in the background.

▼ Albert Dock is home to the Tate Liverpool art gallery, the Maritime Museum and The Beatles Story exhibition as well as a number of restaurants and hotels. The cast-iron columns were made at an ironworks near the canal in Tipton, West Midlands, in 1843. Visiting boaters can moor in the adjacent Salthouse Dock.

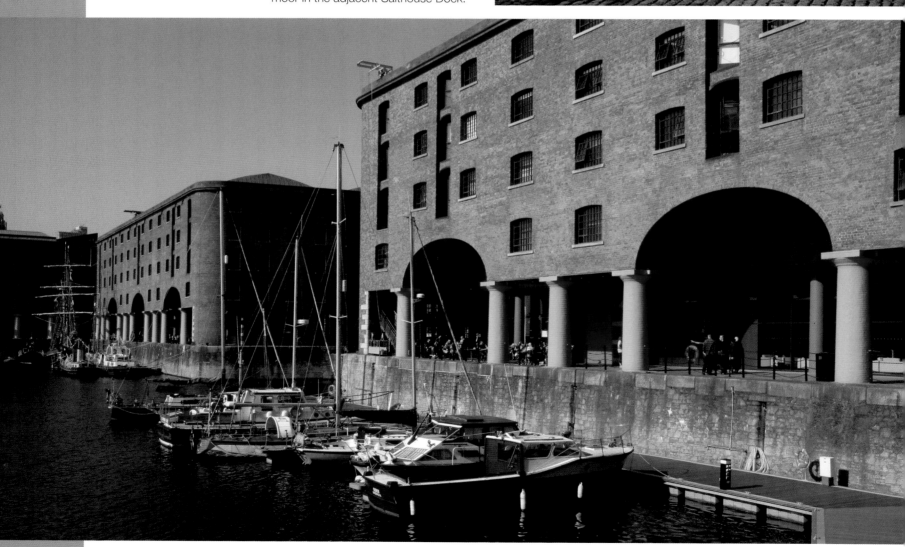

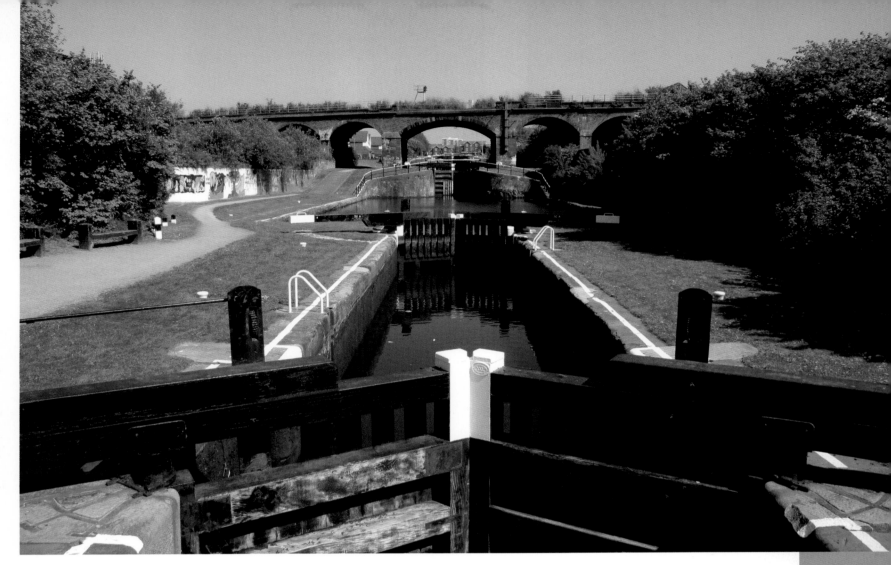

▲ The four Stanley Locks carry the canal from the main line down to the docks and the Liverpool Link.

▶ A statue to Liverpool-born pop singer Billy Fury stands at the edge of Albert Dock. He was very successful, with numerous hits in the early 1960s, but died aged only 42 in 1983.

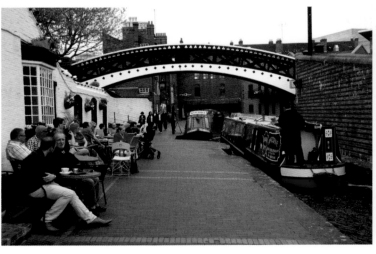

Wigan Pier

Wigan Pier was a 'tippler' where coal-laden tubs from a nearby colliery would pass along a narrow gauge railway and tip their cargoes into canal barges. The name was made famous as a music hall joke by George Formby senior and was recorded for posterity by author George Orwell in his book *The Road to Wigan Pier*. The book (published in 1937) spotlighted the industrial decline of the region. When Orwell came to Wigan he couldn't find the pier because it was demolished in 1929 and sold for scrap. The present Wigan Pier was built in 1986 by students from local colleges.

▶ The curved rails in the foreground represent today's Wigan Pier.

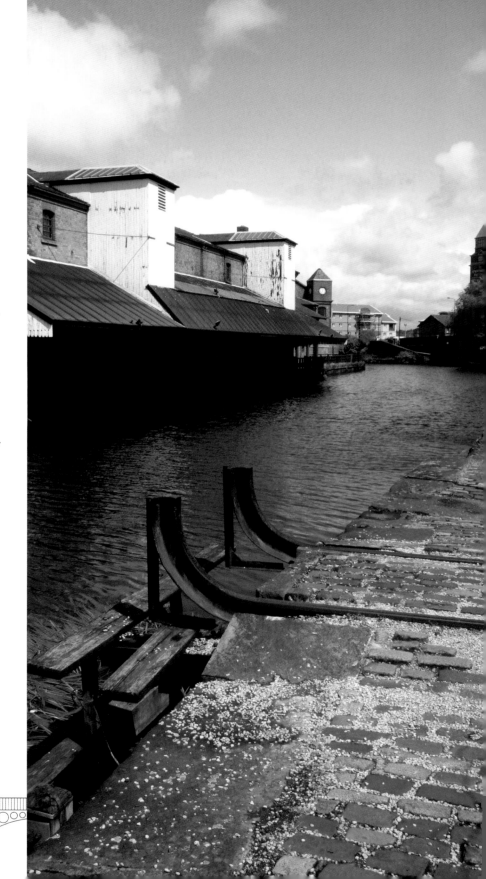

▶ The Orwell pub and restaurant stands on the site of a former Victorian cotton warehouse. In recent years it has achieved fame for its Frog and Bucket Comedy Club evenings which have featured a number of well-known northern comedians. The building is also believed to be haunted as paranormal activity has been reported by staff and visitors. The pub is named after George Orwell author of the classic *The Road to Wigan Pier*.

▼ Trencherfield Mill was one of the largest cotton mills in the region. It is currently being partly converted into luxury apartments, but its huge steam engine remains as a museum attraction.

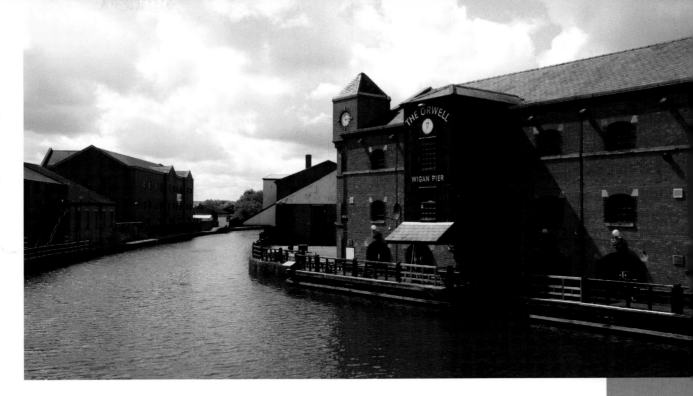

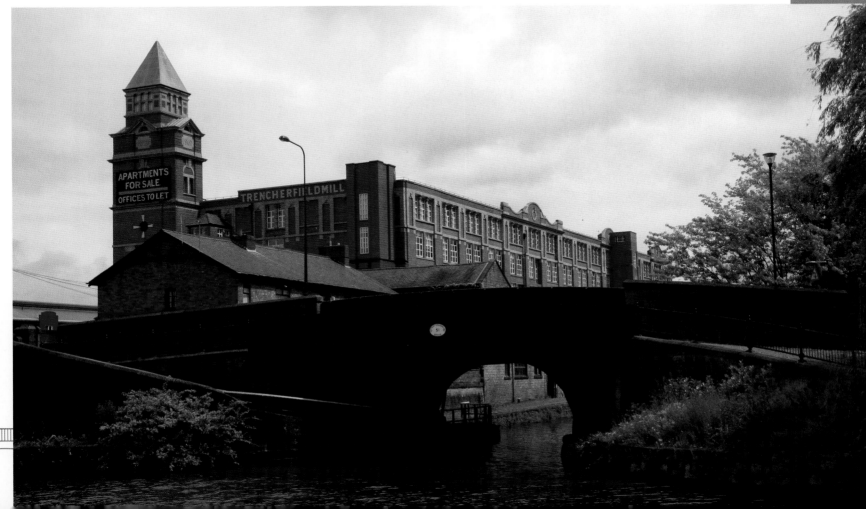

Lancashire Mill Towns

Cotton weaving started as a cottage industry and Lancashire developed into the cotton capital of the world. The Leeds and Liverpool Canal boosted the economy of cotton mill towns such as Burnley and Blackburn by bringing in imported American raw cotton from Liverpool Docks. By mid-Victorian times most of the world's cotton manufacturing was based in Lancashire. Trade was disrupted and then lost by the First World War followed by mass unemployment in the 1930s. New industries such as heavy engineering became prominent after the Second World War and many of the old cotton mills were forced to close. Fortunately, a lot of fine old mill buildings have survived and are being used for new purposes. The same can be said of the canal, which is now used for pleasure and no longer carries freight.

▶ The Leeds and Liverpool Canal at Burnley in the early 1970s. Burnley was once the leading town in the production of cotton and the canal was lined with mills and weaving sheds. This area is now known as the Weaver's Triangle, and there is a visitor centre and museum in an old warehouse. Unfortunately, some of the buildings in the picture have since been demolished.

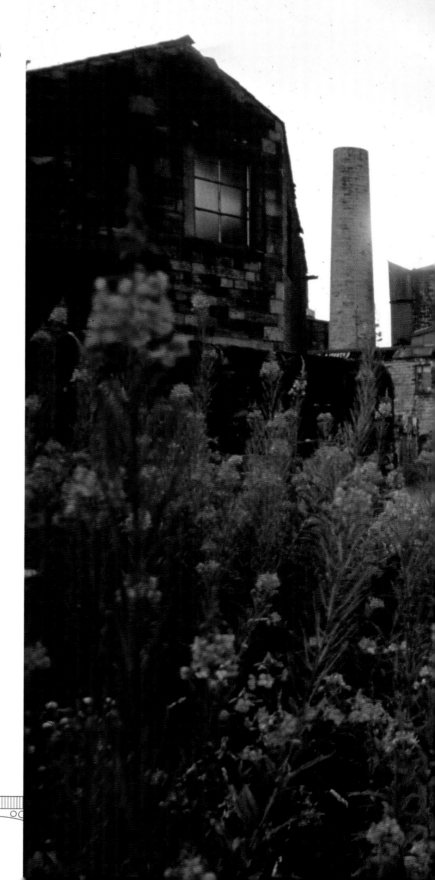

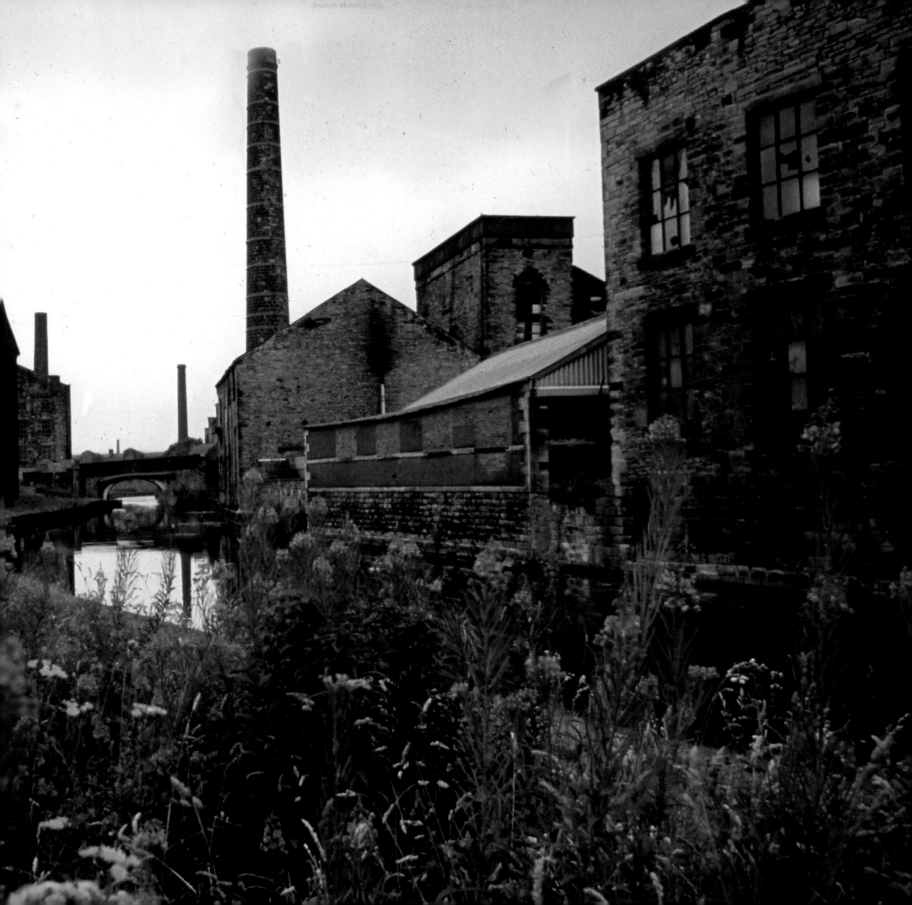

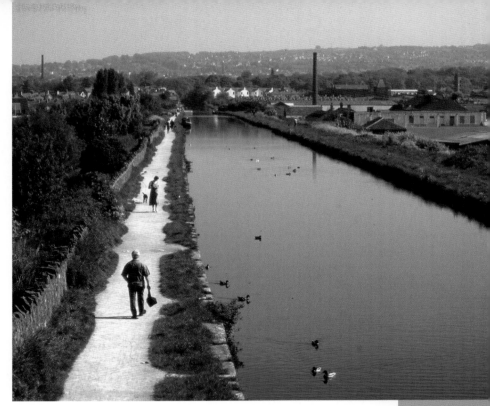

◄ Daisyfield Mill at Blackburn was built in 1848 as a cotton mill. It later became a flour mill called Appleby's and after that a wallpaper factory. It has now been converted into office units and a television studio.

▲ The 60-foot-high Burnley Embankment, locally known as 'The Straight Mile', cuts across the centre of the town. It was built between 1796 and 1801, and was a massive achievement at a time when there was no mechanised earth-moving equipment.

◄ Blackburn waterside is at Eanam Wharf where canopied warehouses are now business units and a pub.

Aire Valley Towns

On the Yorkshire side of the Pennines, the Leeds and Liverpool Canal follows the River Aire valley all the way from Gargrave to the centre of Leeds, a distance of 34 miles. On its way, it passes through Skipton, Bingley and Shipley, where the canal was lined with mills serving the woollen and textile industries. The village of Saltaire (near Shipley) was built by Sir Titus Salt in 1853 to house the workforce employed in his mill. It is a now a World Heritage Site.

▶ Sir Titus Salt's mill at Saltaire now houses a large collection of work by local artist David Hockney, plus exhibitions of art and antiques.

▼ Old warehouses at Shipley Wharf are now home to a restaurant and trip boats. Nearby Shipley Glen is a beauty spot reached by Britain's oldest working cable tramway.

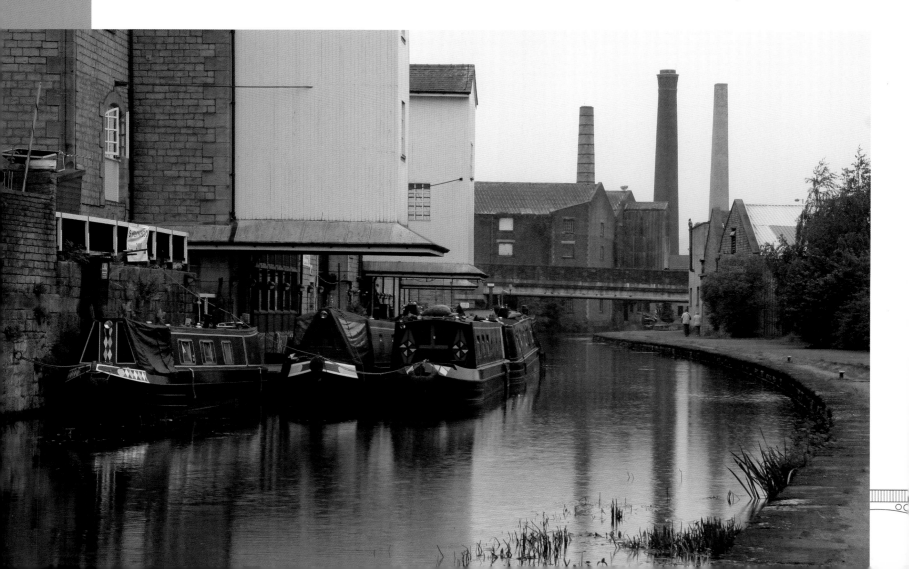

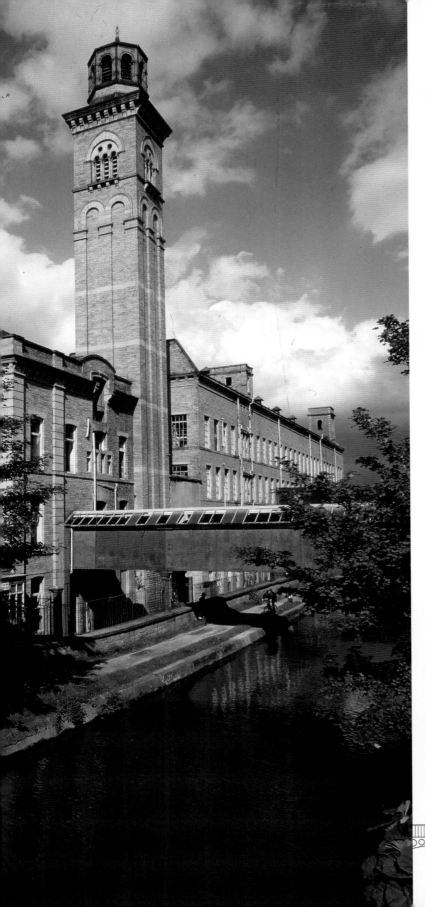

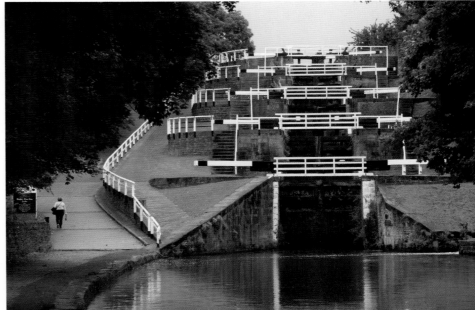

▲ The dramatic Five Rise Locks at Bingley raise the canal by 60 feet. They are grouped in a staircase formation where each chamber immediately leads into its neighbour. A resident lock-keeper is on hand to help confused boaters through the flight.

▼ At Skipton the half-mile-long Springs Branch leaves the Leeds and Liverpool main line to end beneath the towering Skipton Castle. It was built to carry limestone from the Earl of Thanet's quarries.

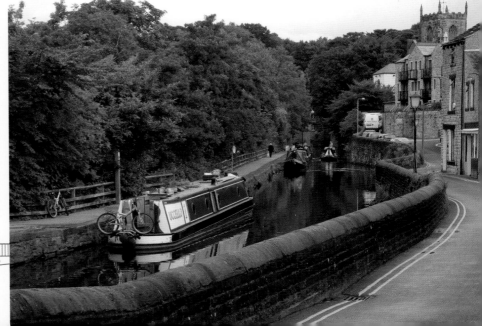

Leeds

The Leeds and Liverpool Canal took 40 years to complete. Eventually it connected with the older Aire and Calder Navigation in the centre of Leeds in 1816, opening up a direct route between the Rivers Humber and Mersey. Waterside factories and mills made this part of the city a busy centre of commercial activity. As trade declined the area became extremely run down, but in recent years the Leeds waterfront has been transformed into one of the city's major visitor locations. Granary Wharf, with its restaurants, bars and hotels, has become an urban oasis in the centre of the city. The Royal Armouries at Clarence Dock, and Brewery Wharf, with its nightclubs and bars, are prominent waterside attractions. The Leeds Industrial Museum at Armley Mills can be found a mile or so from the city centre along the Leeds and Liverpool Canal. Thwaite Mills Museum is a similar distance in the opposite direction along the Aire and Calder.

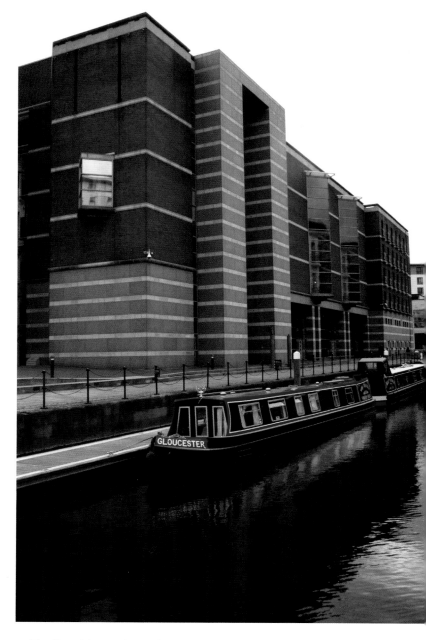

▲ The Royal Armouries at Clarence Dock, Leeds, opened in 1996. It has one of the world's largest collections of arms and armour, and a tiltyard where visitors can enjoy jousting and equestrian displays. Thousands of exhibits are displayed in five galleries showing the development of weaponry from Roman times to the present day.

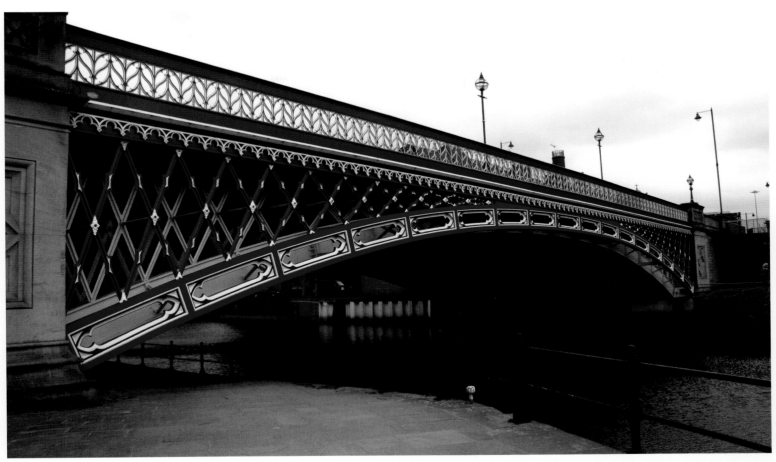

▲ Crown Point Bridge over the River Aire was built in 1842. At first it was a toll bridge, but this was abolished in 1862.

▶ The Hall of Steel, with its ferocious display of weaponry, can be seen inside the Royal Armouries. The items on display include 17th- and 19th-century armour and military equipment. *(Photo reproduced with permission of the Royal Armouries.)*

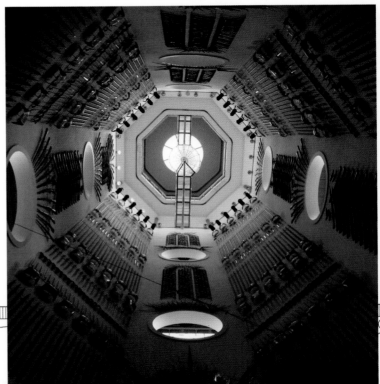

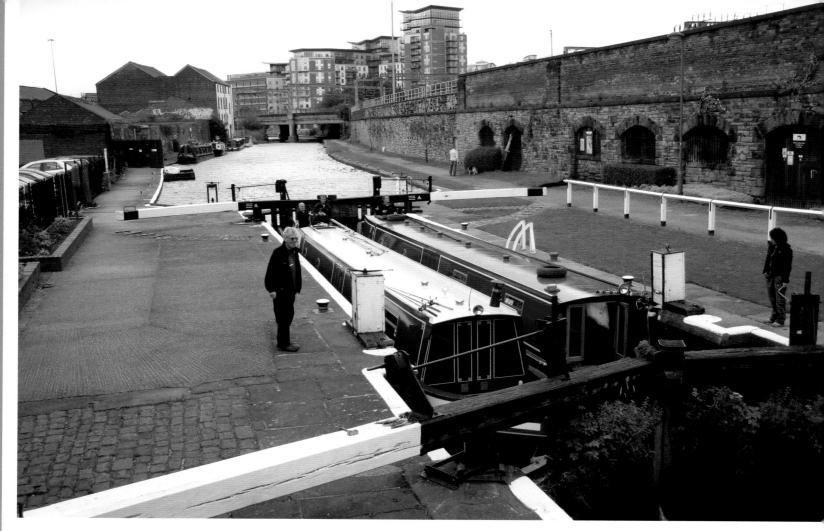

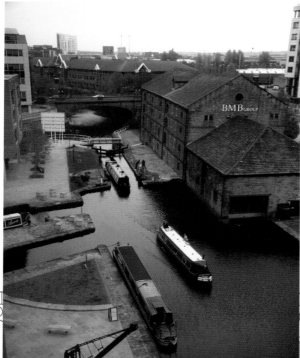

◁ River Lock is the first of 91 locks on the Leeds and Liverpool Canal, which begins its 128-mile journey to Liverpool here at Granary Wharf in Leeds.

▲ Office Lock in the centre of Leeds is the second lock on the Leeds and Liverpool Canal.

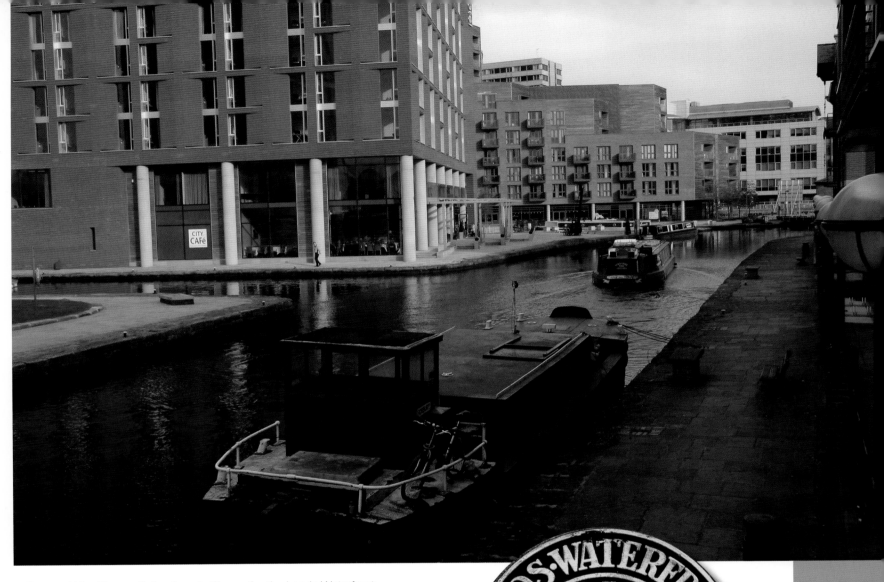

▲ Granary Wharf is a revitalised part of the canal next to Leeds Central railway station. A new hotel, offices and apartments are recent additions to the Leeds Waterfront.

▶ Plaque for the Leeds Waterfront Heritage Trail.

LEEDS · WATERFRONT · HERITAGE · TRAIL

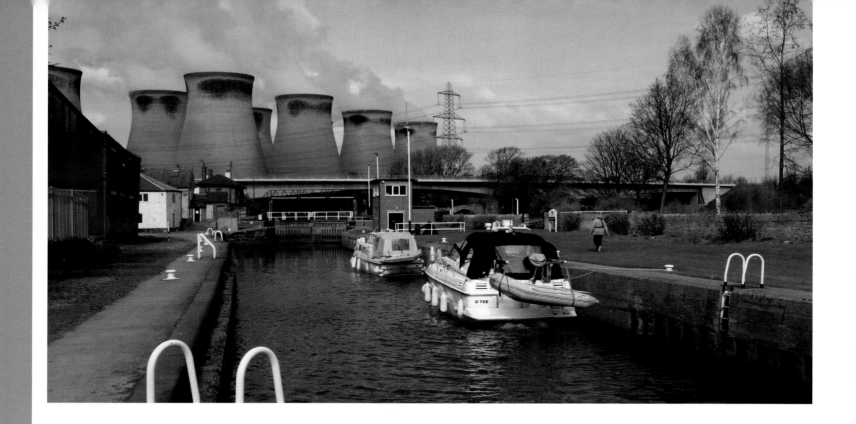

Castleford and Ferrybridge

The River Aire (between Castleford and Leeds) and the River Calder (between Castleford and Wakefield) were made navigable during the first decade of the 18th century. Improvements were made over the next 100 years, including the Castleford Cut, which opened in 1775. The navigation really became a success after the Aire and Calder was built between Knottingley and Goole in 1819, and it has been transporting coal in huge quantities until recent times. The coal-fired power station at Ferrybridge even designed special hoists which lifted and upturned barges filled with 170 tonnes of coal onto conveyor belts. Forty-three million tonnes of coal was moved this way in 35 years, ending in 2002. It is hard to believe that very little coal is now carried by water. Oil and gravel are the main commodities still carried on the navigation.

Ferrybridge Lock is the start of a long canal section on the Aire and Calder Navigation that ends at Goole. The cooling towers of Ferrybridge Power Station can be seen in the background. The power station was once the largest in Europe and used coal mostly brought in by water transport.

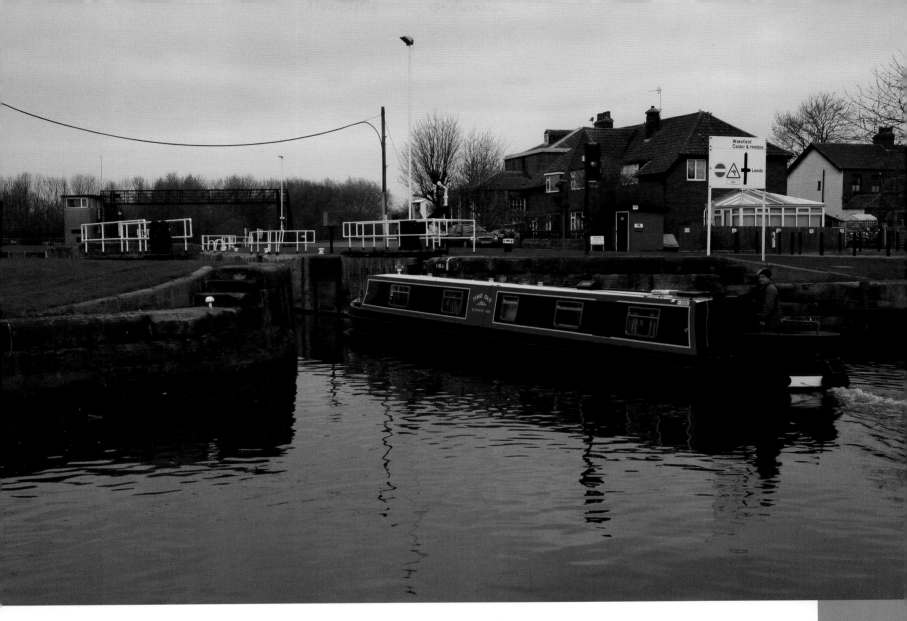

▲ A privately owned narrowboat enters Castleford Flood Lock. Castleford stands at the junction of the River Aire (navigable to Leeds) and the River Calder (navigable to Wakefield). Until recently, this was a place of intense commercial activity with coal barges, oil tankers and grain barges often queuing to pass through the lock. All Castleford's coal mines, along with its glassworks and potteries, have since closed down, although sand and gravel barges still pass through on their way to discharge at Whitwood on the River Calder. Castleford is well known for Allinson's flour mill and also makes some famous chocolate products. Its Xscape leisure complex has one of the largest indoor real snow slopes in Europe.

Overleaf: The old bridge at Ferrybridge near Knottingley once carried the A1 Great North Road. It was replaced by an elevated viaduct which crosses the Aire and Calder Navigation close to the old bridge.

Goole Docks

Goole has been called 'The Port in Green Fields' because of its location so far from the sea. The village of Goole developed as a port because of its proximity to the River Ouse and the arrival of the Aire and Calder Navigation in 1826. There are eight docks and three miles of quaysides containing storage warehouses. Its success as a port was largely due to the export of coal from the Yorkshire coalfields and importing produce from Scandinavia and the Baltic. It is still a busy port and in 2006 handled over two and a half million tonnes of cargo. The Yorkshire Waterways Museum in Goole Docks has exhibitions on the growth of the Port of Goole and the story of the Aire and Calder Navigation.

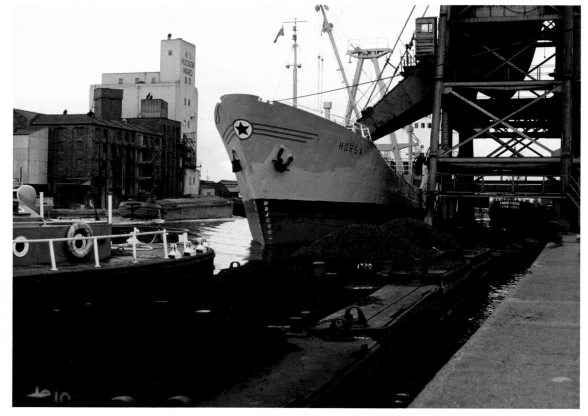

◀ One of the Goole Hoists filling a Norwegian coaster with coal in 1968. There were five working hoists at Goole, each able to handle 300 tons of coal per hour. 'Tom Pudding' coal compartment boats were separated and then individually raised to a height where their cargoes could be tipped into the ship's hold. The hoists closed down in 1985.

A train of 'Tom Puddings' carrying coal along the Aire and Calder Navigation to Goole in July 1968. 'Tom Puddings' were invented by William Bartholomew in 1863. Trains of up to 20 compartment boats, each able to hold around 40 tonnes of coal, were lifted into the hydraulically operated hoists in Goole Docks. 'Tom Puddings' ended service in 1986 because of a reduced demand for coal. A few remain as floating exhibits at the Yorkshire Waterways Museum.

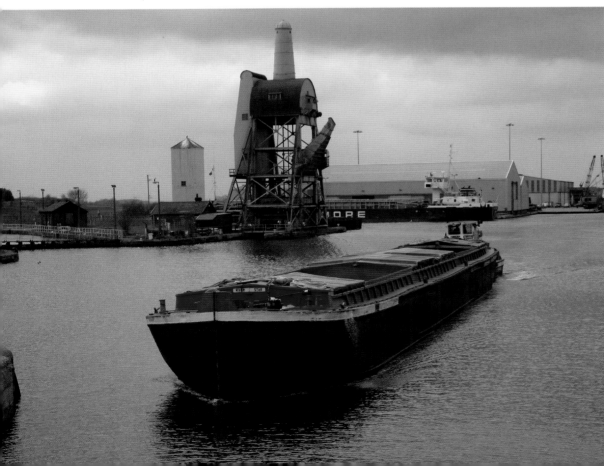

The sand barge *River Star* at Goole Docks in 2010. Behind the barge is the one remaining coal hoist, which is now an exhibit for the Yorkshire Waterways Museum.

York and the River Ouse

The River Ouse has been a commercial navigation since Roman Times, when York was called Eboracum. York was a busy inland port until 1826 when the building of the Aire and Calder Navigation diverted trade to Goole. Nowadays, the river traffic is confined to passenger trip boats and pleasure craft. York's many attractions include its beautiful Minster, the Jorvik Viking Centre and the National Railway Museum. The city is enclosed by medieval city walls.

▼ Lendal Bridge spans the River Ouse near York city centre. It was built in 1863 and designed by Thomas Page, who was also responsible for nearby Skeldergate Bridge and Westminster Bridge in London. The first bridge collapsed in 1861 during construction, killing five men. It replaced an earlier ferry whose operator received £15 compensation and a horse and cart. Until 1894, the new bridge charged tolls to pay for its construction.

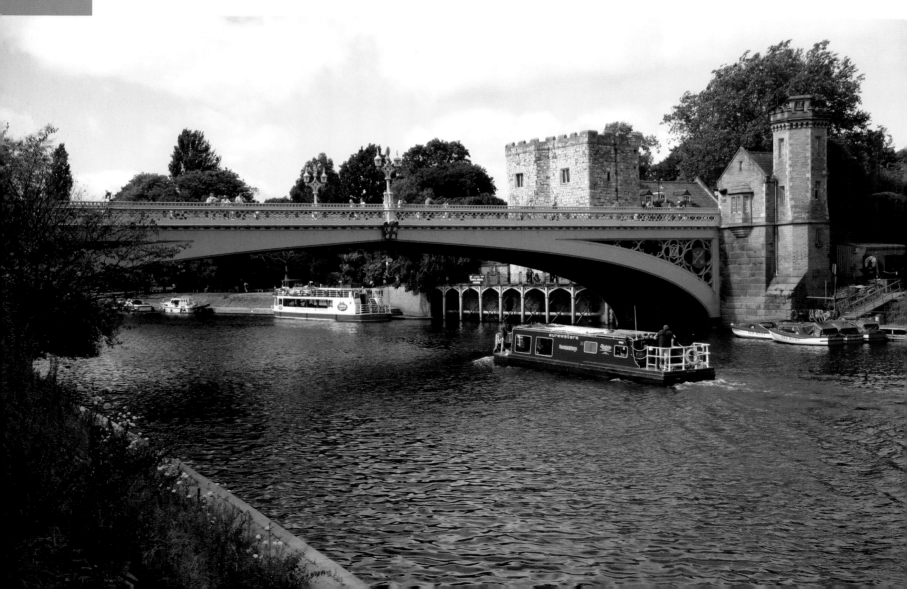

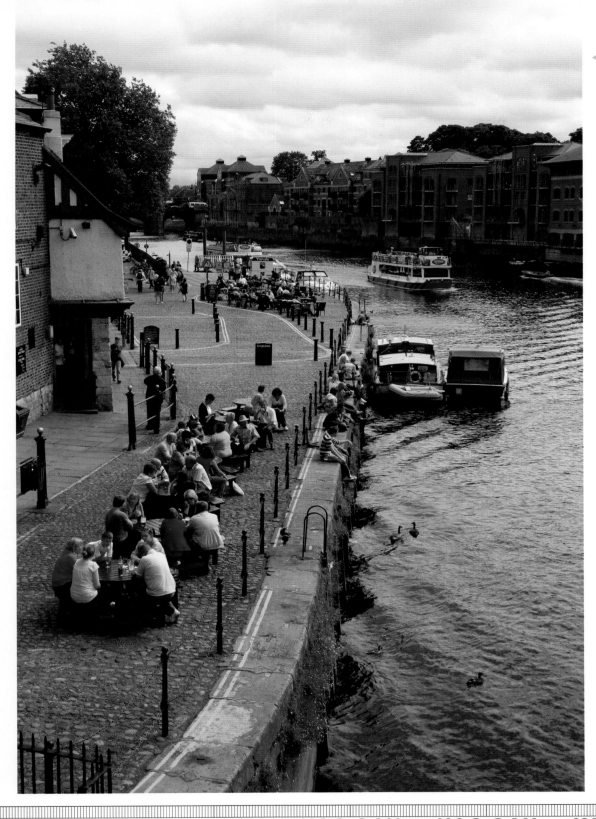

York's waterfront viewed from Ouse Bridge. In the background is one of the public trip boats that regularly operates on the river. Most of the city's tourist attractions (such as York Minster, the Castle and the Shambles area of narrow streets) are near Ouse Bridge. There have been several bridges at this point, some going back to Roman times. A 14th-century bridge supported shops, a hospital, a prison, a chapel and reputably the first installation of a public toilet in England!

York's Millennium Bridge, with a design based on the spokes of a bicycle wheel, opened in April 2001 and cost £4.2 million. It replaced an earlier rope ferry.

The Shambles in York is a medieval street with overhanging buildings, some of which date back to the 15th century. The name derives from the now obsolete word Fleshammels meaning 'flesh shelves' as the street was lined with butchers shops and slaughterhouses. There were still 26 butchers shops in the Shambles as late as 1872 but now they have all gone. In 2010 the Shambles won Google's award for 'Most Picturesque Street in Britain'.

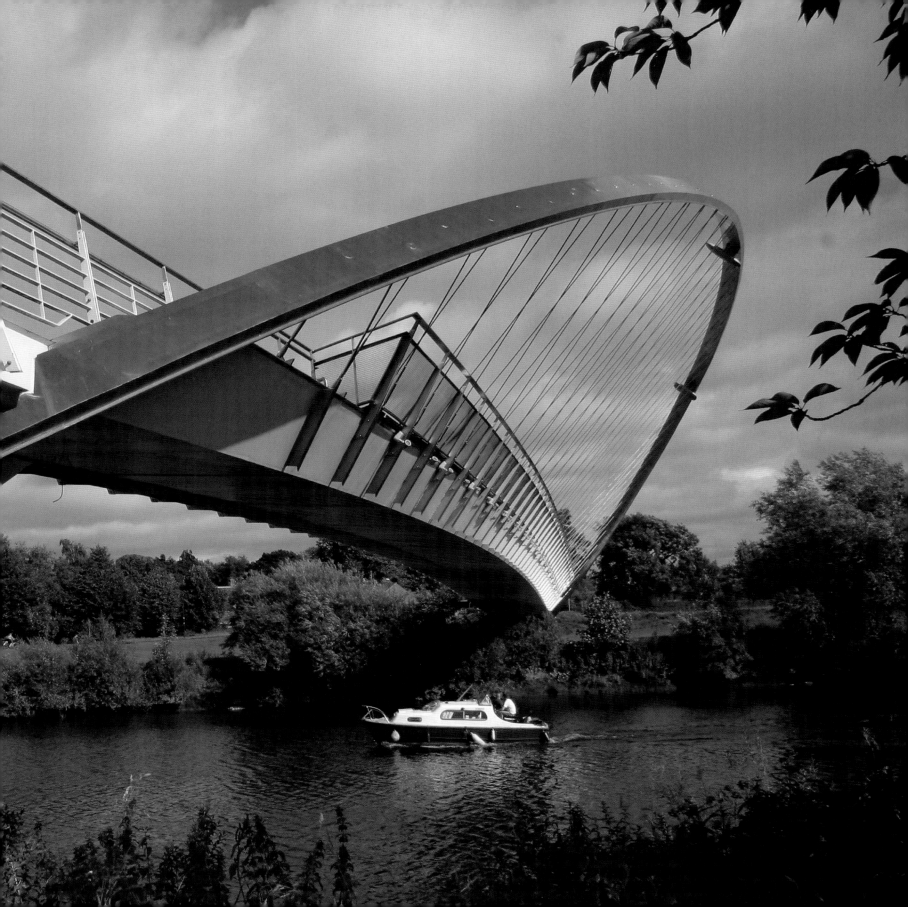

Sheffield and Victoria Quays

The Sheffield and South Yorkshire Navigations are a combination of the Sheffield and Tinsley Canal, the River Don Navigation and the Stainforth and Keadby Canal, and connect the City of Sheffield to the sea via the Trent and the Humber. A link was made to the Yorkshire coalfields via the Aire and Calder Navigation to bring much needed coal to the city's steelworks. The industrial towns of Doncaster and Rotherham are on the route and both were important users of the navigation. In the 1980s, locks were widened and improvements made to promote Rotherham as an inland port but the scheme was never successful. The Don Valley Stadium, which stages major athletic events, and the Sheffield Arena, are close to the canal at Tinsley. The developments at Victoria Quays in Sheffield are a popular leisure facility for local people, and bring in visitors by boat.

▶ The former warehouse at Sheaf Quay has been restored and is now a pub and restaurant.

▼ The Straddle Warehouse in the background of the picture marked the terminus of Sheffield and Tinsley Canal. It was built in 1895 on stilts across the canal basin.

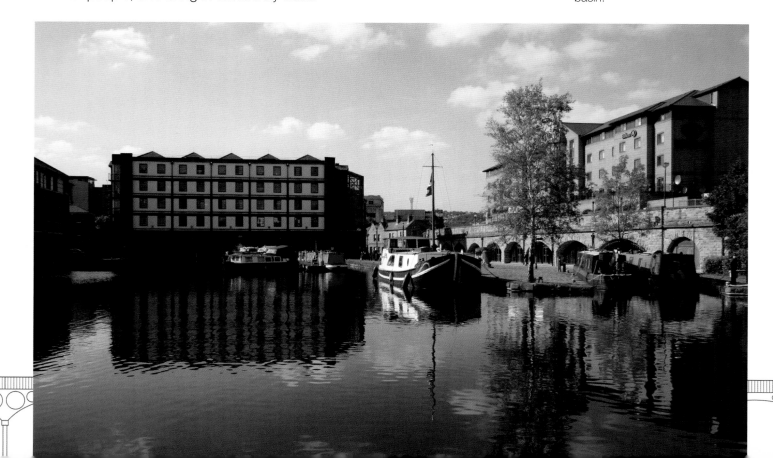

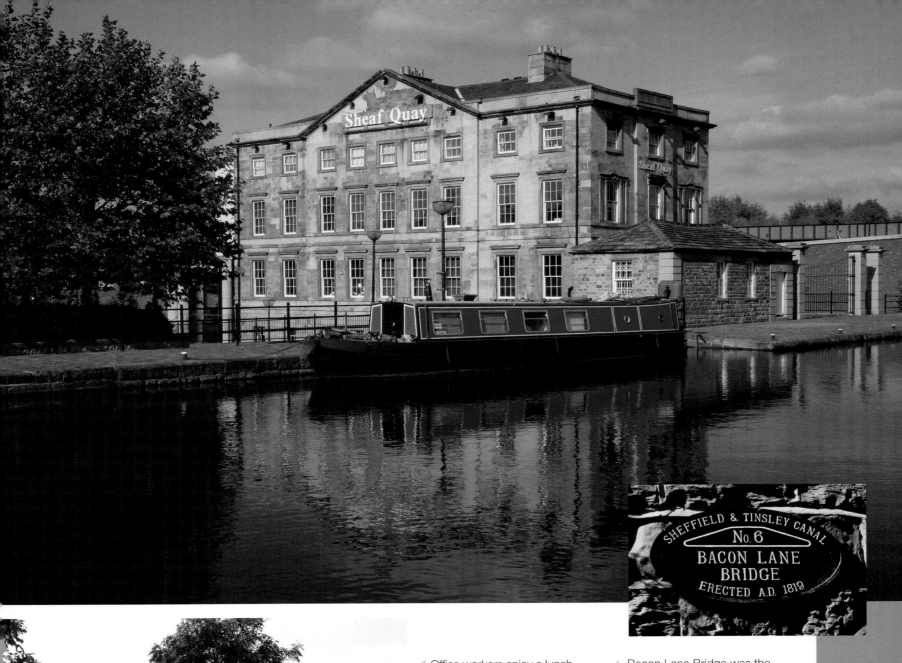

SHEFFIELD & TINSLEY CANAL
No. 6
BACON LANE
BRIDGE
ERECTED A.D. 1819

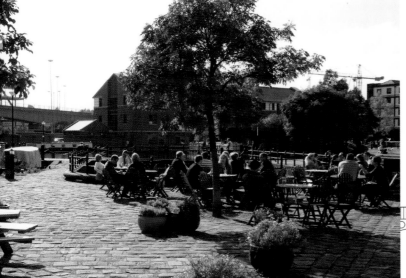

◀ Office workers enjoy a lunch break in the sun at Sheffield Canal Basin, now known as Victoria Quays. In its commercial heyday this quayside would have been busy with boats unloading raw materials for local industry and loading finished goods for export. Today it is lined with hotels, pubs, offices and a marina.

▲ Bacon Lane Bridge was the location for a famous scene in the film *The Full Monty*, which featured a sinking car in the canal. Working boatmen called the bridge 'the eye of a needle' because the height and width of the bridge was so small that a large boat could just squeeze through.

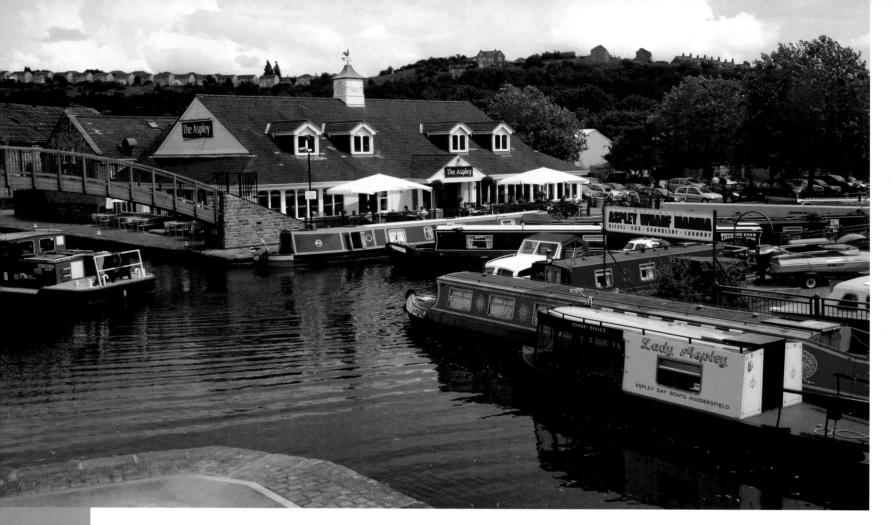

Huddersfield

The Huddersfield Broad Canal and the Huddersfield Narrow Canal combine to form one of the three trans-Pennine Canals that were so important connecting Yorkshire to Manchester and Lancashire. Wide boats (known as Yorkshire Keels) were not able to navigate the Narrow Canal, so goods had to be transhipped at Aspley Basin in Huddersfield. The Huddersfield Narrow Canal, with its 74 locks and the longest canal tunnel in Britain (at Standedge) was never a great commercial success and eventually closed in 1944. It was restored to full navigation in 2001 at a cost of £32 million.

▲ Aspley Basin was once surrounded by mills and warehouses. As a transhipment basin between two canals it would have been bustling with commercial boats. Today, it has a marina with a large pub and restaurant.

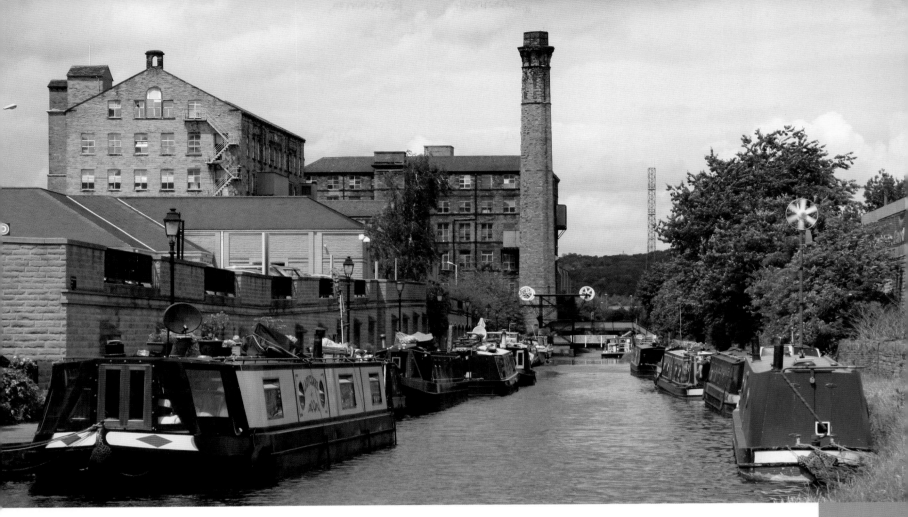

▲ A view of Huddersfield Broad Canal from Aspley Basin. Below the mill, in the background of the picture, is the unique Locomotive Bridge. This is a lift bridge over the canal that looks as though it was put together with a Meccano set. The Huddersfield Broad Canal was originally called Sir John Ramsden's Canal after the local textile businessman who financed its building in 1776.

▶ Huddersfield University stands next to the canal. The Quayside is a cultural events centre and part of the university campus.

Sowerby Bridge

Sowerby Bridge is a stone-built mill town in Upper Calderdale. Its development as a textile centre was mainly due to the two waterways that meet in the town. The Calder and Hebble Navigation (built in 1770) brought in coal from the Yorkshire mines to the Calder Valley, but it was the building of the Rochdale Canal in 1804 that allowed wide-beamed boats to reach Manchester from Yorkshire. Whites Directory of 1853 described Sowerby Bridge as a large and well-built village with extensive cotton, worsted and corn mills, commodious wharves, chemical works and iron foundries.

▼ Sowerby Bridge Canal Basin is where the Calder and Hebble Navigation meets the Rochdale Canal. It grew in importance as a storage and transhipment centre between the two waterways. The restored warehouses are now home to restaurants, workshops and Shire Cruises' boatyard.

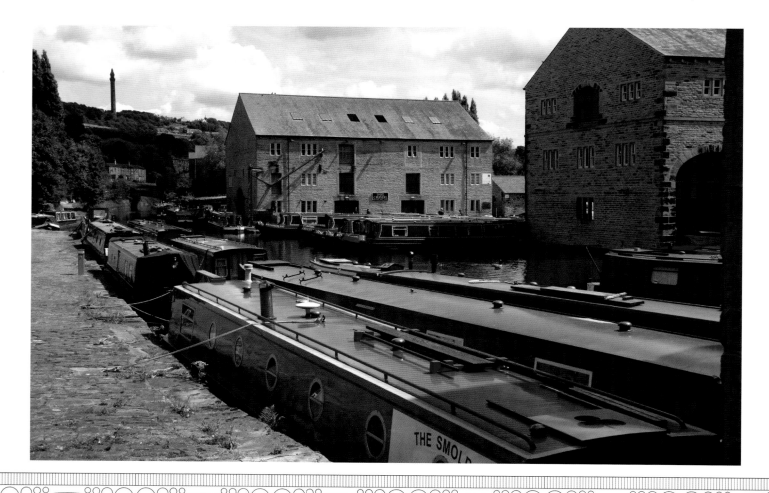

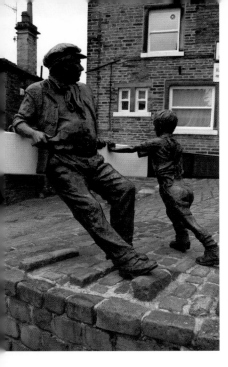

◀ This sculpture of a boatman and his son pushing a lock beam stands at the entrance to Sowerby Bridge canal basin.

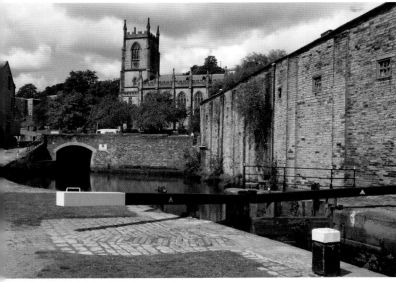

▲ Tuel Tunnel carries the Rochdale Canal under Sowerby Bridge's main street. The tunnel was built in 1996 to replace a section of canal filled in when a road junction was widened.

▶ Tuel Lane Lock replaced two earlier locks which became derelict when the Rochdale Canal fell into disuse. It is the deepest canal lock in Britain.

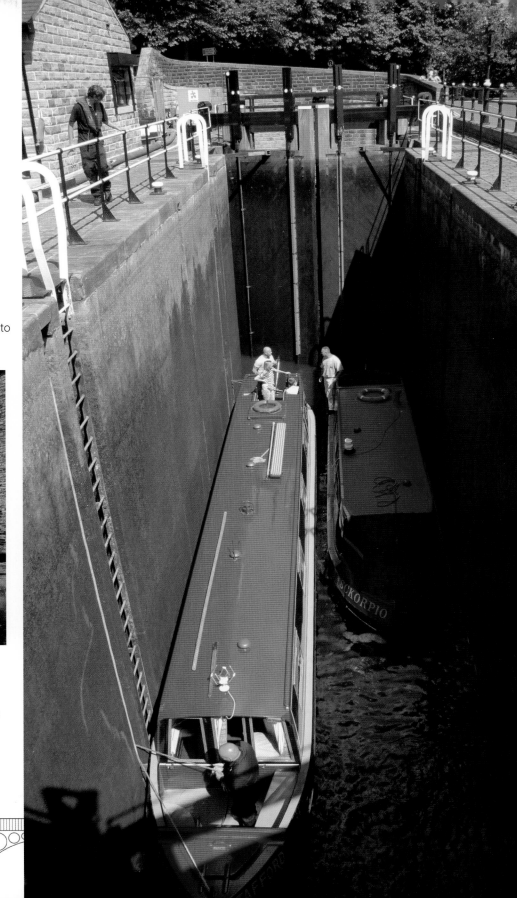

Hebden Bridge and Todmorden

Hebden Bridge achieved prosperity from its high quality textiles. The Rochdale Canal, which passes through the centre of town, played a big part in the town's growth, carrying produce to Manchester, the Lancashire mill towns and to Yorkshire. Heptonstall, built on a steep hillside overlooking Hebden Bridge, is where most of the millworkers lived, in terraced houses known as 'double deckers'. The self styled 'King David' Hartley, head of a notorious gang of local counterfeiters known as the Cragg Vale Coiners, is buried in Heptonstall graveyard. He was hanged at York in 1770. The humorous author John Morrison's Milltown trilogy was inspired by Hebden Bridge.

▼ Blackpit Lock at Hebble End, Hebden Bridge. Hebble End is now an Alternative Technology centre, attracting visitors from all over the north of England. Some old mills survive but most of them have been converted to luxury apartments. Hebden Bridge's waterside buzzes with activity, especially in the summer months when the town plays host to coachloads of visitors.

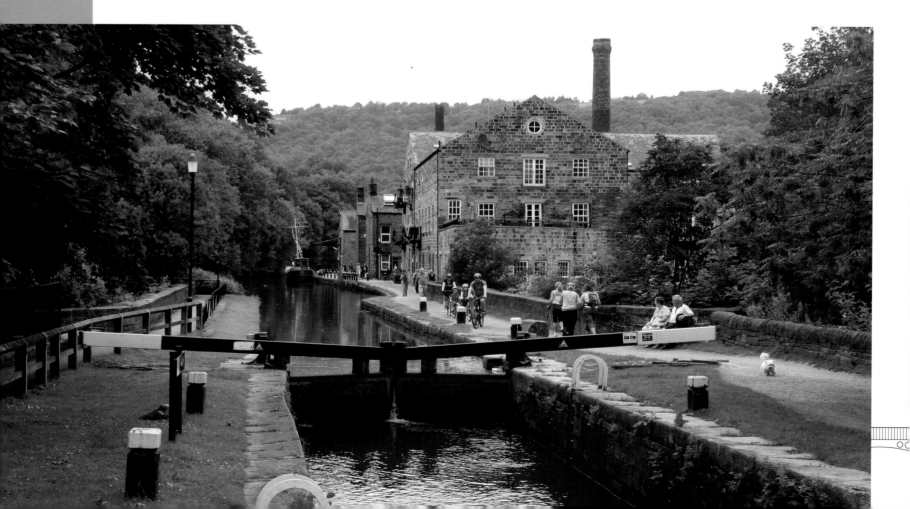

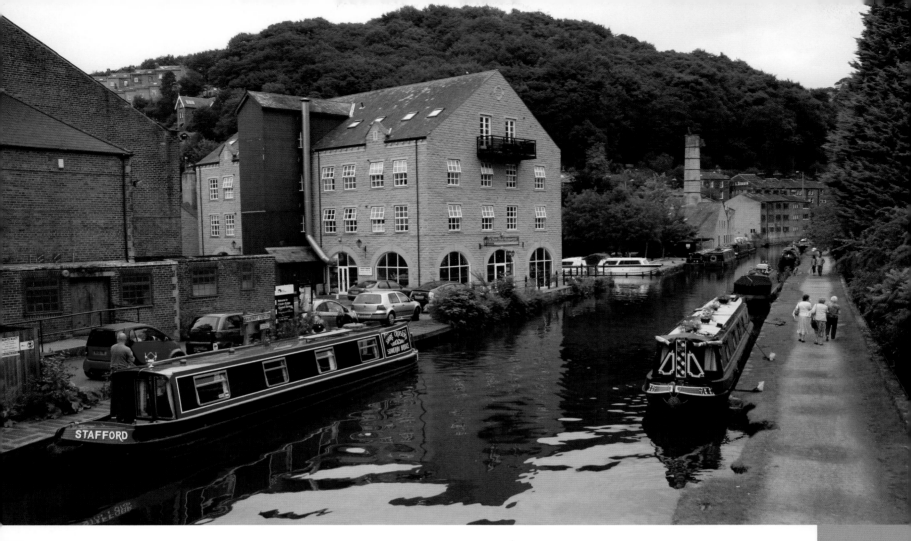

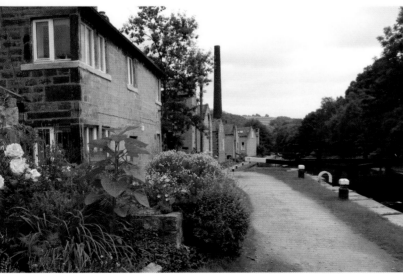

▲ The restored mill building in the picture is now a Thai restaurant. Behind it is the Hebden Bridge Canal Centre, which tells the story of the Rochdale Canal in Calderdale.

Overleaf: Most of the mills and factories that lined the canal at Todmorden in the 1970s have now gone. West of Todmorden, a long flight of locks carries the Rochdale Canal to a short summit level surrounded by splendid Pennine moorland.

◄ Canalside houses by Stubbings Locks at Hebden Bridge. Visitors can take a 30 minute cruise on a trip boat from outside a pub near these locks.

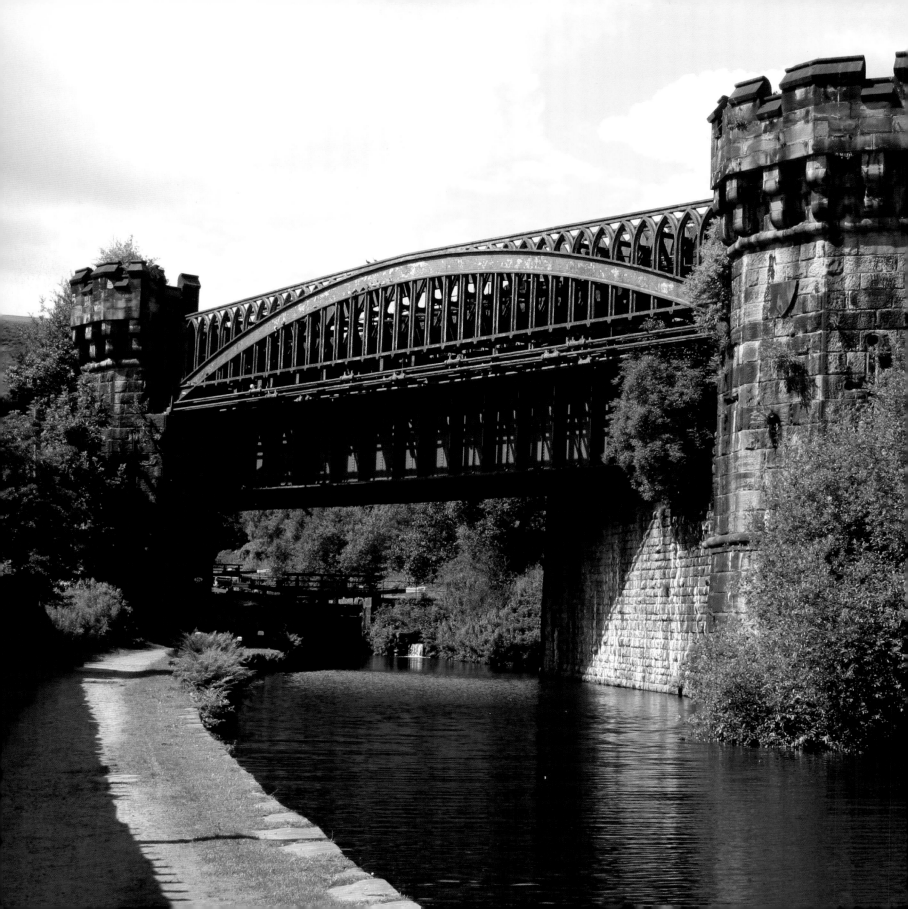

▲ A retaining wall, popularly known as the Great Wall of Todmorden. Built with four million bricks, it prevents the elevated railway from falling into the canal.

◀ Gauxholme Viaduct is a castellated structure that crosses the canal at Shade Lock, Todmorden. It is also known as Skew Bridge because of its shape.

▲ Todmorden's indoor market is renowned for local produce such as cheese, pies and meat.

Northwich and the Anderton Lift

Northwich is the largest town on the banks of the River Weaver. The Weaver could be called the 'Salt River', because it was the production of salt that made Northwich prosperous. The river was made navigable in the mid-18th century to bring coal in from the Mersey and carry salt out to the ports for use in the fishing industry. The suffix 'wich' is derived from an Anglo-Saxon word meaning 'salt'. Northwich has a Salt Museum, which tells the history of the salt industry. Boat building and repairing was once very important but most of the yards have now closed down. The Anderton Boat Lift, which was built in 1875, replaced a system of chutes which loaded salt from boats on the Trent and Mersey Canal on to flat-bottomed boats on the river called Mersey Flats.

▼ The Town Bridge and moorings at Northwich. Town Bridge was the first bridge in Britain to be built on floating pontoons to counteract subsidence from salt mining. It was also one of the first two electrically powered swing bridges in Britain. The other is also in Northwich.

▶ The Anderton Boat Lift was built in 1875 to allow boats to connect the Trent and Mersey Canal to the River Weaver 50 foot below. It was designed by Edward Leader Williams, who went on to design and engineer the Manchester Ship Canal. His brother Benjamin Williams Leader was a well-known English landscape artist. Originally the lift worked with two hydraulically operated water-filled tanks that were counterbalanced like scales. In a new design in 1908, each tank worked independently by weights attached to wires and pulleys, with electricity replacing steam power. Over the years the lift suffered badly with corrosion from nearby chemical factories and it was forced to close in 1983. It reopened in 2002 at a cost of £7 million and has become a major tourist attraction for this part of Cheshire. It has a visitor centre, exhibition and café, and visitors can take a boat trip including a ride in the lift.

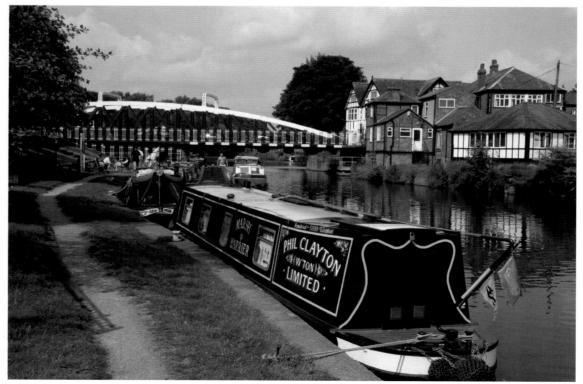

The Weaver Hall Museum, formerly known as the Salt Museum in Northwich. The museum covers the cultural and social history of west Cheshire, as well as a salt archive. The building was once a workhouse and this is reflected in the exhibits. The nearby Edwardian Pumping Station has an unusual circular design and looks like a medieval fort.

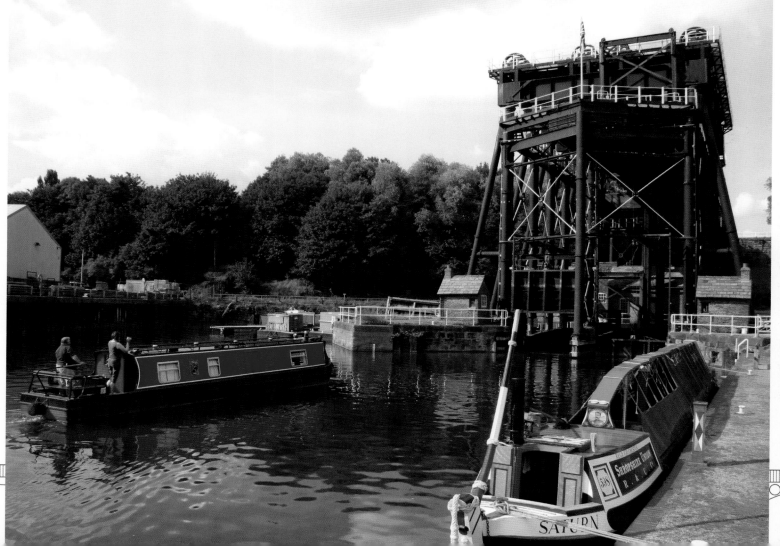

Etruria and Stoke-on-Trent

Josiah Wedgwood (1730–1795) was a highly influential person both in the pottery industry and as a promoter of canals. He saw the benefit of smooth water for carrying delicate porcelain products and promoted the building of the country's second major canal, the Trent and Mersey. He built his first waterside factory by the canal at Etruria in 1769. Etruria was named after a district in Italy where the raw materials for some of his pottery were obtained. The Wedgwood factory later moved to Barlaston where today there is a Wedgwood Museum and Visitor Centre. The bottle kilns, once such a feature alongside the canal through Etruria, Hanley and Stoke, have almost all gone. Local author Arnold Bennett wrote about the Potteries, calling them 'the Five Towns' and mentioning the canal in several of his books.

▼ A pair of hotel boats moored outside the Etruria Industrial Museum. The building was opened in 1857 as Shirley's Bone and Flint Mill which supplied ground bone and flint to the pottery industry. Production ended in 1972, but it has been restored as a museum with most of its original machinery, including an old beam engine called 'Princess', which steams on selected weekends. The museum stands at the junction of the Trent and Mersey Canal and Caldon Canal.

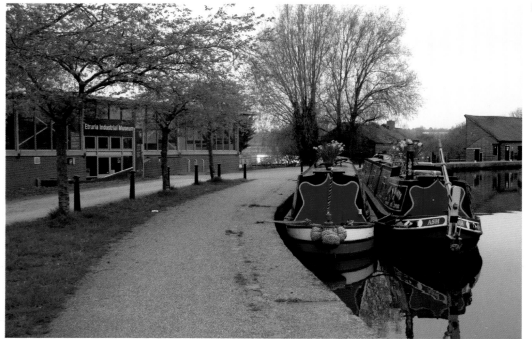

▶ The two tunnels at Harecastle seen from the southern portals. The entrance to Brindley's original tunnel, which is no longer in use, can be seen on the left. The tunnel on the right (by Thomas Telford) was completed in 1827 and is the one still used today. Brindley's tunnel had no towpath so boats had to be 'legged' through by the boat crew. This involved lying on a plank and propelling the boat by pushing along the tunnel wall. Telford's tunnel was built with a towpath so the boat horses could pull the boat through. Boating through the tunnel is one way only and controlled by a keeper at each end. The towpath has now been removed so walkers must follow a footpath over the top of the tunnel.

▶ A statue to pioneer canal engineer James Brindley stands at Etruria Junction opposite the Industrial Museum. It was while surveying the route of the Caldon Canal in 1772 that Brindley was soaked in a rainstorm, caught a chill and died. Wedgwood wrote of him as, 'One of the great geniuses who seldom live to see justice done to their singular abilities, but must trust to future ages for that tribute of praise which they so greatly merit from their fellow mortals'.

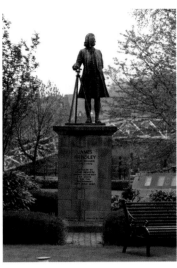

▶ The statue of Josiah Wedgwood at the entrance to the Wedgwood Visitor Centre at Barlaston.

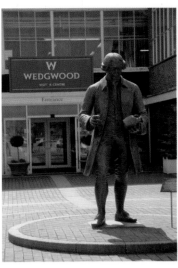

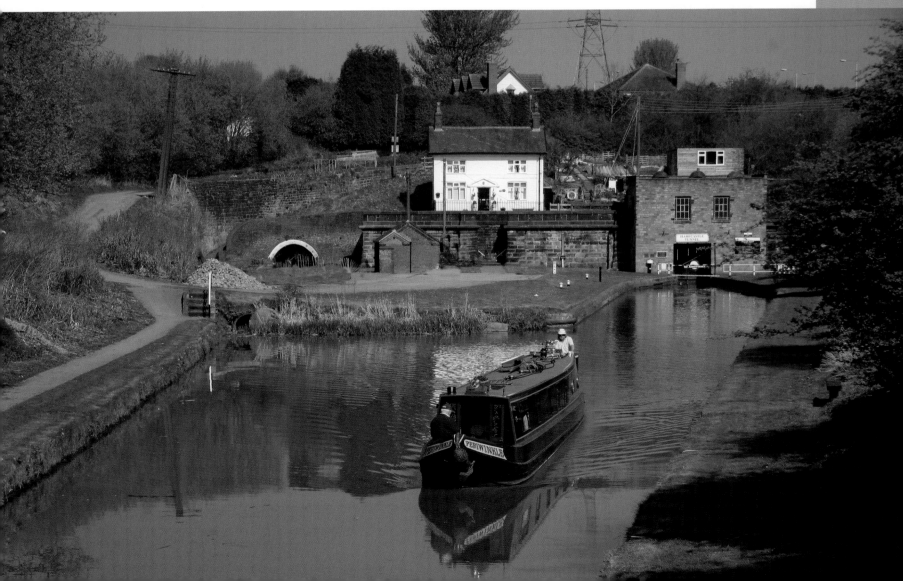

Nottingham

The canal in Nottingham is actually a bypass for an un-navigable section of the River Trent. It is part of a much longer route that once gave Nottingham a direct link to the coalfields to the north. Most of the original Nottingham Canal is now derelict, but the surviving section has an important role to play in the city's revitalised waterfront. The canal now leaves the River Trent at Beeston Lock to the west of the city and ends at Meadow Lane Lock close to Trent Bridge.

▼ A drab area of disused warehouses has been transformed, with bars and restaurants using some original buildings. This redevelopment has become the focal point for Nottingham's inner city waterfront.

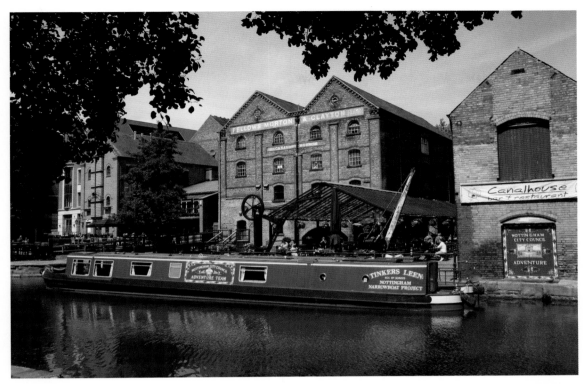

Fellows, Morton and Clayton were the best known and most important carriers on the canal system. Their warehouse in Nottingham opened in 1895, and during their peak trading years the company had 32 depots around the country. They eventually ceased business in 1948. The Nottingham warehouse became a canal museum in 1977, but was not a success. In 2000 it became the Canal House bar and restaurant.

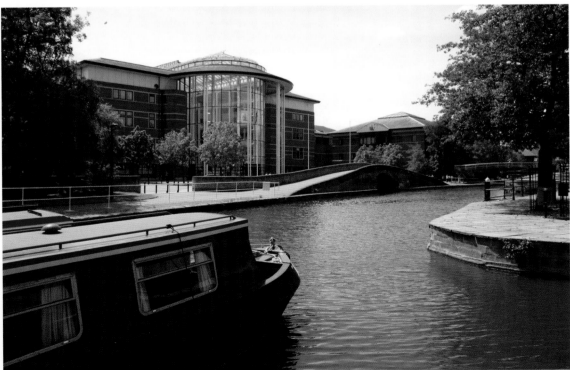

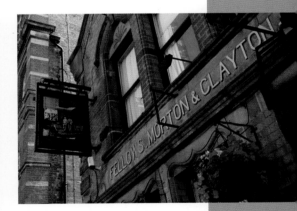

A former brewery is now a pub and has adopted the Fellows, Morton and Clayton name.

The modern lines of the Magistrates' Court building contrast with older buildings that surround it on Nottingham's waterfront.

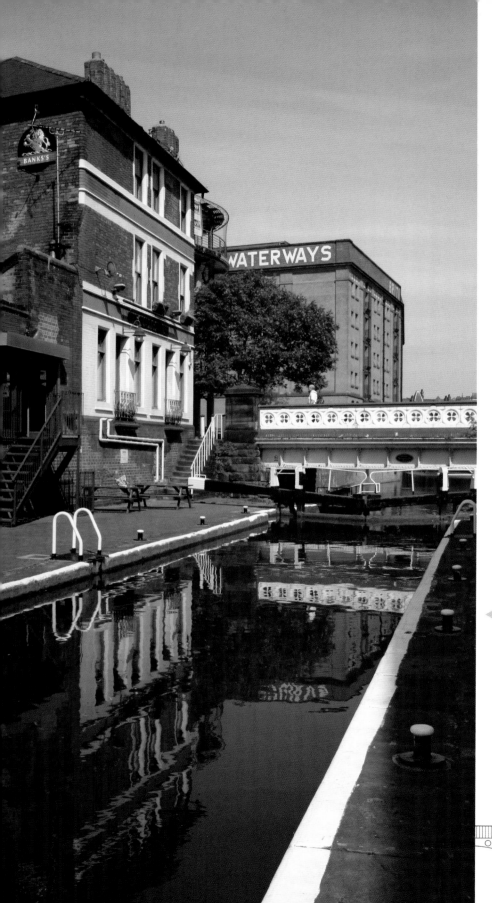

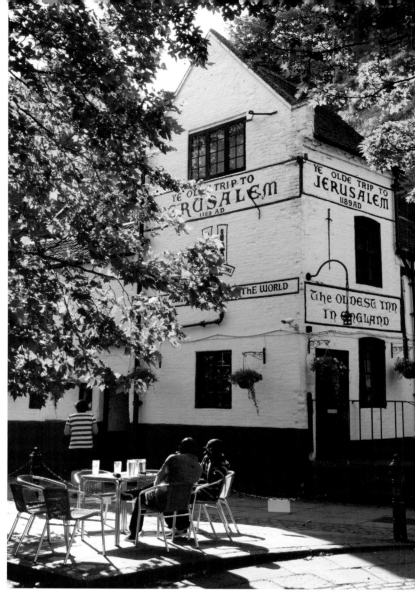

◀ Patrons of the Navigation Inn can sit next to Castle Lock. Nottingham Castle and shopping areas are just a short walk away.

▲ Ye Olde Trip to Jerusalem pub was built in 1189 and is reputed to be the oldest inn in England. It is built into the rock face of the towering Nottingham Castle.

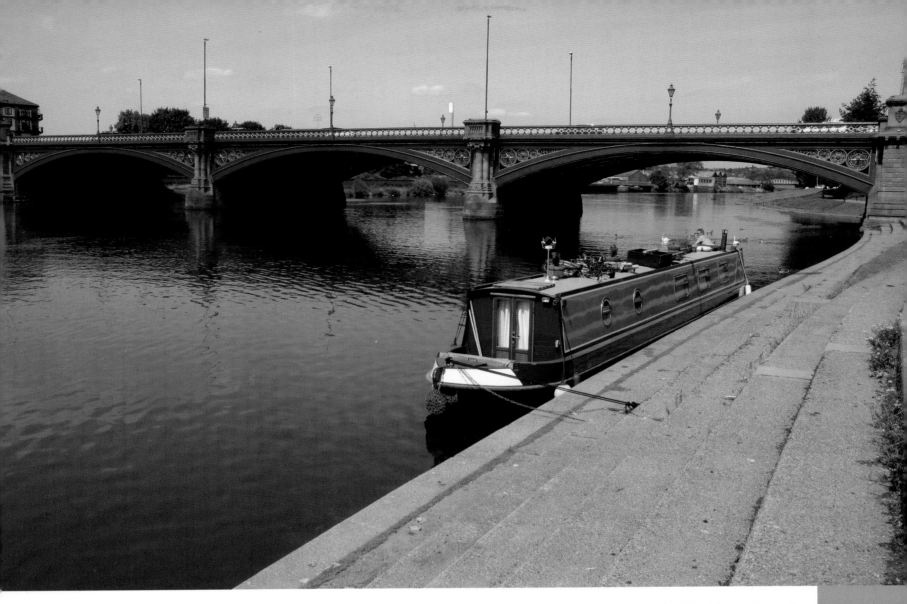

▲ Trent Bridge was built in 1871 and widened in 1926. It gives its name to the international cricket ground which has been a regular Test match venue since 1899. Nottingham Forest football stadium and its football neighbour, Notts County, face each other on opposite sides of the river near Trent Bridge.

▶ Nottingham Marina has a bar and restaurant.

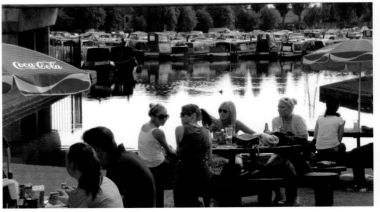

BIRMINGHAM AND THE MIDLANDS

The discovery of coal, iron ore and limestone turned the area around Birmingham into the workshop of the world. Industry blossomed throughout the region, which ever since has been known as the Black Country. Travelling in the West Midlands today, it is hard to imagine towns like Oldbury and Tipton once being isolated farming communities as they were before 1769, when the first canal was dug in this area.

Birmingham's first main line canal built by James Brindley connected to the Staffs and Worcester Canal at Wolverhampton in 1772, providing access for boats to the River Severn. Fifty years later, Thomas Telford's New Main Line Canal was built in a straight line, which shortened the original route by seven miles. A whole network of canals sprung up throughout the Black Country, amounting to 160 miles in the peak years of commerce. They became known as the Birmingham Canal Navigations (BCN). Trade was so immense that some lock flights around Birmingham became congested with working boats. By-pass canals were built to enable boats not involved with local business to pass through the area.

The BCN remained busy right into the 20th century and was not as affected by railway competition as were many other canals. Inevitably, trade did diminish and about 60 miles of canal became derelict, were filled in and built over. Today, many of the remaining canals are underused for pleasure boating, apart from local enthusiasts or visiting boaters wanting to explore the BCN. For local people, the canal towpath offers a peaceful release from traffic-congested roads. A surprising amount of wildlife can be found living by the BCN, whose banks are ablaze with wildflowers in the summer months. Also watch out for evocative names, such as Pudding Green, Spon Lane Locks, Bumble Hole, Gas Street, Windmill End and Oozells Street Loop.

By the 1970s a large section of canal in central Birmingham had become very run down. It was flanked with derelict buildings and its towpaths

had become the haunt of the city's low life. The area has since been transformed and Brindley Place is the centrepiece. It opened in 1994, and was named in honour of the pioneer canal engineer James Brindley. With hotels, restaurants, pubs and shops, it is now the vibrant focal point of Birmingham's nightlife. The International Convention Centre, the National Indoor Arena, Symphony Hall and the Sea Life Centre are all around Brindley Place. A recent addition, called the Mailbox, incorporates a former Royal Mail sorting office. Restaurants and shopping now overlook once disused wharves, and public trip boats pass along the canal.

The restoration of Coventry's canal basin is on a much smaller scale and is less dramatic than the Brindley Place development in Birmingham. In Coventry's case a number of fine old warehouses were saved from destruction and turned to new uses. Throughout the region there are many examples of the reuse of redundant industrial sites, most prominently at Brierley Hill near Dudley where the former Round Oak Steelworks has become the Merry Hill shopping park. This is one of the largest retail parks in the country with over 300 shops. The Dudley Canal is an integral part of the development with a marina, waterside hotels, bars and restaurants.

Birmingham is still the hub of the English canal system, with waterways leaving its centre in every direction. Although some later canals shortened the distances between Birmingham and the ports, Brindley's original canals live on, a testament to his workmanship and his dream of the Grand Cross of waterways.

Birmingham Central

There are two Birmingham main line canals, known as the Old Main Line and the New Main Line. Both were built to link Birmingham with Wolverhampton and the rest of the Black Country canal system. The original canal, built by James Brindley, was a contour canal only using locks when he could not go around high ground. The New Main Line, built 60 years later by Thomas Telford, was a straight line canal using deep cuttings, embankments and tunnels. It had towpaths on both sides and cut seven miles off the old route. Both canals are still in use today, with the old main line now reduced to a series of loops until it reaches Smethwick, where it follows its original meandering course to Tipton.

▶ Gas Street Basin is where the Worcester and Birmingham Canal meets the Birmingham Canal at a narrow section formerly called the Worcester Bar. This was a barrier built by the Birmingham Canal Company to prevent the Worcester and Birmingham Canal taking away precious water supplies. This meant that cargoes had to be manually carried from one boat to another over a very short distance. The Birmingham Canal Company eventually relented and the barrier was replaced by the stop lock which remains today. The company Toll Office has now been converted into a café.

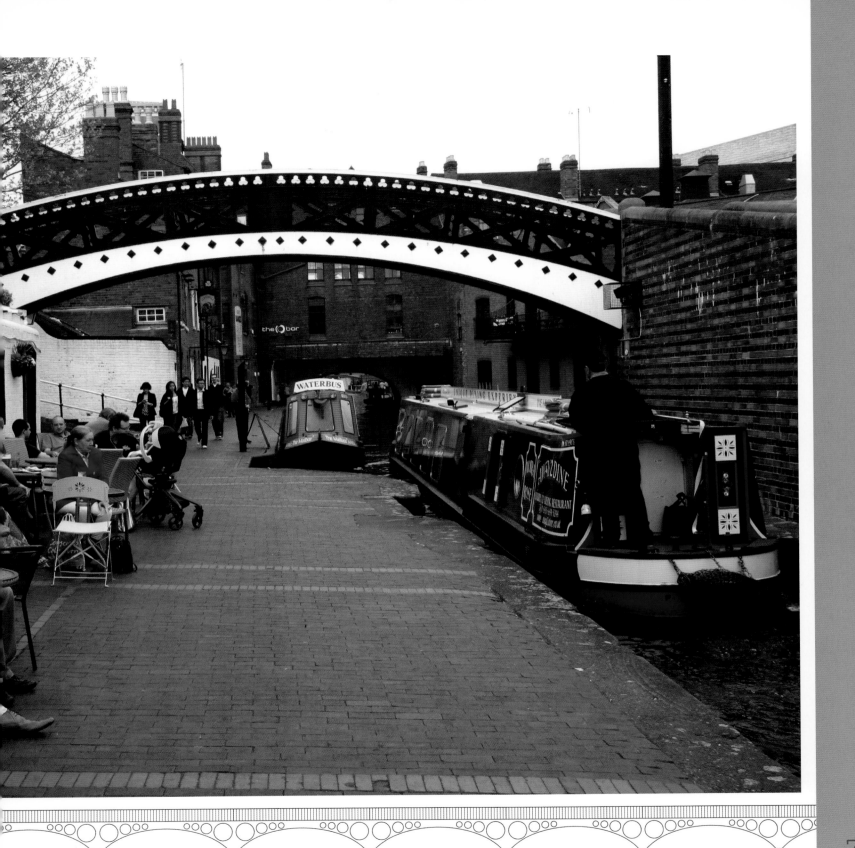

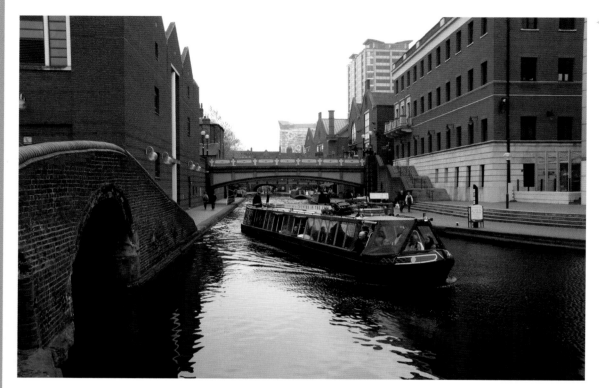

◀ Brindley Place opened in 1994 on the site of old factories that had been derelict for many years. The International Convention Centre on the opposite bank opened in 1991. Brindley Place is a lively mix of restaurants, bars, hotels, galleries and offices. In the 1970s the area was a sleazy walled cutting, often the haunt of the city's lowlife.

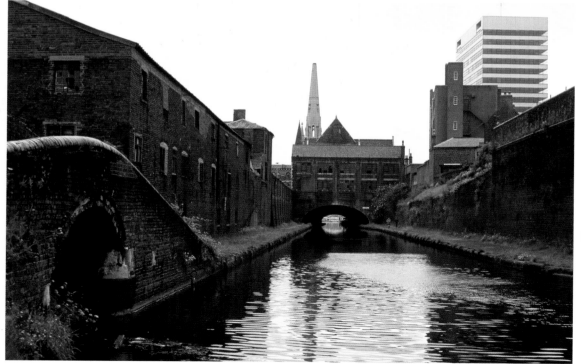

◀ The same scene in 1977. Most of the buildings in the picture have since been demolished.

▶ The Mailbox, once the largest sorting office in the country, closed in the 1990s. It has been redeveloped as a shopping centre with restaurants and offices. Many of the restaurants overlook the canal where diners can sit outside and watch the boats pass by.

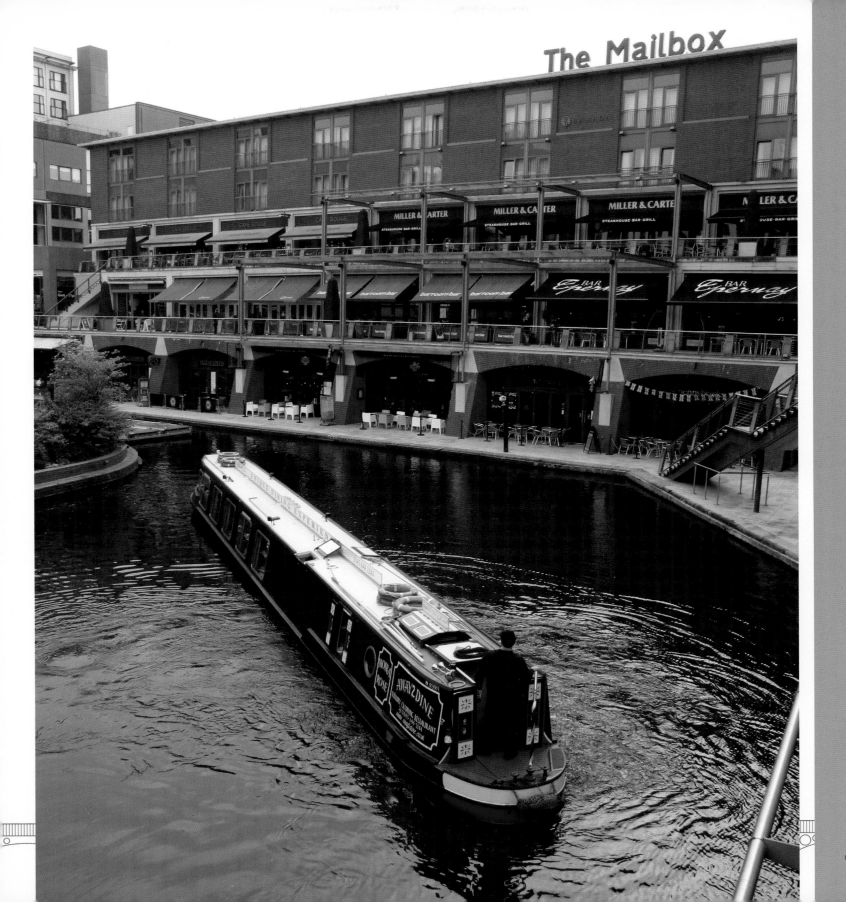

The Birmingham Main Line Canal meets the Oozells Street Loop at Ladywood Junction. The Oozells Street Loop (on the right of the picture) is part of the original Brindley Old Main Line Canal. It used to have coal wharves and a warehouse belonging to the famous canal carrying company Fellows, Morton and Clayton. It is now lined with modern apartments and moorings.

Despite being a long way from the sea, the National Sea Life Centre at Old Turn Junction has proved a success since it opened in 1996. It features displays of freshwater and marine life and has a transparent underwater tunnel. The boat in the picture is one of the passenger trip boats that operate on the central Birmingham canals. The Sea Life Centre is built on the site of a former bedding manufacturer's factory.

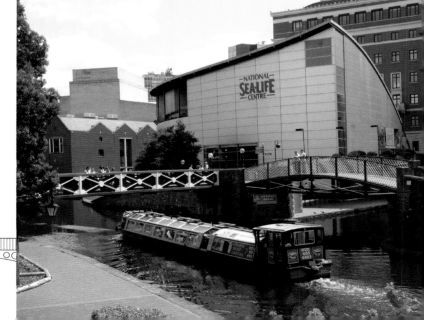

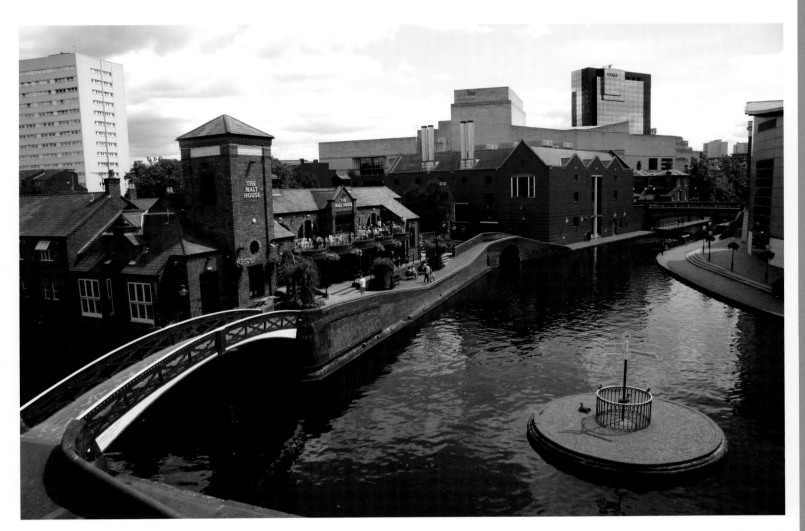

Old Turn Junction in central Birmingham is the meeting place of three canals. The canal ahead leads to the Worcester and Birmingham Canal, to the left is the Birmingham and Fazeley and to the right the Birmingham Main Line Canal. The Malt House pub is built on the site of the Birmingham Brewery Company, which had its own canal arm.

The entrance to the arm can be seen to the right of the pub. In 1998, President Bill Clinton downed a pint and waved to the crowds from the Malt House balcony. He was in Birmingham for the G8 summit held at the International Convention Centre, just a short walk along the canal from the Malt House.

7
OLD TURN JUNCTION
(1769)
This junction was formed when James Brindley's contour canal of 1769 was joined by Thomas Telford's New Main Line in 1827.

Farmer's Bridge

Farmer's Bridge Locks on the Birmingham and Fazeley Canal. The thirteen locks on the Farmer's Bridge flight carry the canal from Old Turn Junction to Aston Junction in the intensely urban setting of central Birmingham. These locks were once so busy with working boats that they were gas lit to enable boats to work through the night. The working boatmen who called the locks 'The Old Thirteen' would never recognise the Farmer's Bridge flight today. Modern footbridges connect some office buildings to the towpath while the BT tower overlooks the entire lock flight. The next lock for this boat is situated directly underneath a towering office building.

This plaque for Saturday Bridge can be seen on the Farmer's Bridge lock flight.

Cambrian Wharf, at the top of Farmer's Bridge Locks, was the location for the first of Birmingham's waterside regeneration schemes. The old toll house, which collected passage fees, can still be seen here and British Waterways have a shop and information centre. Cambrian Wharf once had lime kilns, timber yards and coal merchants.

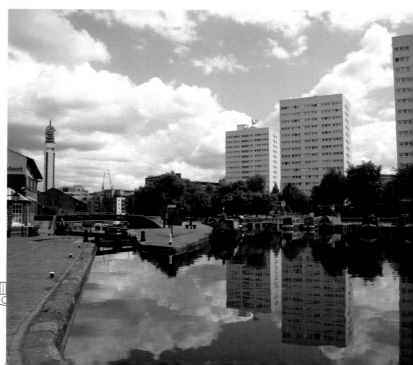

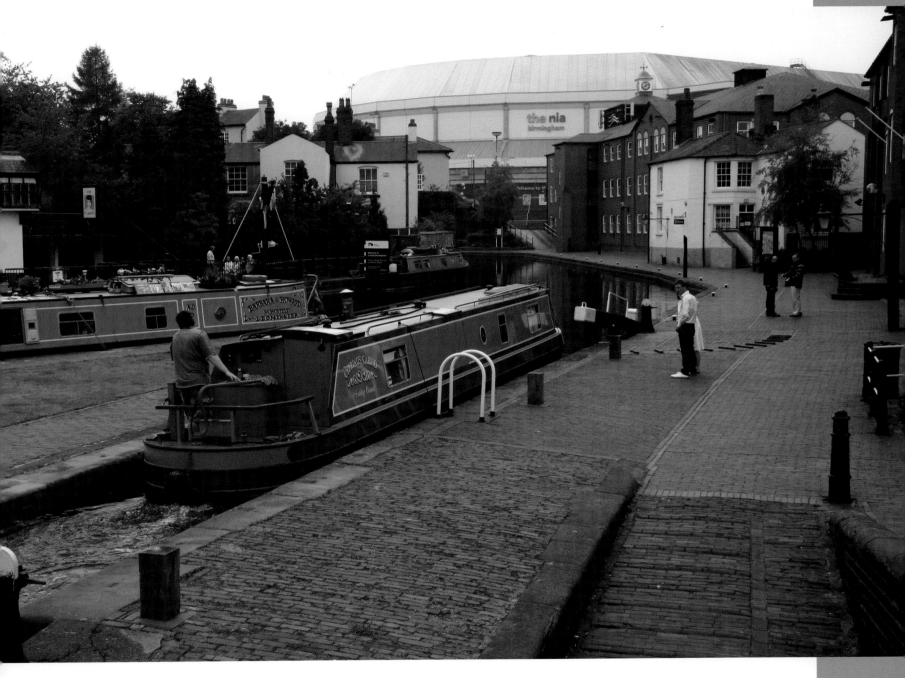

▲ Farmers Bridge Top Lock at Cambrian Wharf. This was the location of the Newhall Branch Canal. It served wharves and warehouses but fell victim to Birmingham city expansion and was filled in and built over.

A short stub remains which is used for moorings. The building in the background is the National Indoor Arena, which opened in 1991 and can seat over 12,000 people.

Galton Valley

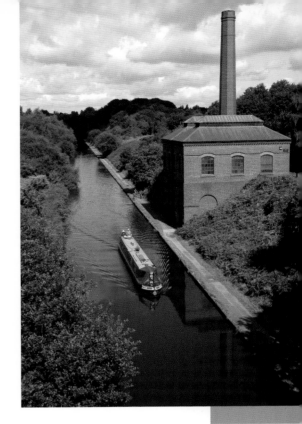

Canal over canal. Telford's New Main Line Canal passes under Stewart Aqueduct, which carries the old Brindley Main Line over its neighbour. Towering above both canals is the elevated M5 motorway, which also spans the railway.

Smethwick Pumping Station stands on an embankment which separates the Old and New Main Line canals. It was built in 1892 and operated by two powerful steam engines that lifted water from the lower New Main Line in Galton Valley to feed the higher Old Main Line. The pumping station was restored from a derelict state and reopened as a museum in November 2000. It is run by the Galton Valley Canal Heritage Centre, which is housed in a building at Brasshouse Lane near the two canals.

Horse power on the Old Main Line at Smethwick in 1972. Scenes like this were commonplace in the working heyday of the BCN. The horse is pulling a boat filled with domestic rubbish but the contract terminated soon after this picture was taken.

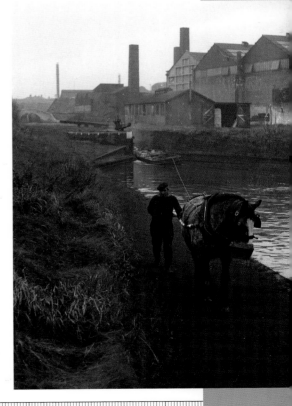

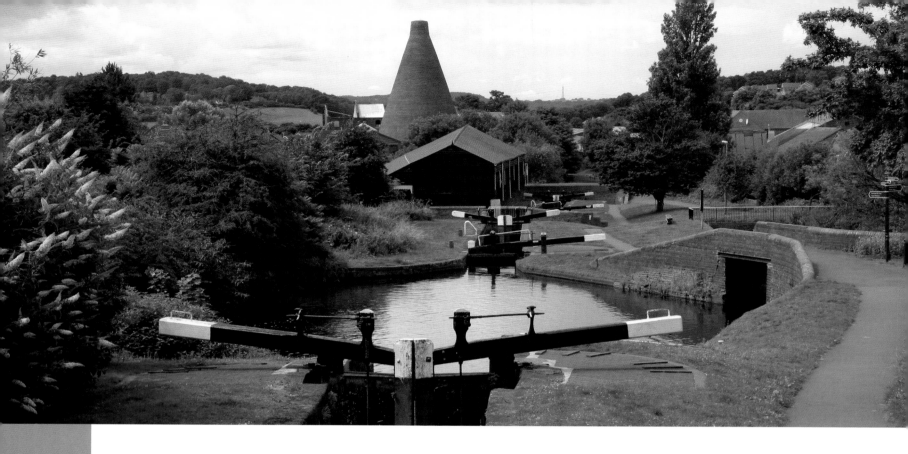

Dudley Canals

'Back of the Map' was the working boatmen's name for the Dudley and Stourbridge Canals that connect the Staffs and Worcester Canal to the Black Country Canals. The big obstacle for the canal builders were the Rowley Hills. This barrier was eventually penetrated by three long tunnels: Dudley Tunnel, Lapal Tunnel, and Netherton Tunnel. Lapal collapsed in 1917 and was closed, never to reopen, and has now mostly been filled in. Netherton has towpaths on both sides and was once gas lit to enable 24 hour passages for working boats. Although it is no longer lit, Netherton is the tunnel used today for all powered boats.

▲ Stourbridge Locks and the Redhouse Glassworks Cone. The 100-foot-high cone created air flow to maintain the high temperatures needed to produce glass in the furnaces. The glassworks belonged to Stuart Crystal, which is now a working museum and open to the public. The black building in front of the cone is Dadford's Shed, built in 1884 as a transhipment shed between road and water for Webbs' seed company.

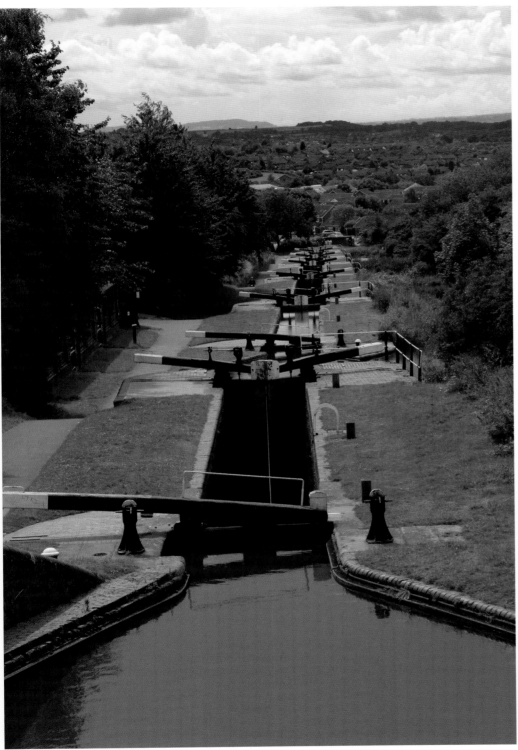

Delph Locks on the Dudley Canal at Brierley Hill. Mining subsidence caused the original nine locks to be replaced by the eight that are there today. Local people still refer to them as 'The Nine Locks' and a pub at the bottom of the flight is confusingly called 'The Tenth Lock'. The bottom of the locks is where the Stourbridge Canal ends and the Dudley Canal begins. The original stables halfway down the flight has been restored and is now a listed building. Remnants of the original line of locks can be seen in undergrowth adjacent to the flight.

Delph Locks in August 1973. The coal mine and attendant slag heaps at the foot of the locks have been replaced by housing estates.

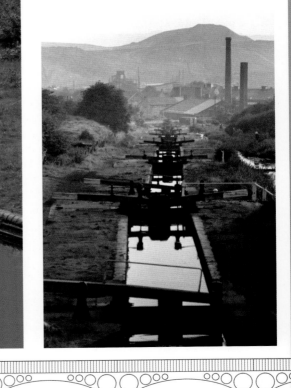

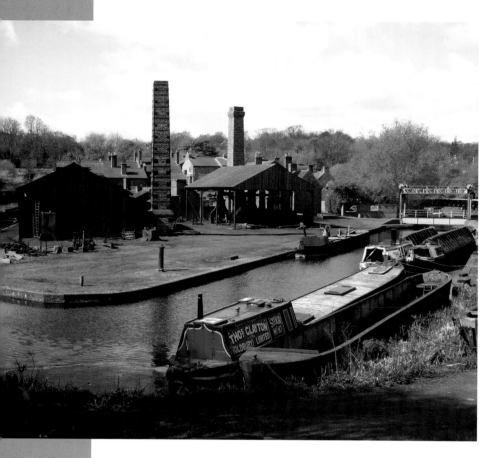

▲ The Black Country Living Museum shows how local people lived and worked between the 18th and early 20th centuries. A Black Country village has been constructed using relocated original buildings and set around an old canal arm. It includes shops, a pub, a school and a cinema showing silent movies. The village canal bridge was originally from Wolverhampton and was removed when the road there was widened. The entire museum is set in 26 acres where visitors can ride on trams and trolley buses, and go down a coal mine.

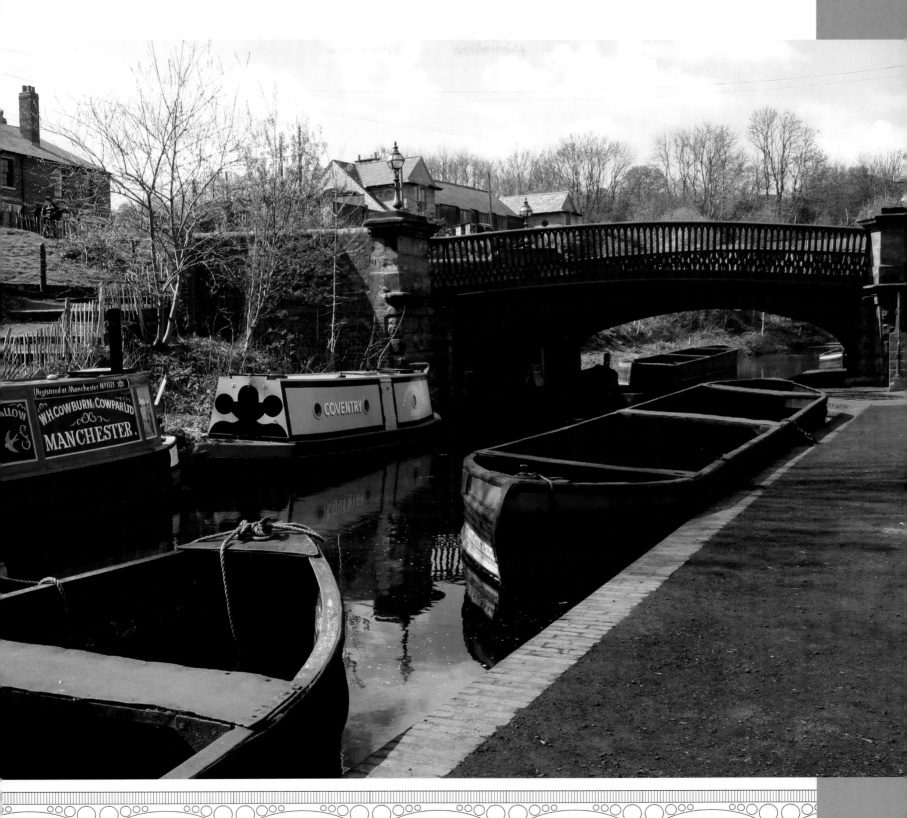

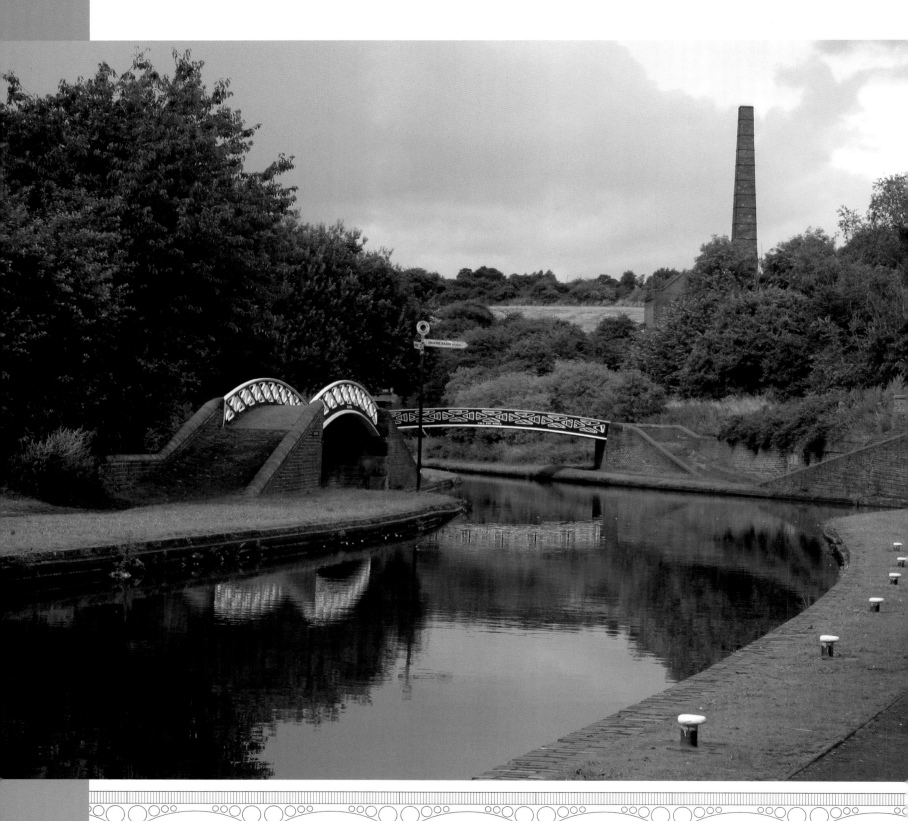

THE FOUNTAIN INN TIPTON
FROM
1835 TO 1851
THE HEADQUARTERS OF
WILLIAM PERRY
'THE TIPTON SLASHER'
CHAMPION PRIZEFIGHTER
OF ENGLAND
1850-1857
THE BLACK COUNTRY SOCIETY

BACK IN THE "OLD DAYS"
WHEN ALL CONTESTS WERE
FOUGHT BAREFIST AND OFTEN
IN THE OPEN AIR, IT WAS ONLY
THE TOUGHEST WHO SURVIVED
TO TAKE PRIZEMONEY.
WILLIAM PERRY WAS SUCH
FIGHTER, BORN IN PARK LANE
TIPTON 1819 HE BEGAN HIS
CARREER IN ABOUT 1835.
SOME TIME LATER HE DEFEATED
AN OPPONENT IN NEARBY
OLBURY WITH SUCH
"TERRIFIC HITTING", THAT FROM
THEN ON HE WAS KNOWN AS
"THE SLASHER"
MANY FIGHTS FOLLOWED, SOME
WITH AS MANY AS 100 ROUNDS
OR MORE AND WITH VARYING
AMOUNTS OF PRIZEMONEY
"THE SLASHER" FOUGHT FOR
THE NEXT 20 YEARS OR SO AND
FINALLY THREW THE TOWEL IN,
CHRISTMAS EVE 1880
AGED 61

▼ An electrically-driven trip boat takes visitors into the Dudley Tunnel. The boat is operated by the Dudley Canal Trust and is one of the main attractions at the Black Country Museum. Dudley Tunnel (3,154 yards long) was opened in 1792, after many problems in construction.

◄ Windmill End on the Dudley Canal. The elegant bridges were built by the Horseley Iron Works Company at Tipton and similar structures can be seen throughout the BCN. The chimney in the background of the picture is part of the ruined Cobb's Engine House. Inside the building was a steam engine that pumped water from nearby coalmines into the canal. The entrance to Netherton Tunnel is beyond the Engine House. Pleasant green hills with nature reserves belie Windmill End's industrial past for this was once a region of coal mines, quarries, foundries and factories.

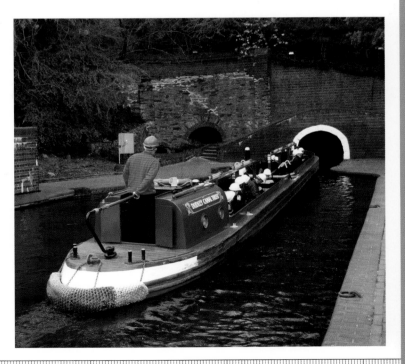

Walsall Canals

The Walsall Canal had numerous connections with other canals that fed coal to industry in the heart of the Black Country. Some of the branch canals closed and were filled in while others were foreshortened to become weedy backwaters. Most of the ironworks and foundries have gone, replaced by housing and light industry. Even the huge power station at Ocker Hill was demolished in 1977. Bushes and trees have turned former industrial sections of the canals into green corridors and the Walsall Town Arm is being redeveloped. Bars, cafés and an art gallery have brought new life to the Walsall Town Basin, which had become very run down. Walsall has long been a centre for leather-making and the Leather Museum is just a short walk from the canal basin.

▼ These boats at Walsall Town Basin are completing a two-day tour called the BCN Challenge. Boat crews receive points for navigating some of the lesser used parts of the Birmingham Canal Navigations. They are mooring below the New Art Gallery, which opened in 2000.

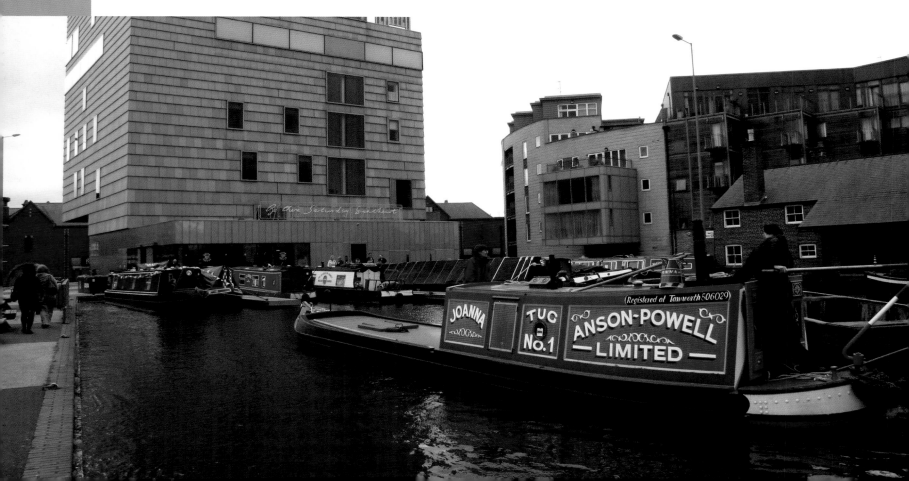

A boatman's rest was built at Walsall Top Lock in 1900 for the welfare of working boatmen. In later years it became a canal museum but it was never a success and has since closed. A fine example of a BCN toll house stands adjacent to the mission building. It is recorded that in 1900 around 200 boats would pass through the Walsall locks every working day.

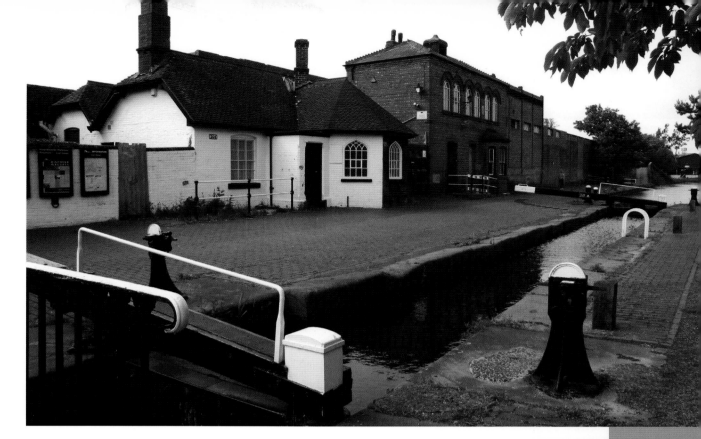

Albion Flour Mill was built in 1849 and has recently been converted into apartments. It had a covered loading dock where boats could load and unload while sheltering from the weather.

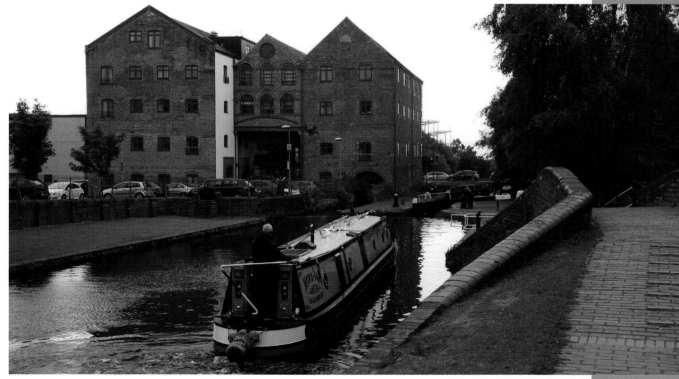

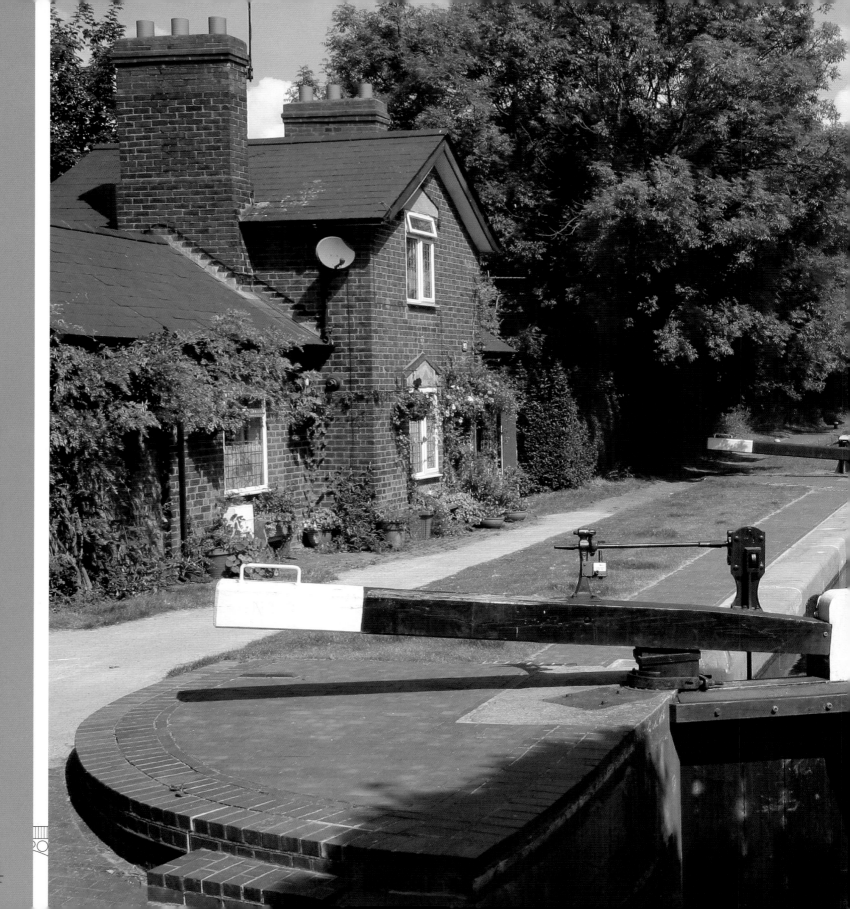

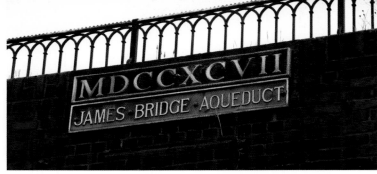

The Rushall Canal was built in 1847 as a more direct line to connect Birmingham to the Cannock Coalfields. It passes to the east of Walsall, but does not have a direct connection with the Walsall Canal. It is a wooded waterway for much of its three-mile length, with some fine canal buildings.

James Bridge Aqueduct on the Walsall Canal is unusual in having its construction date illustrated by Roman numerals: MDCCXCVII translates as 1797.

The Walsall Canal passes along a high embankment between Walsall and Darlaston. This section of canal was once flanked by factories and foundries, but is now very green, with reeds and bullrushes.

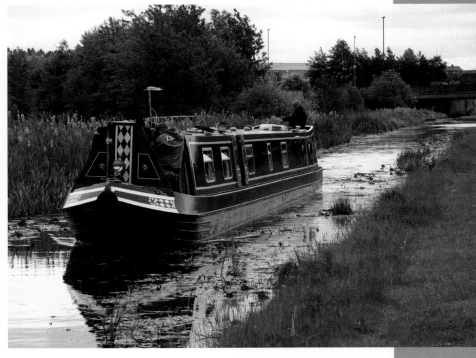

Tame Valley

The Tame Valley Canal opened in 1844, making it a latecomer on the BCN scene. It was built to relieve congestion on the central Birmingham canals and to connect with local collieries. It is almost nine miles long with deep cuttings and 13 locks at Perry Barr. The working boatmen called the locks 'The New Thirteen' in comparison with the 'Old Thirteen' at Farmer's Bridge. It leaves the Walsall Canal at Ocker Hill and joins two more canals at Salford Junction. The huge motorway interchange that opened in 1972 directly above the two canal junctions is universally known as Spaghetti Junction. This maze of elevated roads has become a landmark on the Birmingham canals.

▼ A working boat at Perry Barr locks.

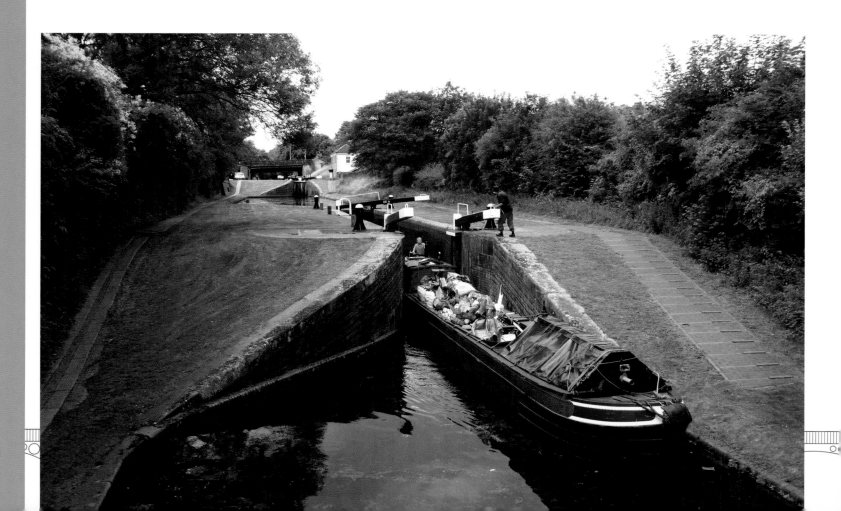

▲ Poppies growing from a bridge by the canal at Spaghetti Junction.

▶ Boating beneath the Spaghetti Junction motorways.

Overleaf: The huge motorway interchange that opened in 1972 directly above two canal junctions is universally known as Spaghetti Junction. The official name is the Gravelly Hill Interchange and it covers over 30 acres of ground. It is believed that the supporting pillars over the canal had to be carefully placed to enable a horse-drawn boat to pass underneath without fouling the towing rope. Amazingly, there was still some horse-drawn canal transport on the Birmingham Canal Navigations when the roads were built in 1972. Passing beneath Spaghetti Junction is an awe-inspiring experience whether by boat or on foot.

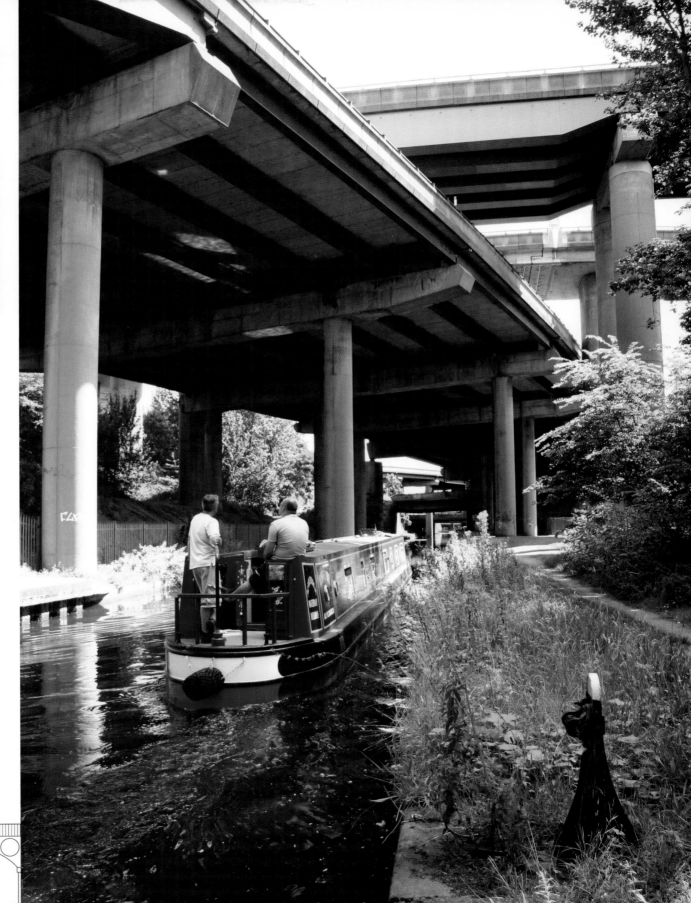

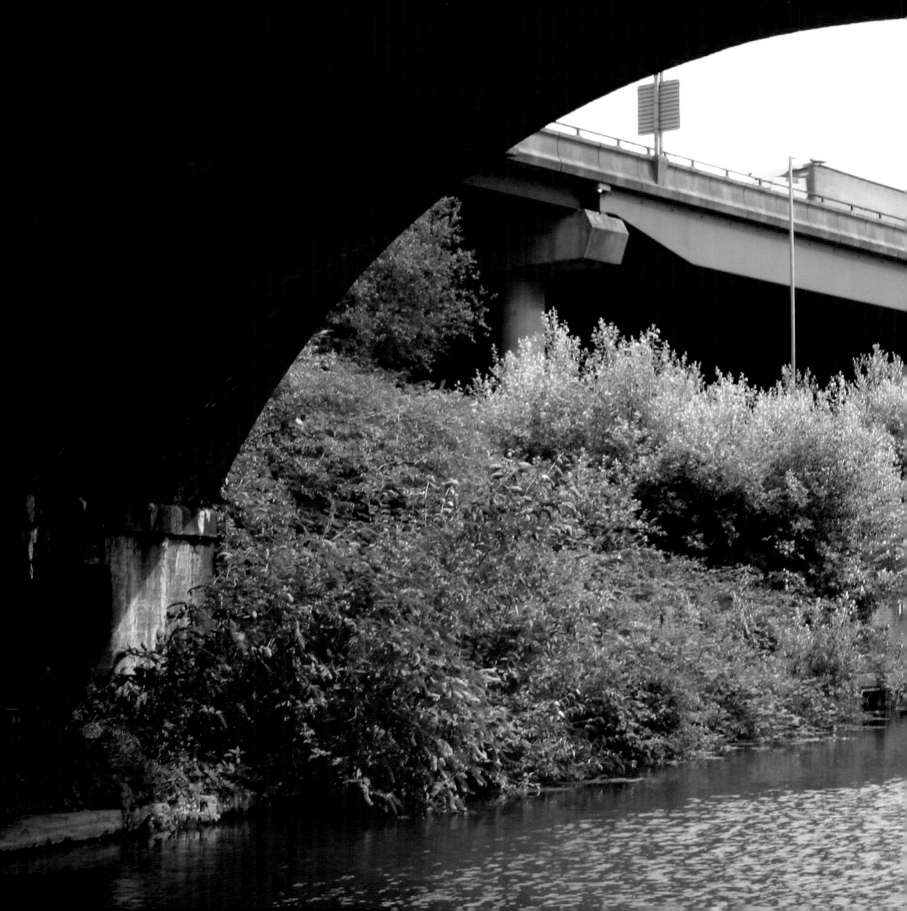

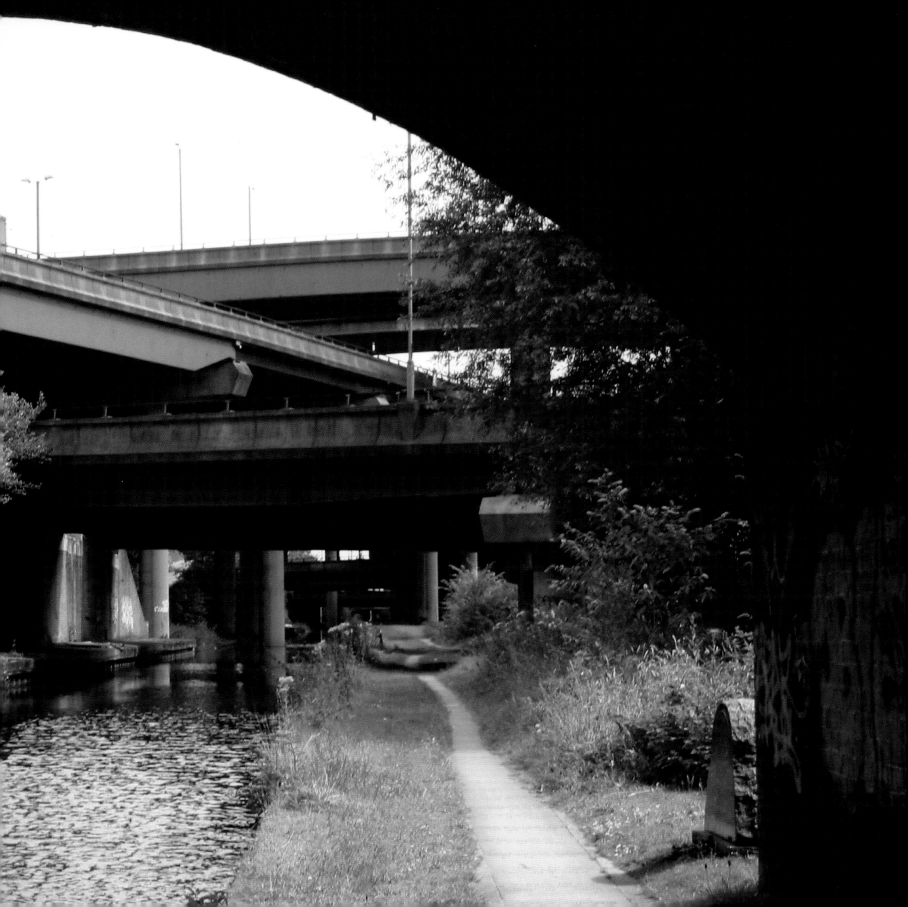

Wolverhampton 21

Twenty one locks carry the Birmingham Main Line Canal from the top lock by the Wolverhampton city centre ring road down to its junction with the Staffs and Worcester Canal at Aldersley. More than half of the locks are flanked by industry and crossed by railways, but they become more countrified as they pass Wolverhampton racecourse. The final four locks are so beautifully wooded that it is hard to imagine you are still within the city limits. In the canal's commercial heyday, unemployed men called 'hobblers' would help boatmen work the locks for a small consideration.

▼ Oxley Viaduct was built in 1848 to carry the Shrewsbury and Birmingham Railway over the canal at Wolverhampton. It is a listed structure with 12 arches and is built on a skew over the canal.

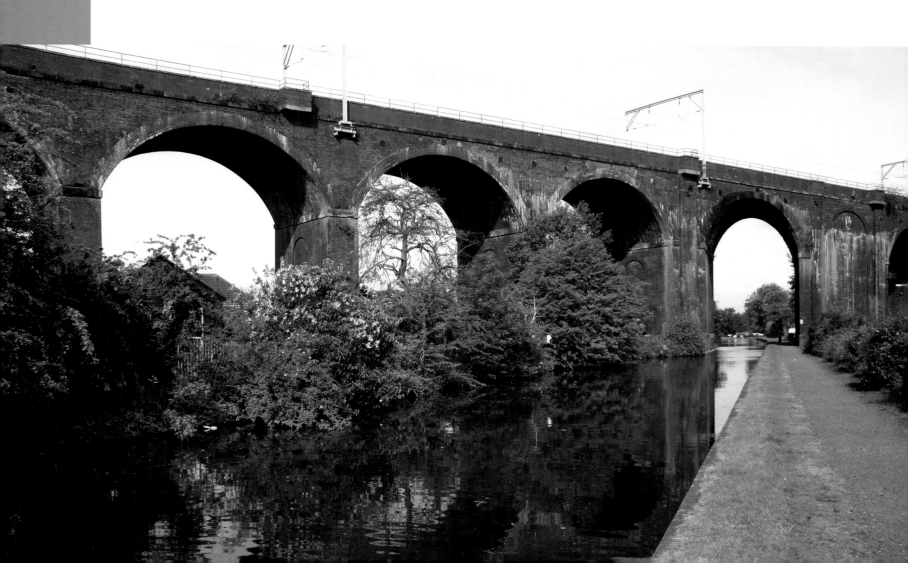

This lock on the Wolverhampton flight is dominated by the council incinerator. It was a once a very smoky place full of coke fumes from the nearby gasworks, which had its own private canal arm. In those days the atmosphere would not have been improved by steam locomotives crossing the canal on the railway bridge beyond the lock.

Aldersley Junction at the bottom of the 21 locks is where the Birmingham Canals meet the Staffs and Worcester Canal. Both canals were engineered by James Brindley who died just a few days after the junction opened in September 1772.

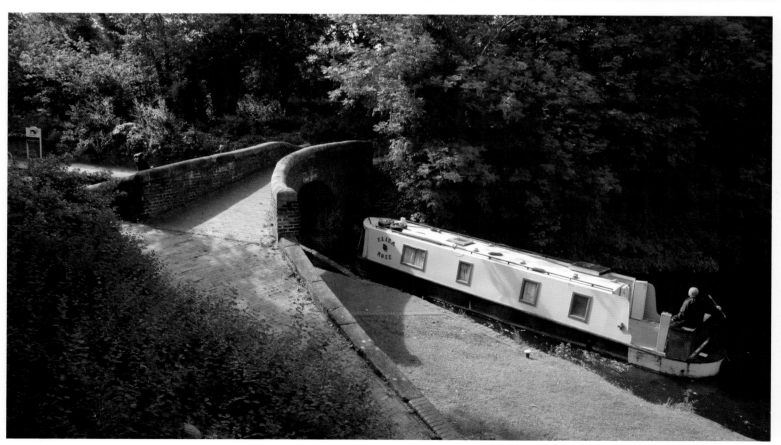

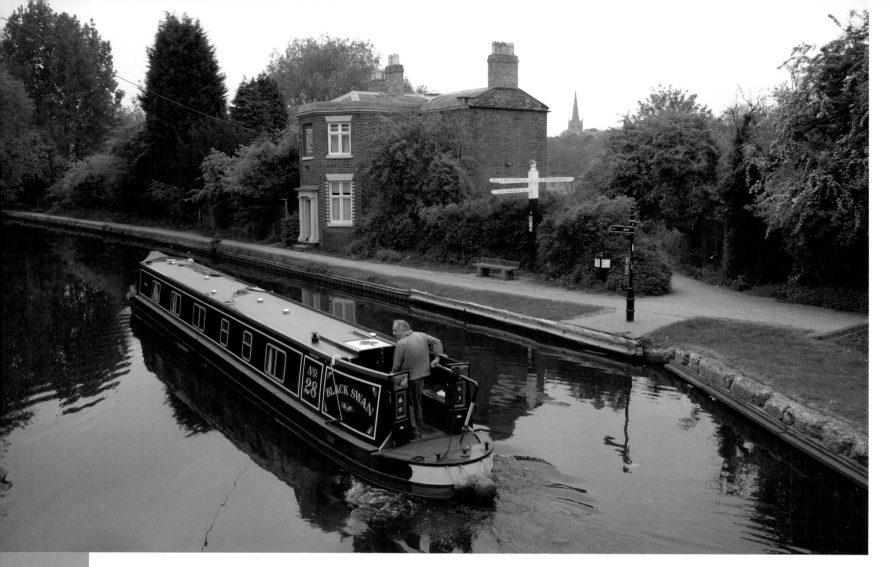

Kings Norton

▲ The junction of the Worcester and Birmingham Canal and the Stratford-on-Avon Canal at Kings Norton. The junction house has a list of toll fees dated 1793.

▶ The 15th-century Old Grammar School at Kings Norton is next to the church and just a short walk from the canal. In 2004, it was the winner of the BBC's *Restoration* programme.

Opposite: Brandwood Tunnel at Kings Norton opened in 1796. It carries the Stratford-on-Avon Canal close to the junction and has a profile of William Shakespeare on its eastern portal.

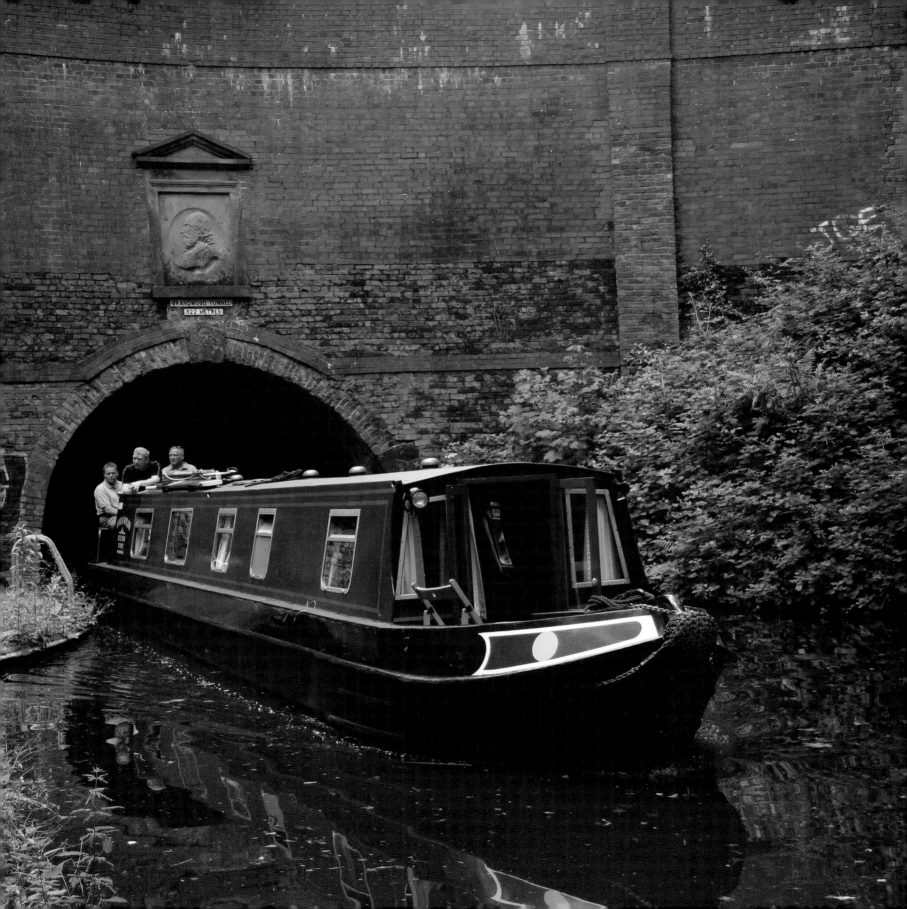

Bournville

▼ The canal was very important to Cadburys, who had its own fleet of canal boats. Charlie Atkins carried chocolate crumb from the Cadbury factory at Knighton on the Shropshire Union Canal to Bournville in his boat *Mendip*. He was known as 'Chocolate Charlie' and was especially popular with the children he encountered on his twice-weekly journey.

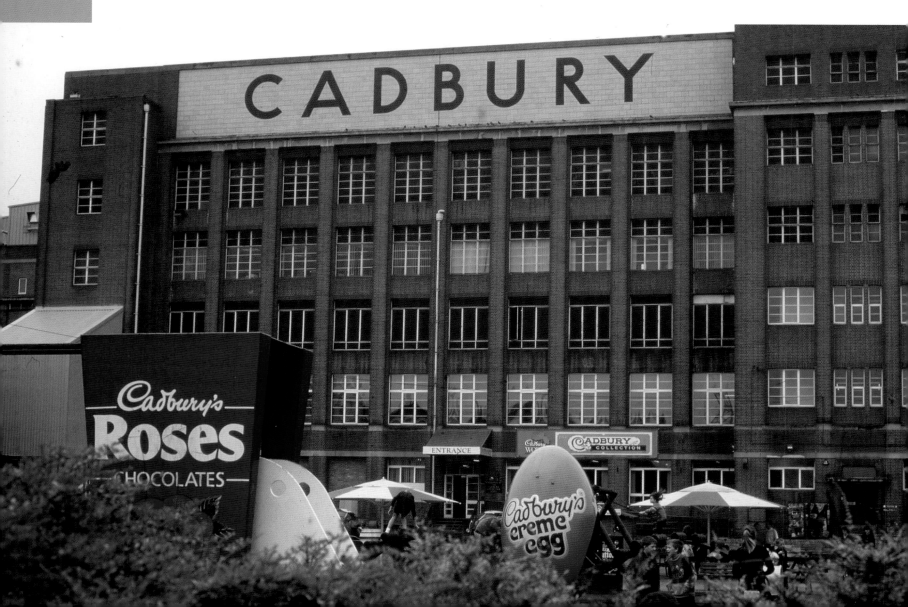

Selly Manor at Bournville once stood in Bournbrook Road about a mile away. After years of neglect, the Cadbury family moved it piece by piece to its present position. It now belongs to the Bournville Village Trust. Minworth Greaves in the grounds of Selly Manor was also moved to its present location by the Cadbury family.

The Rest House at Bournville was built by Cadbury employees to commemorate the 25th wedding anniversary of George and Elizabeth Cadbury in 1913. A plaque reads 'In gratitude for their employer's unceasing interest in their welfare'.

Coventry and Hawkesbury

The Coventry Canal is one of England's oldest canals and was an important link between the Trent and the Thames. Numerous waterside collieries have supplied coal to London and the south-east via the Oxford Canal and the Grand Union Canal. Hawkesbury, at the junction of the Coventry and Oxford Canals, has traditionally been a meeting place for working boat families. The six-mile-long canal between Hawkesbury and Coventry Basin is known as the Greenway. Courtaulds, Daimler and Rover were some of the big manufacturers who once had factories along this length of canal. Today it has a popular art trail, with sculptures and other artworks on its banks. The Ricoh Stadium, home to Coventry City football club, is also close to the canal.

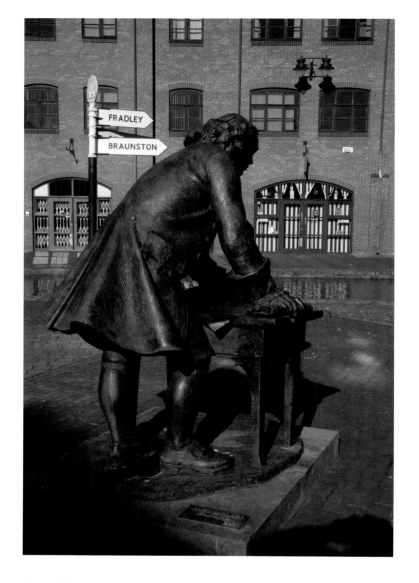

▲ James Brindley's statue looks out across the water at Coventry Canal Basin. Brindley's 38-mile-long Coventry Canal ended at this basin in 1769. The basin is just a short walk from the cathedral and city centre along Bishop Street and across a bridge over the inner bypass road. An 18th-century office with a weighbridge, along with old warehouses, were saved from destruction in the 1980s, when the entire basin was renovated. The basin has an art gallery, craft shops and a café.

▶ A new footbridge close to Coventry Basin.

▼ These terraced buildings near Coventry Basin are known as Cash's Top Shops. They were built in 1857 by the local entrepreneur Joseph Cash, whose company specialised in the production of name tapes. The bottom two floors consisted of housing for the company's workforce, while the top floor was a continuous workshop with powered looms running the full length of the row. The weavers who lived below had only to walk upstairs to begin their work, and probably had the shortest commute in history!

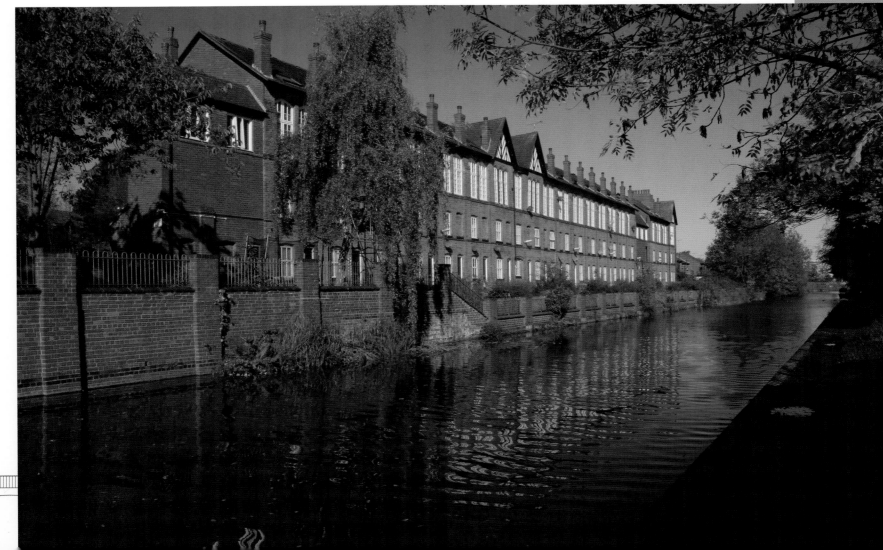

The junction bridge at Hawkesbury was manufactured at the Britannia Foundry in Derby in 1837. This company achieved lasting fame a few years later in 1853 by producing the first cast-iron post boxes which are still in use today. The bridge was designed by J. Sinclair and the original cost was £630.

Hawkesbury Junction, also known as Sutton Stop, is the meeting place of the Oxford and Coventry Canals. Hawkesbury was a very important stopping place in the days of the working boatpeople. Here they would wait for orders from the nearby collieries before taking the next load of coal to factories in the south. The Greyhound Inn, which faces the elegant junction bridge, once provided stables for the boat horses. The pumping station on the left of the picture was built in 1831 and once contained a Newcomen steam engine called 'Lady Godiva'.

A working pair of narrowboats at Hawkesbury Junction in the 1960s. It is likely that these boats would have been selling their coal to customers in the south.

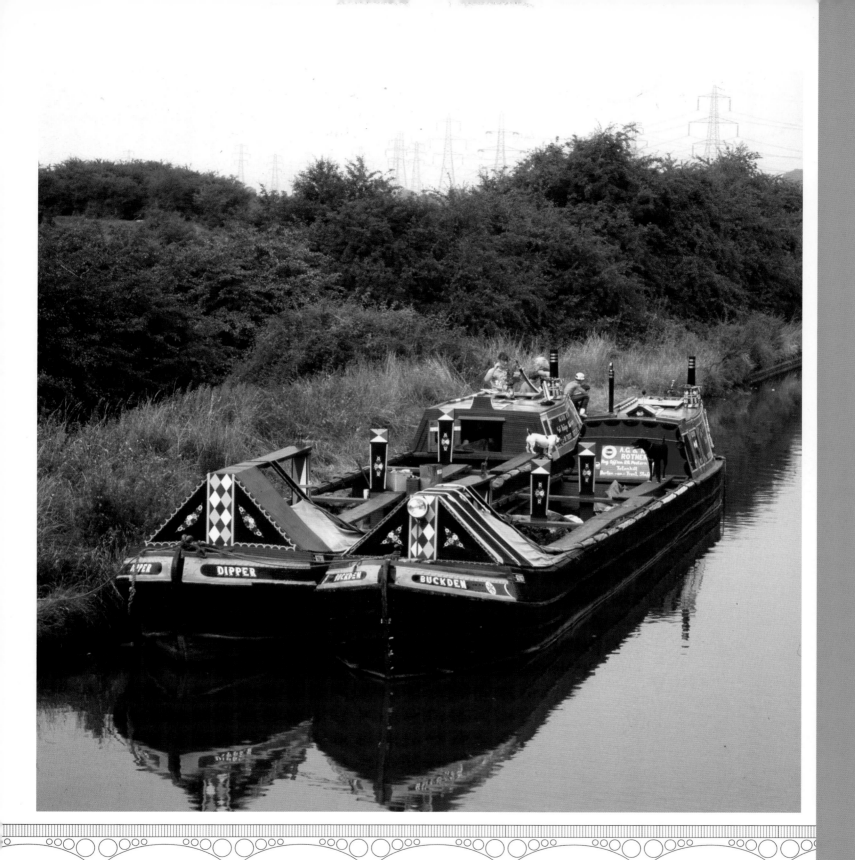

Leicester

During the 19th century the city became famous for the manufacturing of hosiery and footwear, along with textiles and engineering. Some of the factories still remain by the navigation although they no longer use water transport. A number of fine waterside industrial buildings which became redundant have recently been demolished to make way for an intense redevelopment programme.

▼ West Bridge in Leicester is where the River Soar's Leicester Navigation becomes the Leicester Line of the Grand Union Canal.

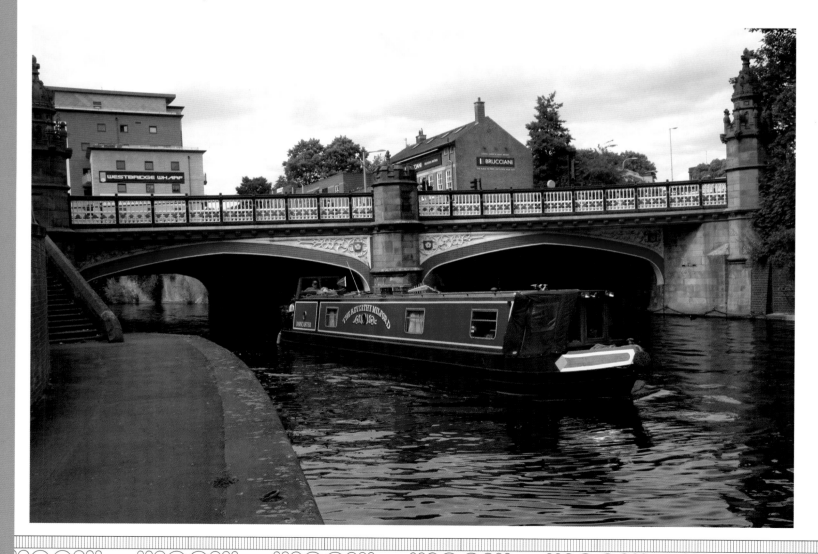

▶ The tower of Leicester's National Space Centre seen from the River Soar near Belgrave Lock. The Space Centre, which opened in 2001, has six galleries with displays of astronomy, cosmology and spaceflight. It has a Soyuz spacecraft, a cinema, a planetarium and the usual shop and cafe.

▼ The bridge over the River Soar in Abbey Park, Leicester. The park, regarded as one of the most beautiful in England, was opened in 1882 on the site of a former swamp. A memorial with a statue to Cardinal Wolsey can be seen in the grounds of the ruined 12th-century Leicester Abbey. Cardinal Wolsey died at Leicester in 1530.

Overleaf: The Mile Straight was originally constructed as part of Leicester's flood prevention scheme in 1890. It is tree-lined and spanned by a series of elegant bridges.

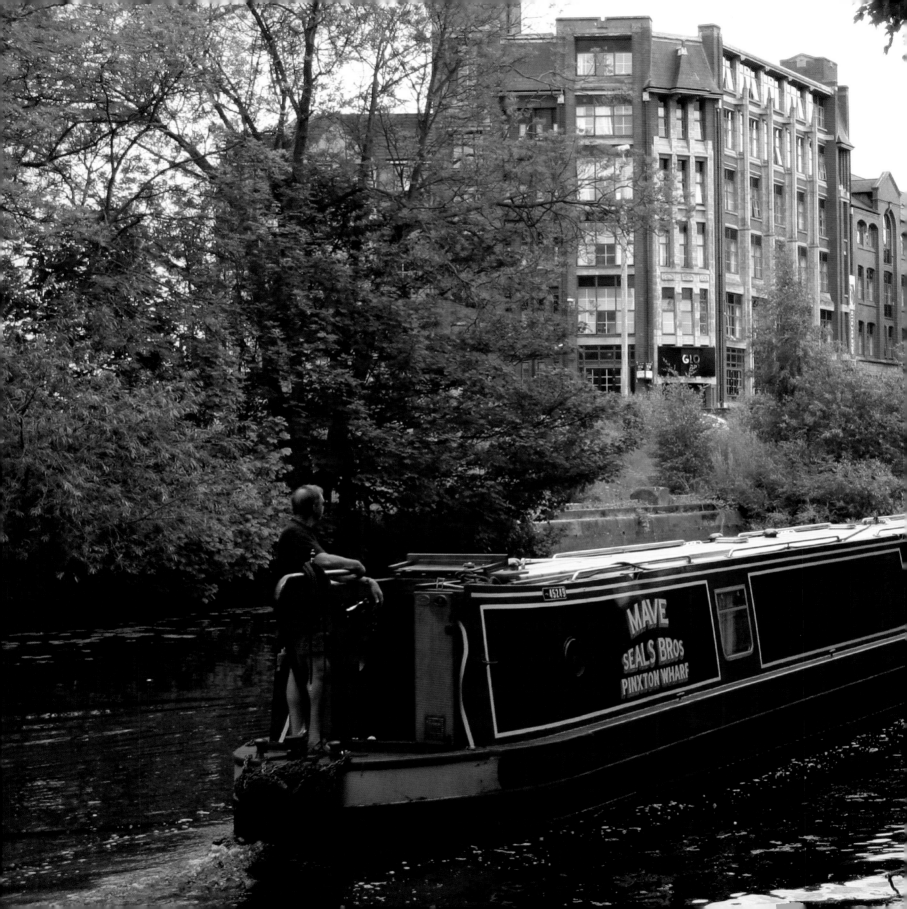

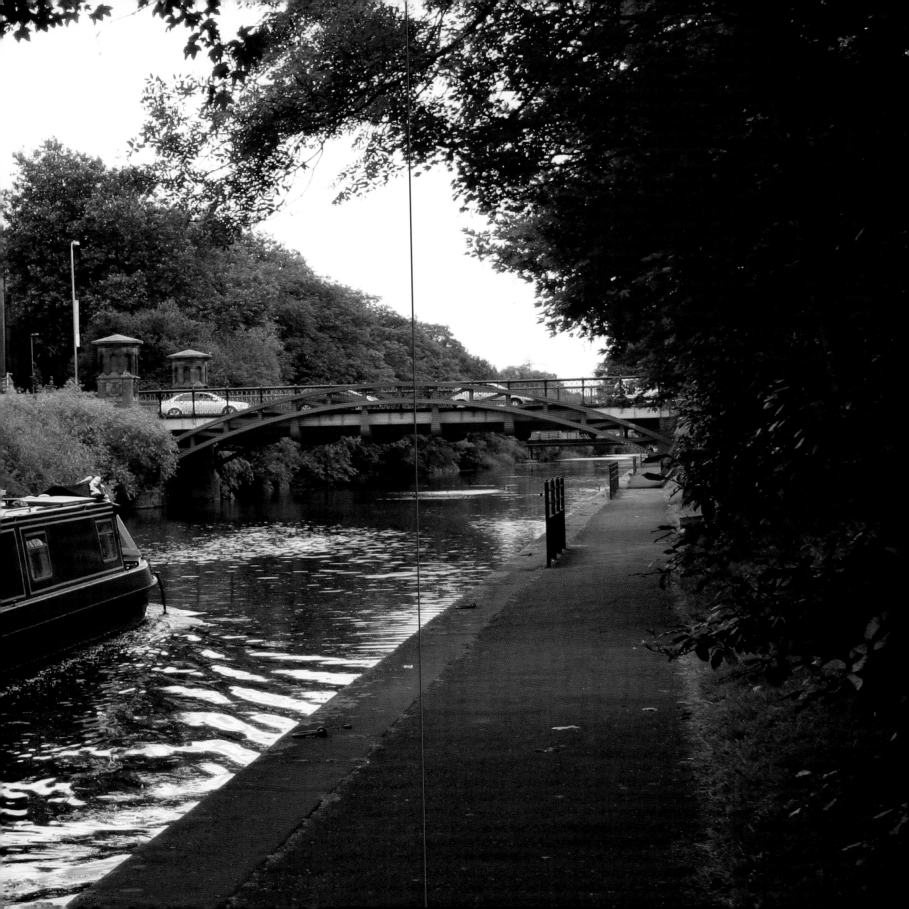

Stratford-on-Avon

Stratford-on-Avon has two contrasting waterways. The River Avon has the Royal Shakespeare Theatre, the ancient Clopton Bridge and numerous public gardens on its banks. These provide the images that illustrate postcards sent by thousands of visitors that throng the town throughout the year. The other waterway is the Stratford-on-Avon Canal that enters the town through 'the back door' and remains unnoticed until it bursts onto Stratford's tourist scene at Bancroft Basin. This is the canal's terminus at the end of a 25-mile journey from Kings Norton. The basin is lined with colourful boats, gardens and the Gower Memorial to William Shakespeare.

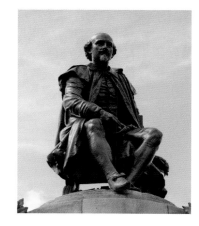

▲ The Gower memorial at Bancroft Basin shows a seated Shakespeare surrounded by characters from his plays, representing Philosophy, Tragedy, History and Comedy. It was presented to the town by Lord Gower in 1888.

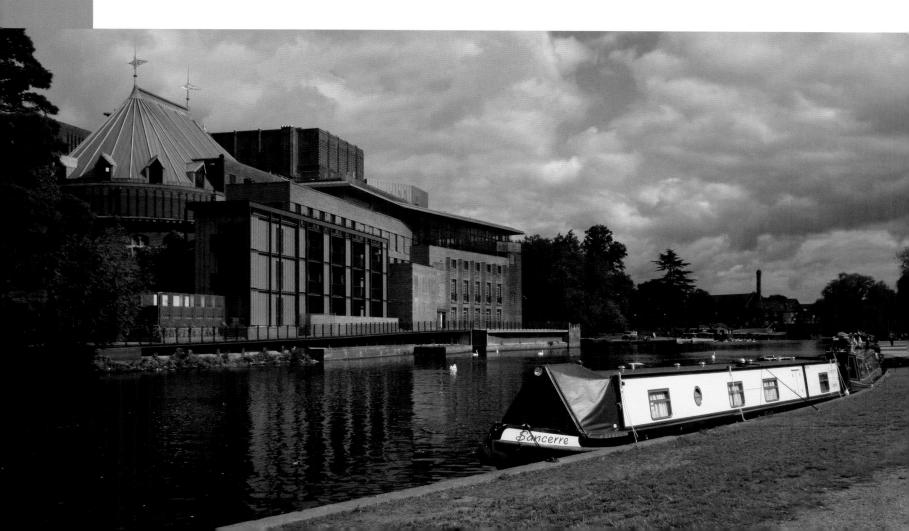

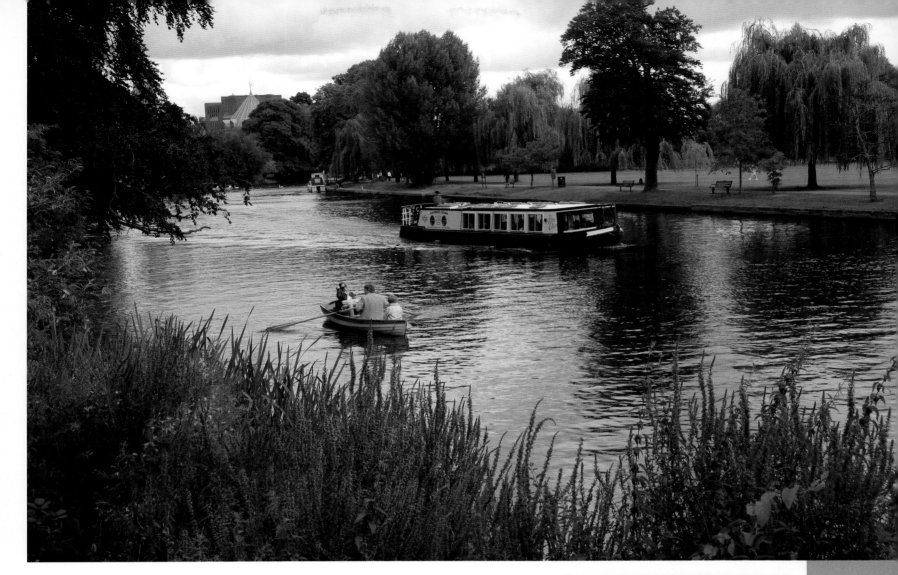

◤ A passenger trip boat on the River Avon at Stratford. This is one of several boats operating on the river where you can either take a 45 minute sightseeing trip or indulge yourself with a dinner on a restaurant cruise boat. Rowing boats are also available for hire.

◀ The Royal Shakespeare Theatre reopened in November 2010 after three years of extensive rebuilding work.

▶ Shakespeare's grave in the 15th-century Holy Trinity Church, by the banks of the River Avon. It is believed that Shakespeare had an obsession with exhumation, which explains the inscription on his tombstone: 'Good frend for Jesus sake forbeare, to digg the dust encloased heare, Bleste be the man that spares thes stones and curst be he that moves my bones.'

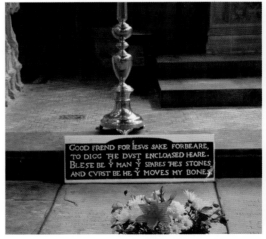

◀ The entrance to Bancroft Basin from the river to the Stratford Canal. A new footbridge over the entrance has provided spectators with a viewpoint of the basin and the first lock.

▼ Bancroft Basin marks the end of the Stratford-on-Avon Canal which begins 26 miles away at Kings Norton. It is a very colourful place packed with moored boats and surrounded by flowerbeds. Stratford's tourist season seems to last all year so the basin is always full of visitors.

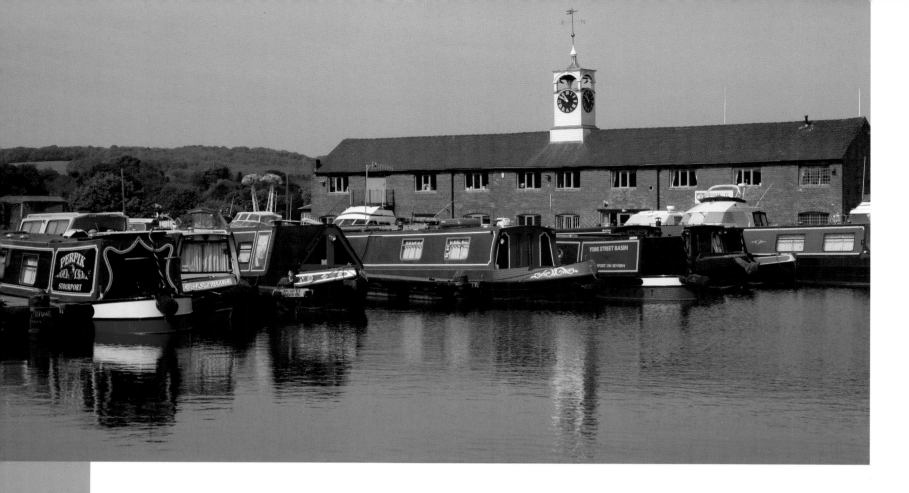

Stourport

Engineer James Brindley completed his Staffs and Worcester Canal in 1772, connecting the new industry and coalfields of the Midlands to the River Severn. In the final few miles he followed the line of the River Stour valley to a village by the River Severn, which developed into the inland port of Stourport. The result was a series of transhipment basins surrounded by warehousing and with locks leading down to the river. Stourport grew as a new town around the success of the port. Most of the basins still survive and are now used for moorings. The town has become a weekend resort for midlanders, with boat trips on the river and a permanent funfair.

▲ The main basin is dominated by the Clock Warehouse built in 1812. It is now used as the headquarters of the Stourport Yacht Club.

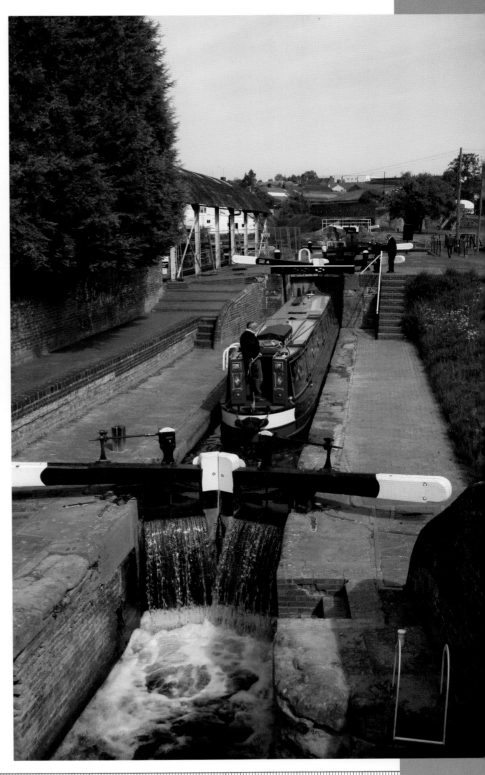

The Tontine opened in 1778 as a 100-bedroom hotel and for a time was the canal company headquarters. In later years it became a pub and was almost demolished in 1977. It was saved after a public outcry and is now converted into apartments. A Tontine was a financial system that allowed the fortunate survivor of a group of shareholders to inherit everything once his colleagues were deceased. What a subject that could have been for an Agatha Christie whodunit!

There are two flights of locks leading into the Severn. One flight is designed for narrow-beamed craft (as seen in the picture) and the other is for barges.

Worcester and the Severn

The River Severn has been an important trading waterway since Roman times but trade reached a peak after the canals made their connections with the river. The Worcester and Birmingham Canal arrived at Worcester in 1816, giving the city a direct link to the Midlands. Before that, trading with the Midlands came via the Staffs and Worcestershire Canal, which meets the river at Stourport. The Worcester and Birmingham Canal passes around the back of the city and is unspectacular in contrast to the River Severn's bold frontage dominated by the cathedral. The city was a Royalist stronghold in the English Civil War and Charles II's forces were heavily defeated here in 1651. Worcester is the birthplace of composer Sir Edward Elgar. Between 1999 and 2007 his portrait appeared on the £20 note, with Worcester Cathedral in the background.

▼ The entrance lock from the river to the Worcester and Birmingham Canal at Diglis. The canal basin at Diglis was a transhipment point for imported timber and canned goods. Another import was cocoa and sugar to Cadbury's chocolate factory at Bournville. Coal from the Cannock coalfields passed through the basin en route to the Worcester Porcelain works and there was an important riverside oil storage depot where 350-ton tankers discharged their cargo. Today, Diglis Basin has a large marina and is surrounded by modern housing.

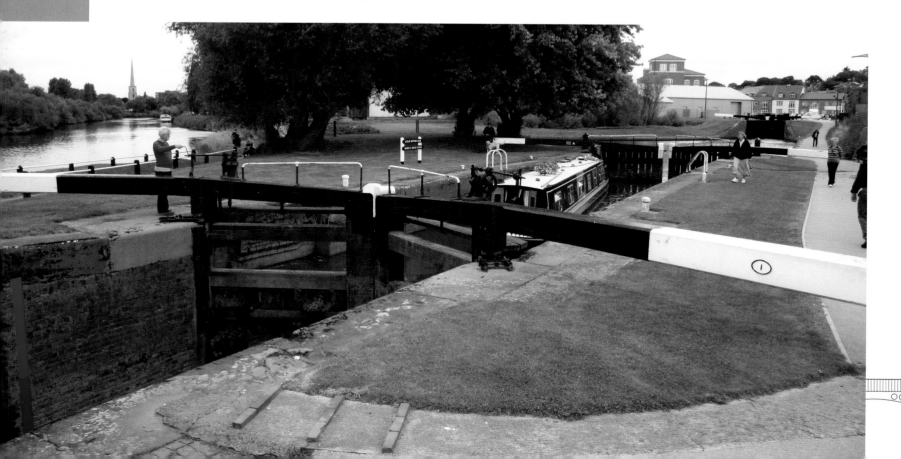

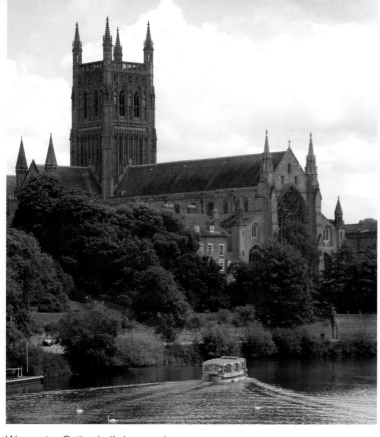

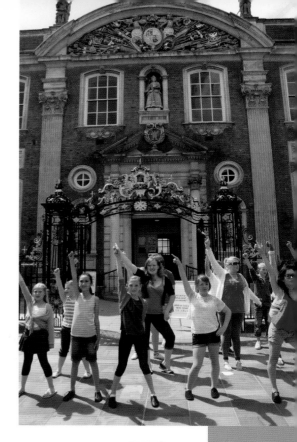

A dance performance by local children in front of Worcester's Guildhall. The hall was designed in 1721 by local architect Thomas White, who was a pupil of Sir Christopher Wren. A statue of Queen Anne can be seen above the entrance.

Worcester Cathedral's impressive perpendicular tower dominates the city's riverside. The present cathedral dates from the 12th century, with structural additions over the following 400 years. It has a stained glass window dedicated to local composer Edward Elgar, and a famous choir that takes part in the Three Choirs Festival, believed to be the world's oldest music festival.

The Commandery became the headquarters of Charles II before the Battle of Worcester in 1651. It opened to the public as a museum in 1977 and has recently had a £1.5 million refurbishment. The Worcester and Birmingham Canal's Sidbury Lock is adjacent to the building.

Gloucester Docks

Gloucester Docks developed as a port after the opening of the Gloucester and Sharpness Canal in 1827. In its commercial heyday it was a very busy port handling imported timber, grain, wine and spirits, and exporting salt. Oil became an important commodity in later years. Now the timber yards have gone and the splendid seven-storey warehouses are converted to new uses, such as Llanthony Warehouse, which is now the Gloucester Waterways Museum. Gloucester Docks are now the main focus for the city's visitors with numerous pubs, restaurants and shopping areas. The ancient cathedral is just a short distance away.

▼ The National Waterways Museum has recently been renamed the Gloucester Waterways Museum. It is housed in Llanthony Warehouse, which was built in 1873 and used for storing grain. During the 1970s it became derelict and was threatened with demolition. Fortunately it was repaired and converted into a museum that tells the story of Britain's canals with interactive displays and archive films.

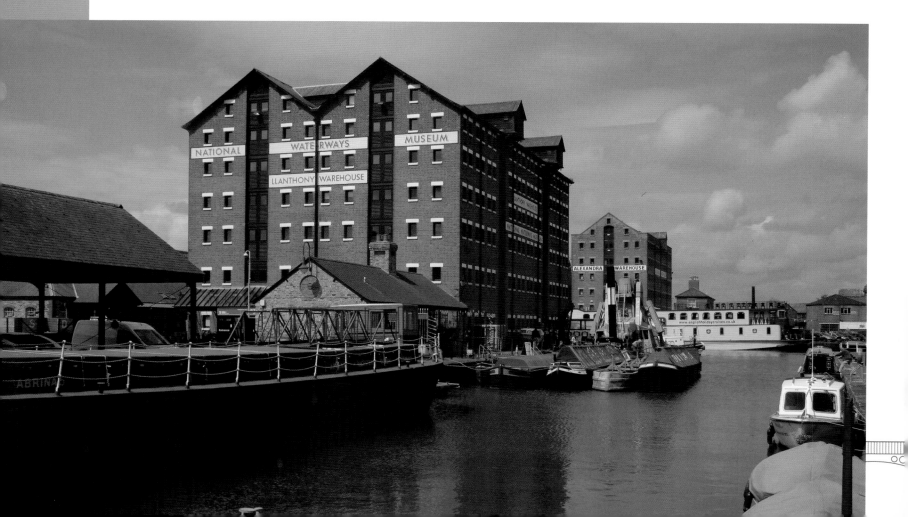

The Mariners Chapel in Gloucester Docks opened in 1849 for visiting seamen. It is still used for worship by local people and has a special Sea Sunday service in July attended by the Mayor and people with maritime links.

Moorings at Victoria Dock. The Albert Warehouse was built in 1851 for a corn merchant and was used for grain storage. It is now used for offices. Its neighbour, the Britannia Warehouse, was also used for grain storage. In 1987 it burnt down in a disastrous fire but was rebuilt to its original design and is now used for offices too.

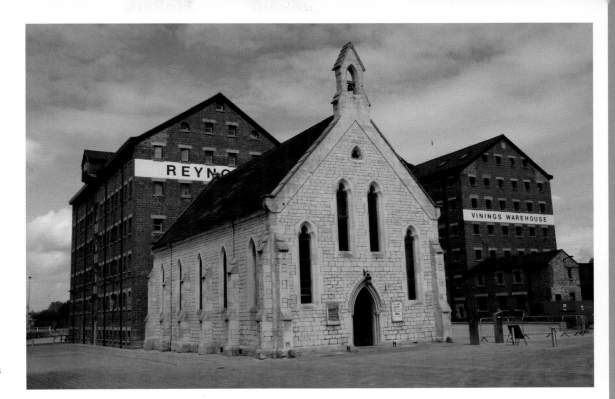

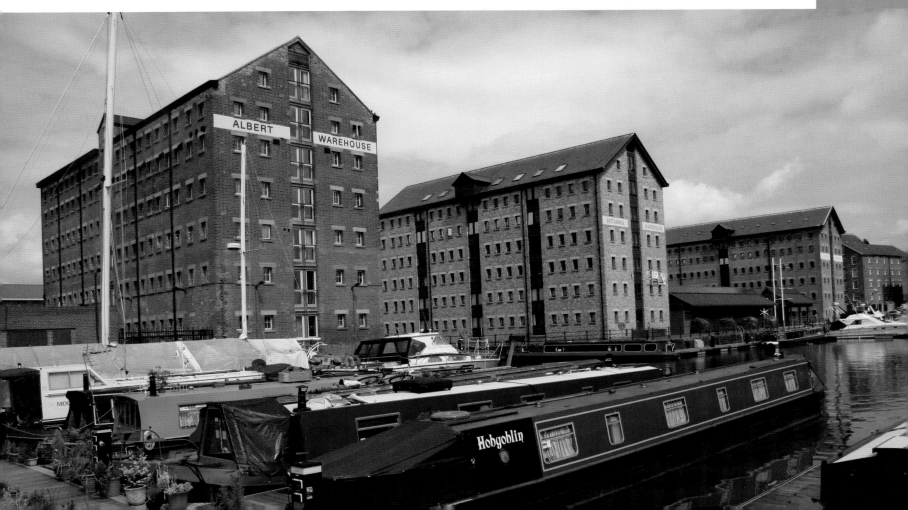

LONDON AND THE SOUTH

Many of the world's great cities have grown up around a waterway. The Romans recognised the Thames as a potential water artery for trade, so London developed on its banks as a Roman port. In the centuries that followed London became the nation's capital city and its chief trading port. The river was the main highway for trade and transport for its population.

By the second half of the 18th century momentous things were happening in the north of England, with the beginnings of the Industrial Revolution and the introduction of inland waterway transport. The only way London could do business with the other developing ports around the country was by voyages around the coast, so London and the Thames were effectively cut off until about 1790, when the Oxford Canal arrived in Oxford from the Midlands. Coal and other supplies had to undertake a journey along narrow winding waterways followed by transhipment to barges at Oxford and then a long arduous journey down the Thames to London. In 1800, the Grand Junction Canal arrived in London, to connect Braunston in the South Midlands with the Thames at Brentford. This route was shorter by 60 miles and the wider locks allowed more boats to work the canal with much bigger cargoes. The Paddington Branch followed in 1805, and in 1820 was extended by the Regent's Canal, which provided a route to the London Docks at Limehouse.

The Paddington Canal follows a lock-free course around what is now the north-west London suburbs. However, when the canal was built it passed through small communities who made a living through farming and market gardening. The availability of convenient, inexpensive transport resulted in industry developing on its banks and so the villages became towns and eventually part of London's urban sprawl. In contrast, the Regent's Canal passed through areas of London that were already built up. Today thousands of visitors take trip boats to

Regent's Park and the London Zoo as well as Camden Lock with its cosmopolitan market, and the former Regent's Canal Dock lives on as Limehouse Basin, with its safe non-tidal marina.

Even as late as the mid-1960s there were lines of cranes working on the river's south bank opposite the Tower of London, where City Hall and HMS *Belfast* are now. Today all the working London Docks have gone and trade on the river has disappeared into the estuary around Tilbury. River transport is mostly confined to trip boats ferrying tourists around the capital's waterside attractions. Many of the old docks are now surrounded by housing but some, like St Katharine Dock near Tower Bridge, have become part of the tourist scene.

In 2012 London will be the focus of world attention as it hosts the Olympic Games. The Olympic Park is built around a labyrinth of backwaters known as the Bow Back Rivers, which are part of the River Lee. These hitherto forgotten and neglected channels have been revitalised and are an urban waterway showcase for the Olympics and east London.

◀ Sunset at Canary Wharf.

London's River

The River Thames in central London has been a working waterway since Roman times. Its banks were lined with wharves and warehouses until the beginning of the 19th century when London's Docks were built in the city's east end. Much of London's south bank was still commercially active until 1951 when the Festival of Britain turned that area into the cultural centre that remains to this day. In later years the docks themselves became redundant and moved to the deeper estuary waters around Tilbury. Docklands, headed by Canary Wharf with its skyscraper office buildings, became an extension of the City of London. The South Bank from Westminster Bridge to Tower Bridge acts like a magnet for visitors initially drawn by the iconic London Eye observation wheel. Experience London's vibrant river on a trip boat from Westminster Pier to Greenwich.

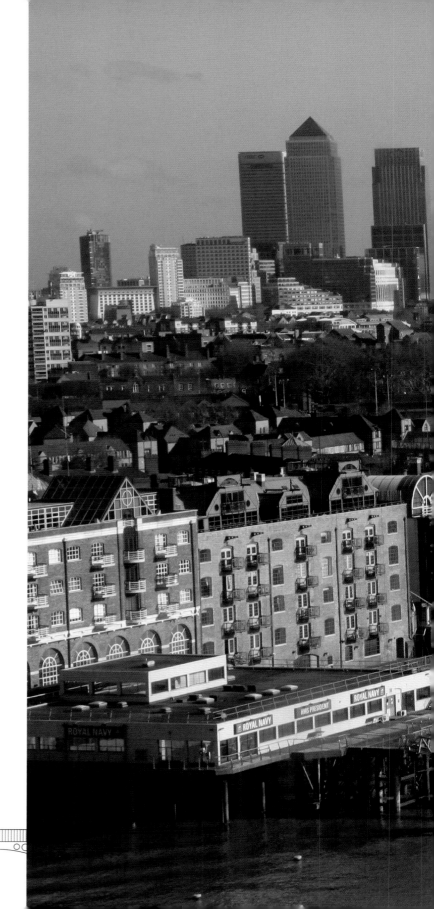

▶ A view of the East End from Tower Bridge. Wapping's waterfront can be seen in the foreground, with Canary Wharf's skyscrapers as a backdrop.

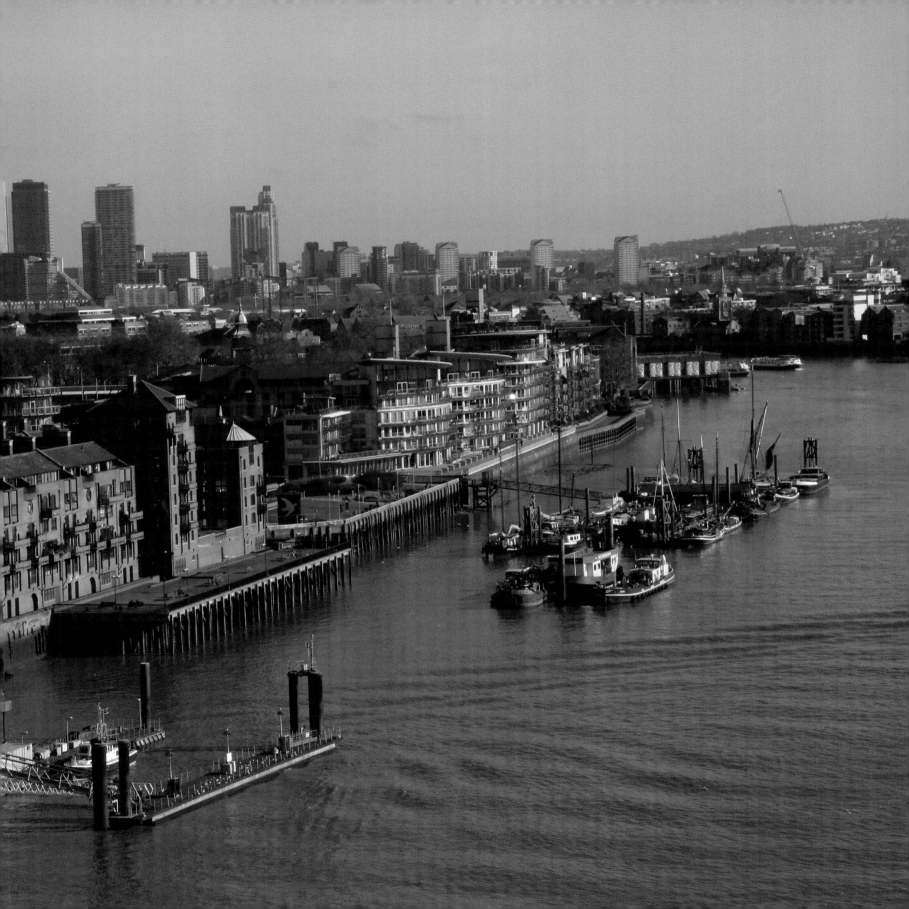

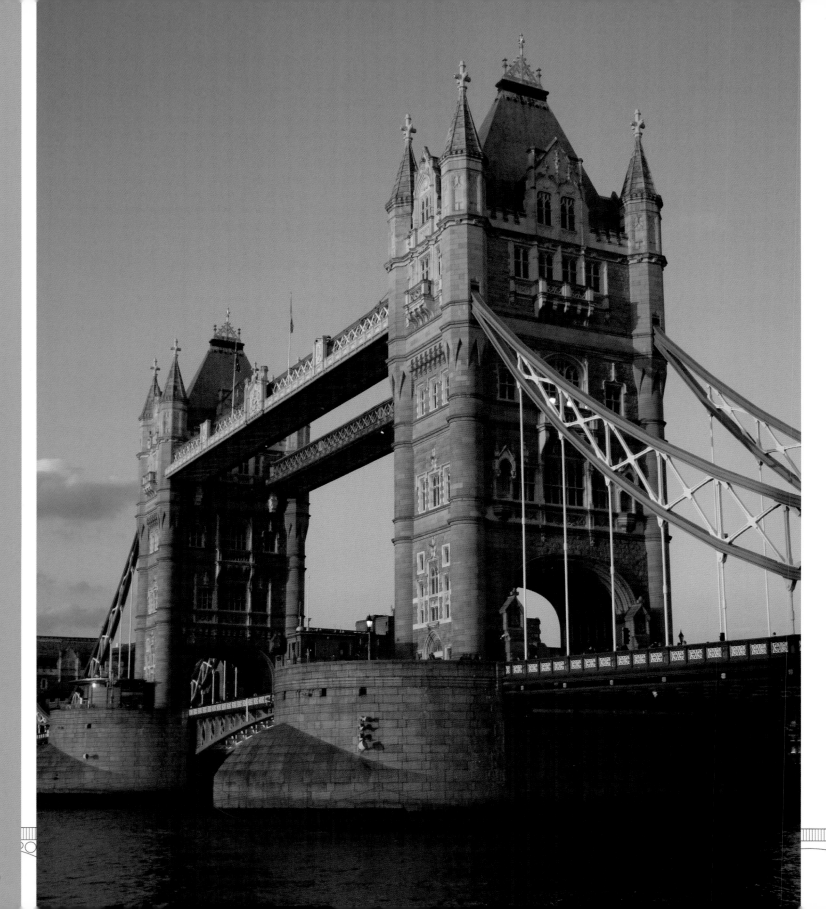

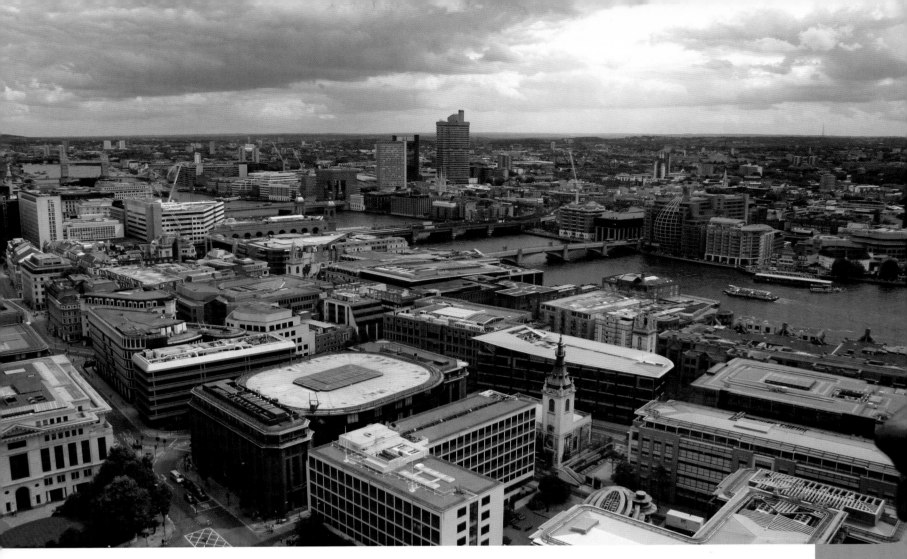

◀ Tower Bridge opened in 1894 at time when London was still a busy port and its bascules were raised many time a day to allow ships to pass through. Its high level walkways, with their superb panoramic views of the city and its river, are now used for exhibitions and displays.

▲ A view of the City of London and the Thames from the top of St Paul's Cathedral.

▶ On view to the public are a pair of 360hp stationary steam engines installed in 1894 to pump water to hydraulic machinery that worked the bascules of Tower Bridge. They were replaced by an electro-hydraulic system in 1974.

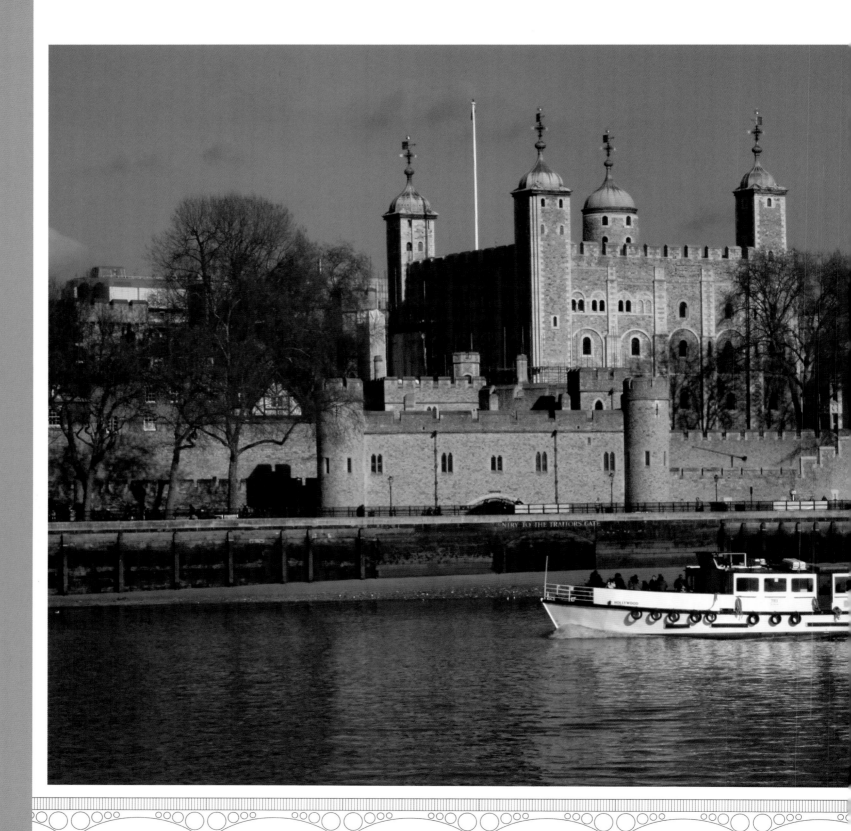

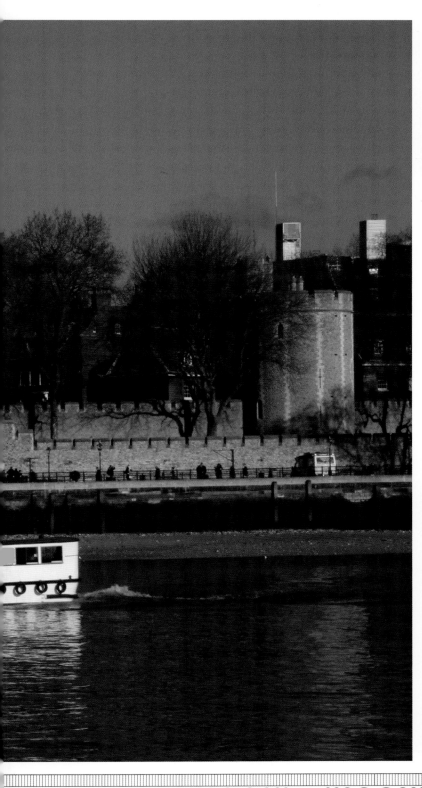

◀ A trip boat passes Traitors' Gate and the Tower of London. The 11th century Norman Tower has served many purposes over the centuries but is best known as a prison and a place of execution. Traitors' Gate was originally built as a riverside entry for royalty but it achieved its name as the place where prisoners accused of treason entered the Tower. Today the Tower is a World Heritage Site and home of the Crown Jewels.

▲ A tug pulls a train of containers past the Festival Pier and Waterloo Bridge.

▼ An urban beach on the South Bank foreshore by Gabriel's Wharf.

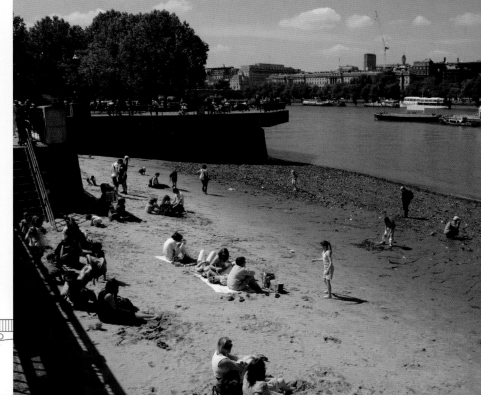

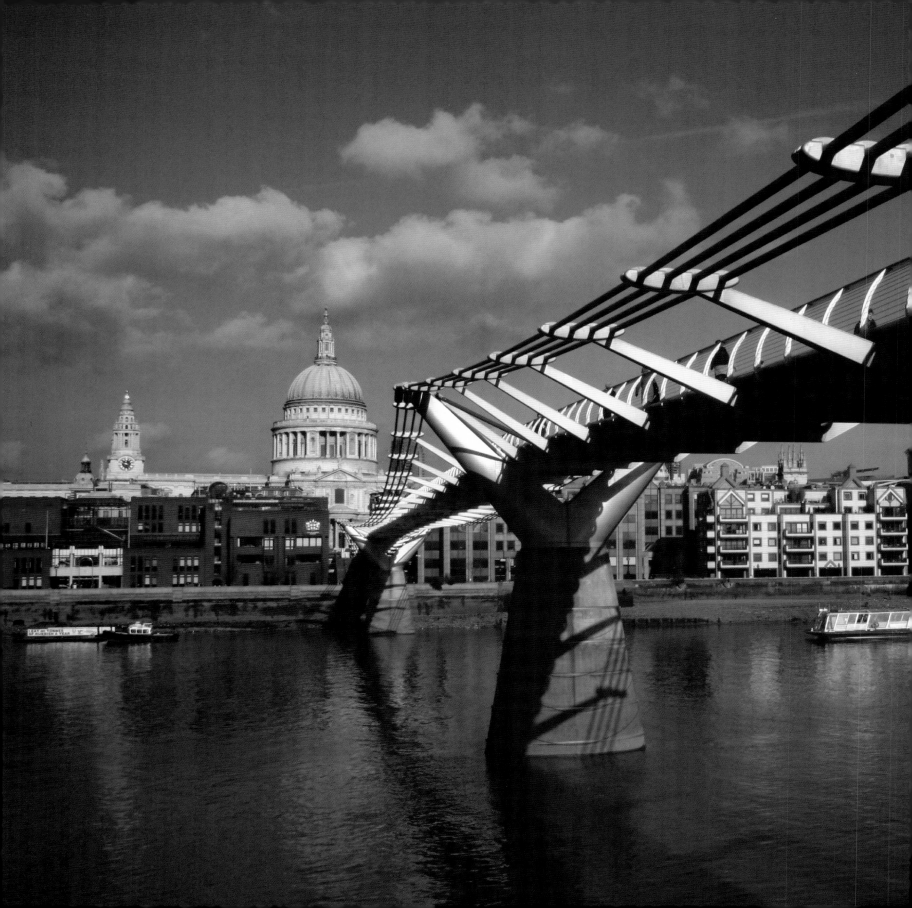

◀ The Millennium Bridge links Bankside to St Paul's Cathedral and the City of London. It opened in June 2000 but closed soon afterwards when the feet of thousands of visitors caused the footbridge to sway. A design fault was eventually rectified and the bridge reopened in 2002.

▲ Since it opened in the year 2000, the London Eye observation wheel has become one of London's landmarks.

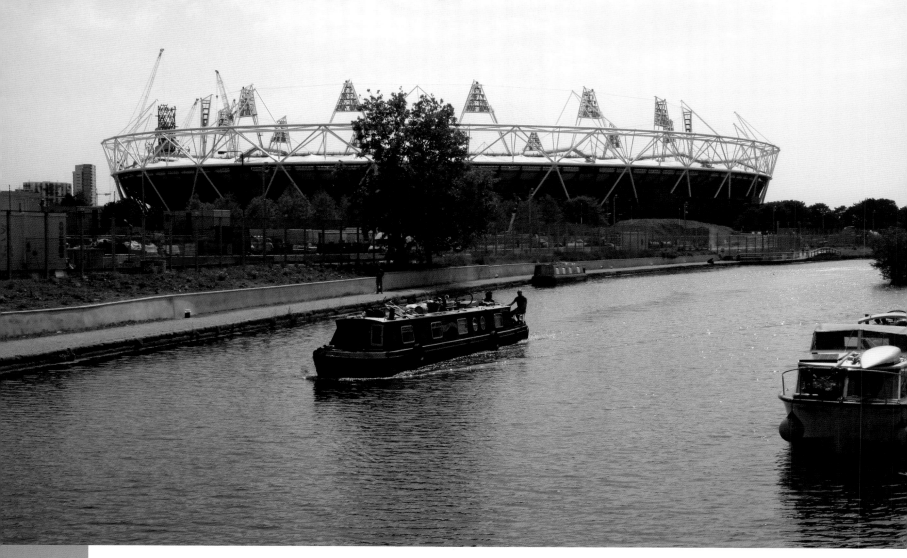

River Lee in the East End

The proximity of the Olympic Park has resulted in much needed improvements for public access to the Lee Navigation towpath in the East End. A new waterside underpass has been built to avoid the previous dangerous road crossing beneath the Bow Flyover. In addition new footbridges have been built to give walkers and cyclists safer access to the Olympic Park when it opens in 2012.

The Olympic Stadium and the Lee Navigation in August 2011, a year before the opening of the Olympic Games.

▲ Three Mills at Bow are a fine group of tide mill buildings on the River Lee, close to the Olympic Park. A tide mill trapped tidal water by floodgates at high tide to release water on the ebb to power waterwheels. The House Mill, built in 1776, is probably the largest surviving tidal mill in the world. Part of the site is now used by a film and television studio.

▶ The towpath of the Lee Navigation is regularly used by walkers and joggers taking exercise during their lunch breaks from offices and factories.

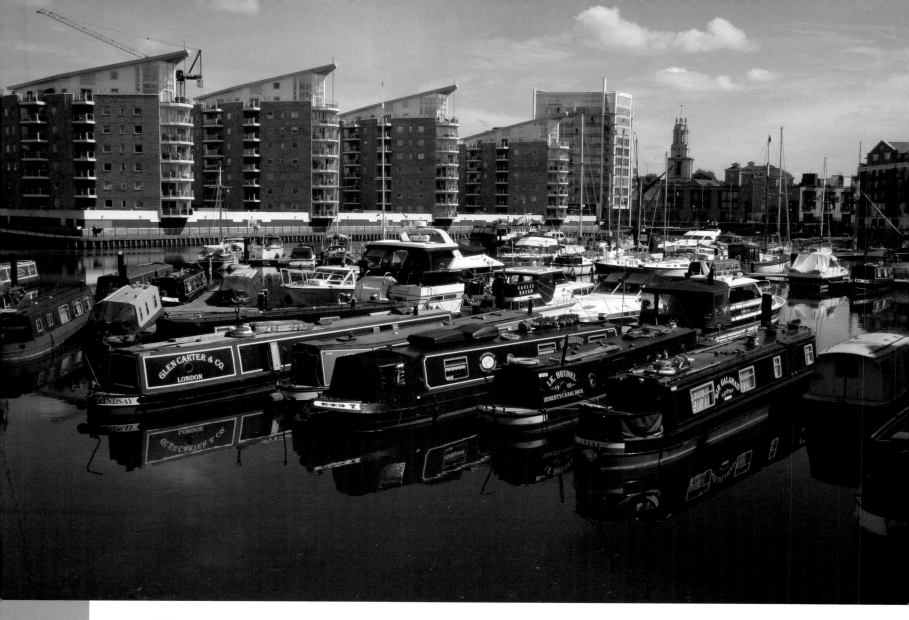

Limehouse

Limehouse Basin was formerly known as Regent's Canal Dock. It was a busy dock where imported goods and raw materials were loaded into canal boats for distribution throughout England. It also exported coal and manufactured products until its closure in the early 1970s. Now surrounded by modern housing, Limehouse Marina is home to a wide variety of craft from canal boats to seagoing cruisers.

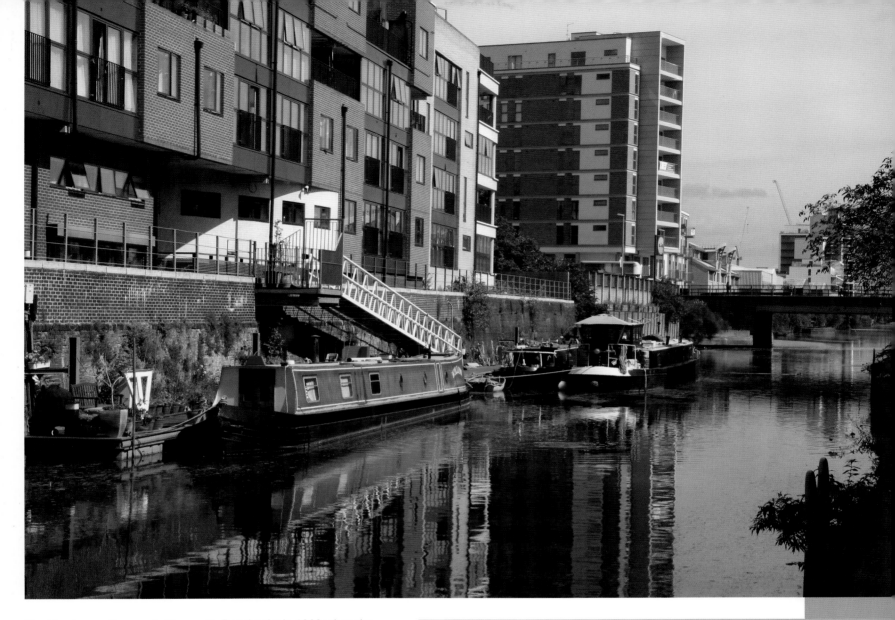

The Limehouse Cut was built in 1770 to connect the Lee Navigation to the Thames, avoiding the winding and tidal Bow Creek. It now links Limehouse Basin to the Lee at Bow Locks.

Bow Locks in 1968 when the Lee Navigation was still a busy working waterway. The locks lead into the tidal Bow Creek while the entrance to the Limehouse Cut can be seen on the left side of the picture.

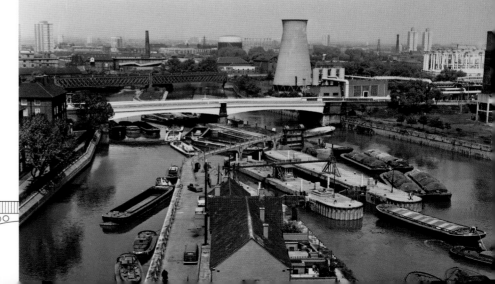

Regent's Canal

▼ A boat approaches Macclesfield Bridge in the Regent's Park cutting. Macclesfield Bridge achieved notoriety in October 1874 when a boat carrying gunpowder exploded beneath the bridge. All that remained was a pile of bricks and the three man crew were never found. The bridge was rebuilt and the supporting columns saved and used again. Ever since it has been known as 'Blow-Up Bridge'.

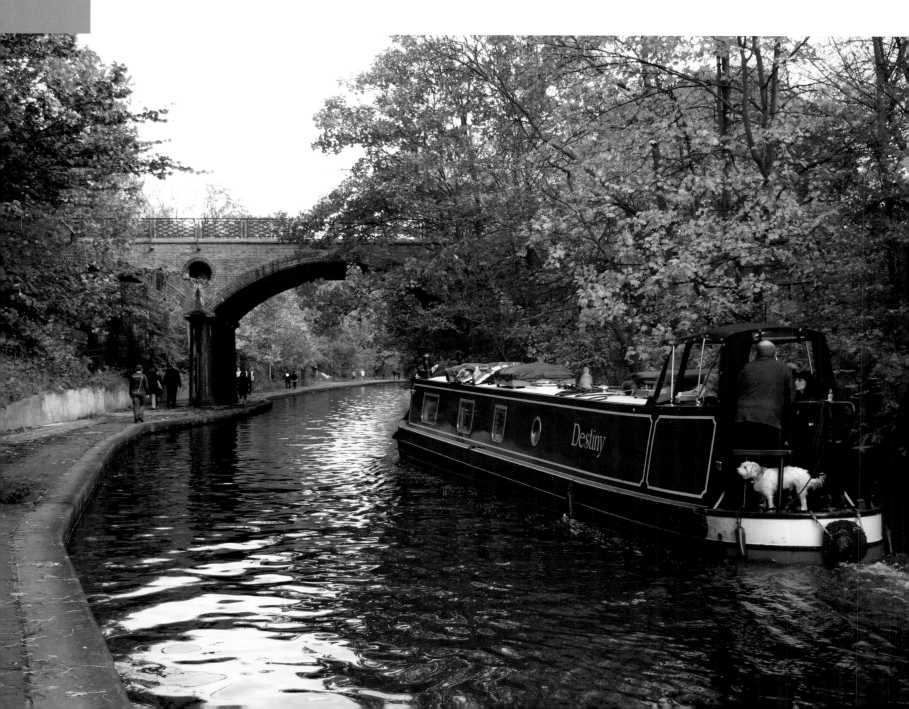

Camden Lock, with its cosmopolitan market, has become a popular venue for visitors to London looking for something a little more unconventional than the usual tourist attractions. The boat in the picture is one of the trip boats operating between Camden Lock and Little Venice.

The Victorian schoolroom at the Ragged School Museum by the Regent's Canal in Mile End. The museum is in the building where Dr Barnardo provided free education for thousands of poor East End children in Victorian times.

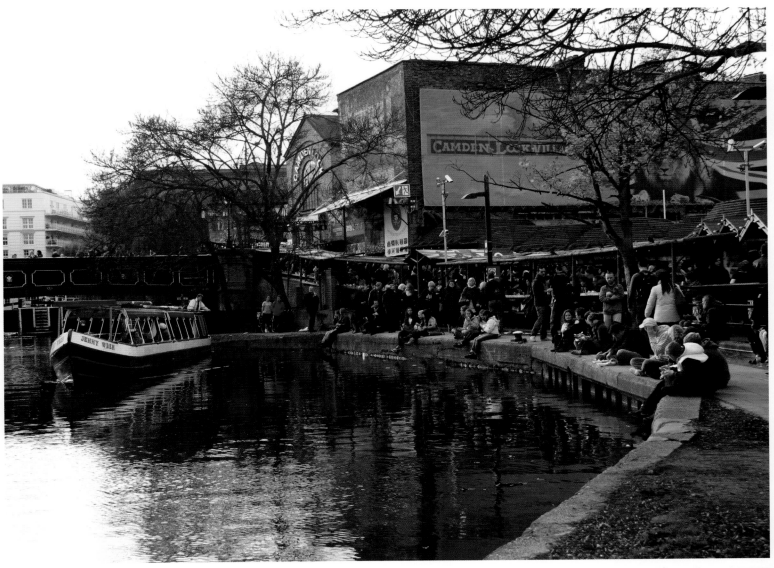

Paddington

Paddington Basin was a bustling mini-port less than a mile from Marble Arch. It was a private world away from the public gaze with boats unloading cargoes onto horse-drawn carts or into the warehouses that flanked the pool. There were horses everywhere, including the ones that pulled the boats filled with all manner of goods. Trade declined after the Second World War and the basin fell into disuse, becoming a rubbish-filled backwater. The transformation of Paddington Basin into Paddington Waterside is one of the largest urban regeneration schemes in Europe. The development has hotels, apartments, shops, restaurants and offices, including the headquarters of Marks and Spencer.

▼ Steam driven narrow boat *President* passing through Little Venice at the time of the annual Canalway Cavalcade. *President* was built in 1909 as a working boat and is now owned by the Black Country Living Museum. The boat travels around the canals during the summer promoting the museum and the waterways. The triangular-shaped pool at Little Venice marks the junction of the Paddington and Regent's Canals. The Canalway Cavalcade is a boating festival held here every year at the beginning of May. There is a regular service of passenger trip boats for Camden Lock and the London Zoo from the quayside at Little Venice.

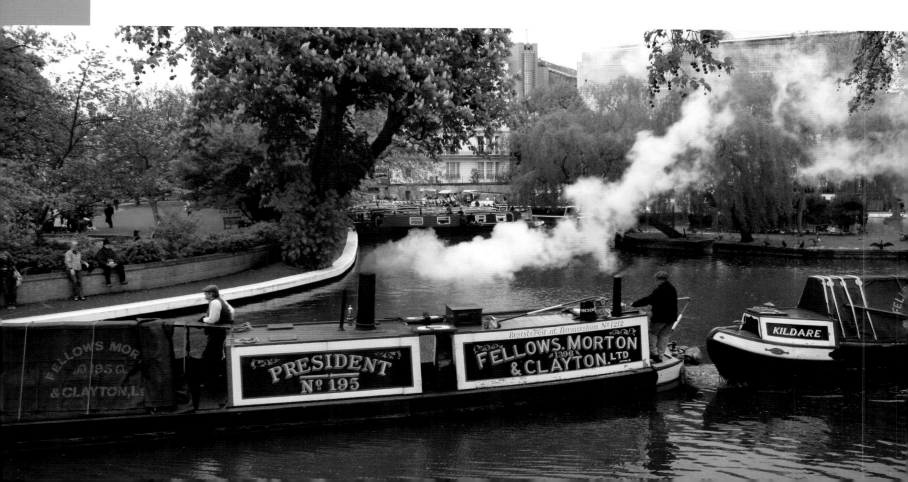

A flat pedestrian bridge unfurls to 12 metres high before curling up into an octagonal ball. This award winning structure opened at Paddington Waterside in 2005 and spans a small inlet in front of the Marks and Spencer headquarters building. A demonstration of the working bridge takes place at midday every Friday.

▼ Midwinter scene at Hanwell Locks. A pleasure boat ploughs through the ice in the pound between two locks. In the days of the working boats, delays due to frozen canals would affect self-employed boatmen who were usually paid on delivery.

▶ Brentford depot was once a very busy place, with canal boats loading and unloading cargoes alongside barges and lighters from the River Thames. There was a sharp decline in trade during the 1970s and the depot fell into disuse by the mid-1980s. Now the warehouses have gone, replaced by modern apartments and a hotel.

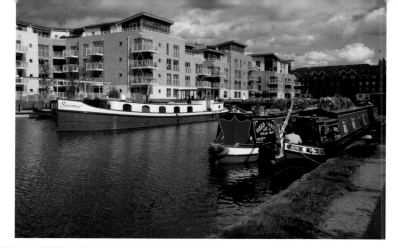

Bulls Bridge marks the junction of the Grand Union Canal Main Line and the Paddington Arm. This was once the location of the canal company offices and repair yard where dozens of working narrow boats would wait for orders. The luxury of running water enabled the boatwomen to do the family wash, while the men would maintain and repair the boat. Beds were provided where boatwomen could have their babies. The yard has gone and has been replaced by a large 24-hour supermarket that provides moorings for visiting boats.

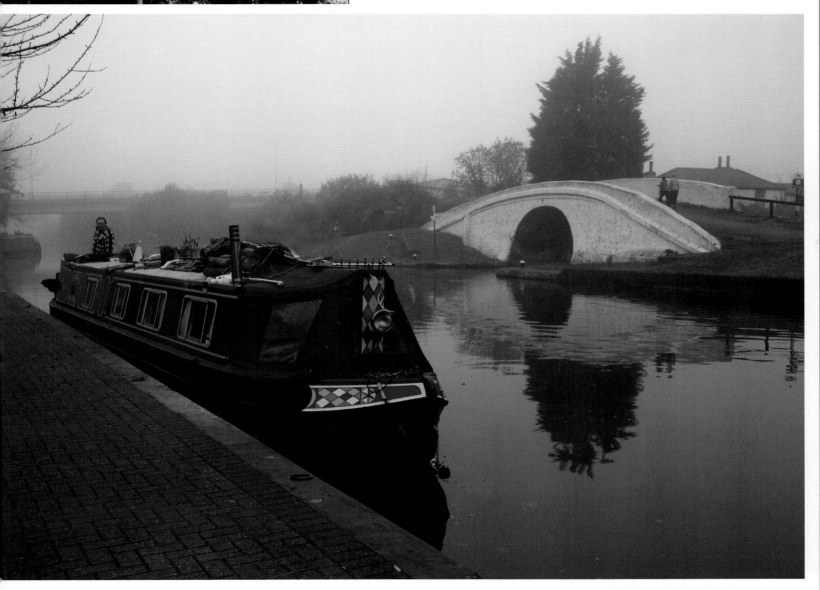

Reading

The university town of Reading stands at the junction of the River Thames and the River Kennet. The town became prosperous for its production of wool but this declined in the 17th century. In later years it was famous for making beer and biscuits. It also has a literary connection with Oscar Wilde, who wrote 'The Ballad of Reading Gaol' about his time in prison there. These days Reading is well known for its riverside music festival held every August and its regatta in June.

▶ County Lock by-passes a weir which leads to a section known as 'The Brewery Gut'. Here the river is often fast flowing with narrow tight bends.

▼ The Oracle Shopping Centre opened in 1999 on the site of a former brewery and bus depot. The River Kennet Navigation passes through the centre of the Oracle, where it is spanned by footbridges and has a landscaped waterside. Because of tight bends, there is no provision for boaters to stop here so they have to moor outside and walk into the centre.

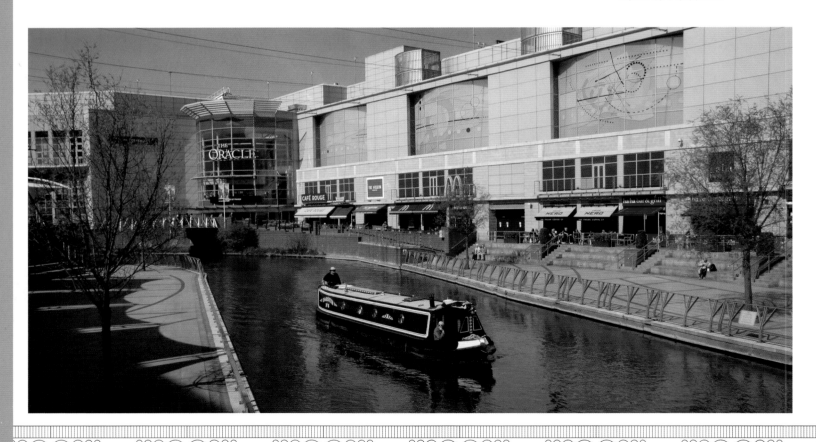

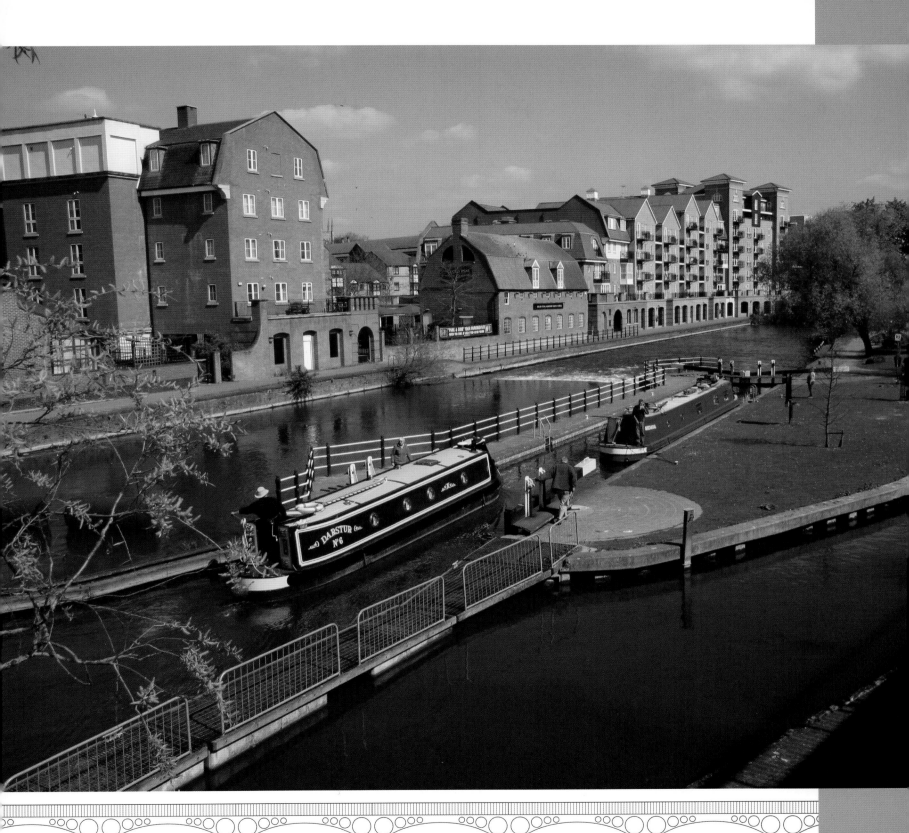

Spectators line the banks of the River Thames at the Reading Regatta.

Swan Uppers examining swans and cygnets at Kings Meadow, Reading. Traditionally all swans on the River Thames belong to the monarch, but two City of London livery companies also exercise a right to ownership. Cygnets are caught and marked by the Swan Uppers on a week-long cruise between Sunbury and Abingdon in July. Swan Upping also acts as a swan census and health check.

▲ Caversham Bridge uses an island in the middle of the river as a central pier. The island was once home to an ancient chapel whose foundations were discovered during the construction of the bridge in 1926.

▶ Moorings by Fry's Island at Reading. Fry's Island is also know as De Montfort Island after a famous duel fought here in 1163 between Robert de Montfort and Henry of Essex. Today, Fry's Island has a bowling club that can only be reached by ferryboat.

Oxford

Oxford does not show its best face to the river. Until recent times it was very much an industrial waterway, with only a glimpse of a college at Christchurch Meadows. Like many other places, most of Oxford's waterside industry has gone and has been replaced by modern housing. It is the River Cherwell, a tributary of the Thames, which flows past several of Oxford's colleges.

Isis Lock and footbridge at the end of the Oxford Canal in Oxford. The lock leads into the Sheepwash Channel which connects the canal to the River Thames above Osney Bridge.

▼ Oxford Castle was first built in 1071 and has served many masters over the years. It was a prison until 1996 and now part of it has been turned into a hotel with a gallery, restaurants and bars. Panoramic views of the city can be seen from the top of St George's Tower and there are tours of the castle and prison. The view in the picture is from Castle Mill Stream.

▶ The Meadow Building of Christ Church College overlooks Christ Church Meadows and the River Thames.

▶ Bottom right: The 12th-century ruins of Godstow Abbey and nunnery can be seen close by Godstow Lock on the River Thames. The Trout Inn at Godstow Bridge has regularly been used by film and television companies, especially for the Inspector Morse TV series.

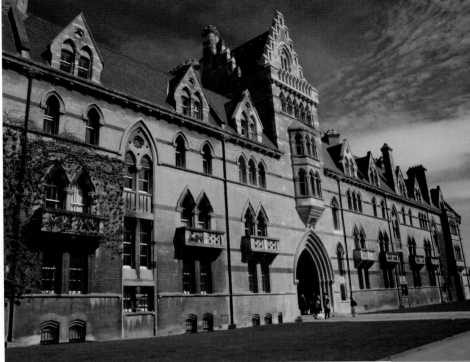

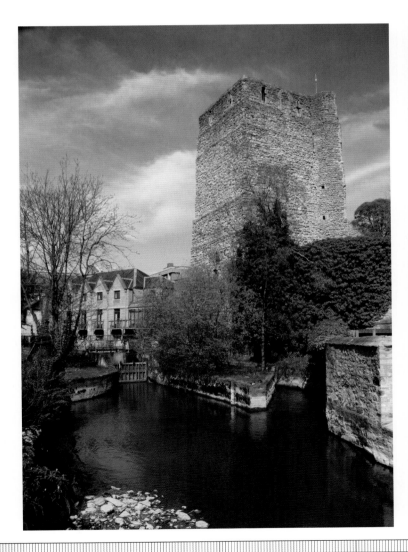

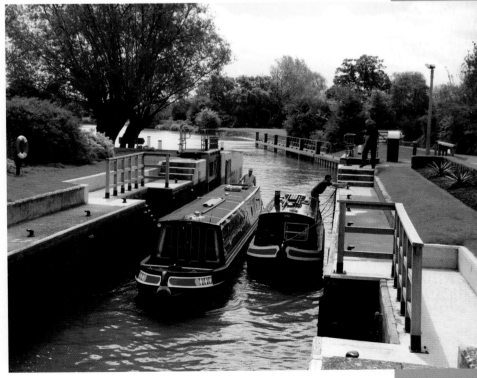

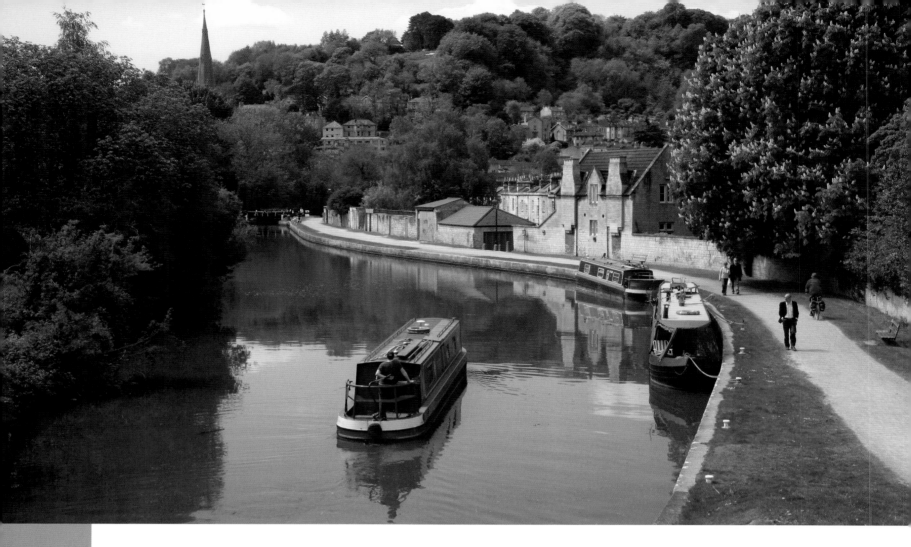

Bath and the Kennet and Avon Canal

The Kennet and Avon cuts across Southern England between Reading and Bristol, connecting the River Thames to the River Severn. It divides into three sections with a river navigation at each end, linked by the Kennet and Avon Canal, which is a 57-mile-long canal between Newbury and Bath. It has 79 broad locks, two superb aqueducts and one long tunnel.

Widcombe Locks at Bath brings the Kennet and Avon to a spectacular conclusion at Widcombe Bottom Lock, the second deepest canal lock in the country. This view of Bath and its canal is from Abbey View Lock.

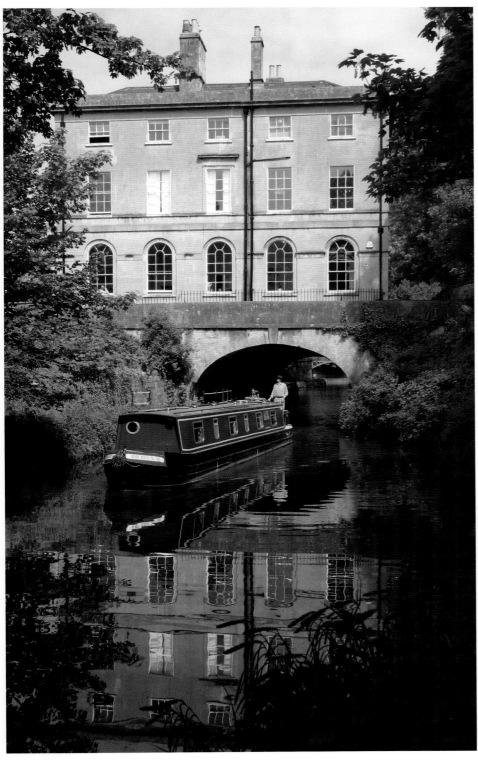

Cleveland House was built in 1820 on top of a short tunnel built by engineer John Rennie in 1800. It was the headquarters of the Kennet and Avon Canal Company until 1864 and is now used for offices.

Sydney Gardens opened as a pleasure park in 1794 in one of the more fashionable parts of the city. The canal cut through the gardens six years later, with the addition of several decorative bridges. It remains as one of the highlights of the canal's passage through Bath.

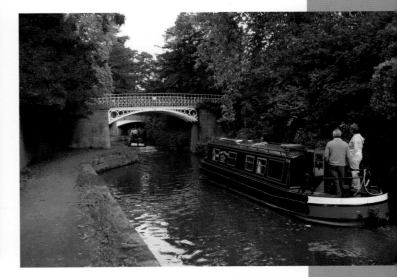

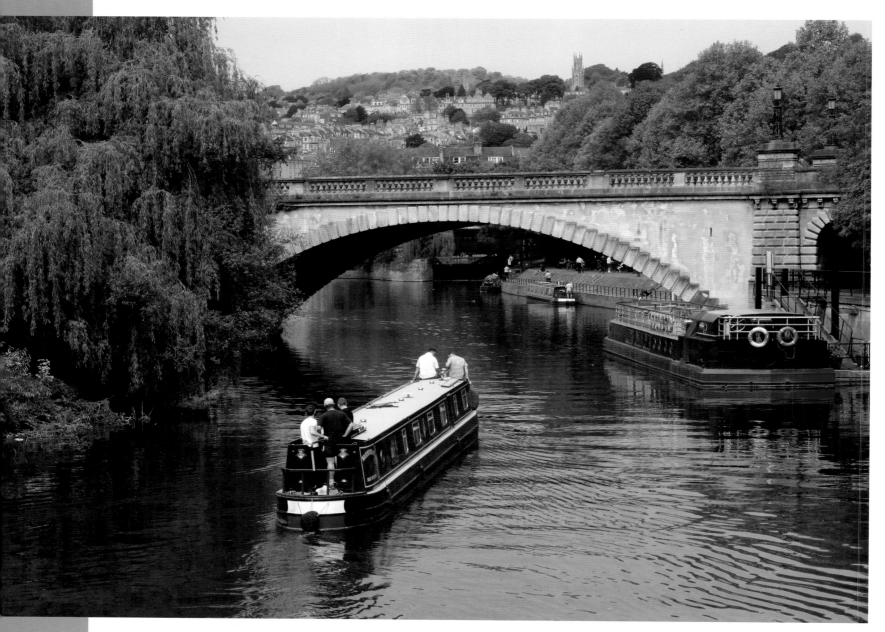

▲ North Parade Bridge on the River Avon. The Avon Navigation connects the Kennet and Avon Canal at Bath to Bristol. This part of the river is on a short navigable arm that ends at Pulteney Bridge.

▶ Pulteney Bridge was built by Robert Adam in 1769 and is lined with shops. The design of Pulteney Bridge was probably inspired by the Ponte Vecchio bridge in Florence. Colourful gardens sweep down to the water's edge where public trip boats carry passengers along this beautiful stretch of the River Avon. Most of Bath's visitor attractions, such as the Abbey and the Roman Baths (which gave the city its name), are close to the bridge.

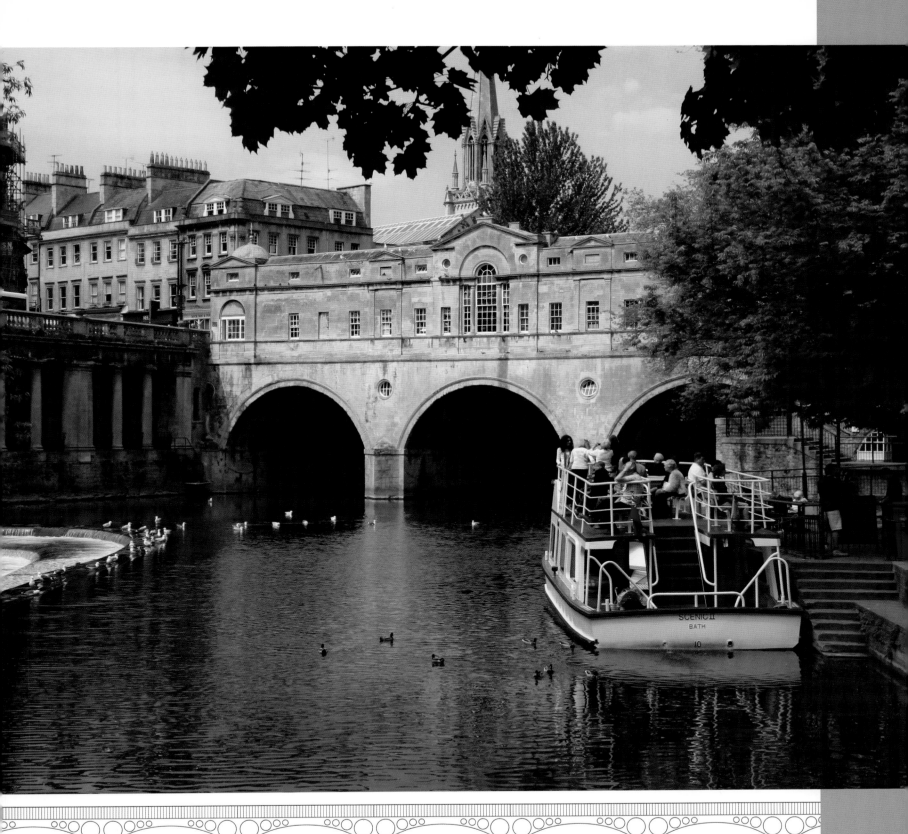

Bristol and the Floating Harbour

The Floating Harbour was built to allow sea-going ships constant access to docks in the centre of Bristol. Water levels in the harbour are controlled by lock gates and so remain unaffected by the tidal River Avon. The harbour was built in 1809 and in the following year the arrival of the Kennet and Avon Canal gave Bristol a direct inland waterway connection to London. In 1972 a new deep water dock was built at the mouth of the Avon, which effectively ended trade in the Floating Harbour. Now the old warehouses have been converted to museums and galleries, and the harbour's waterside bars and nightclubs have turned the three-mile waterfront into a vibrant cultural and social centre.

▼ A ferry boat crosses the harbour, carrying visitors to the SS *Great Britain*. Built by Brunel as a passenger steamship between Bristol and New York, it broke the record for the fastest Atlantic crossing, taking 14 days. It is now a floating museum in the same dry dock where it was built in 1845.

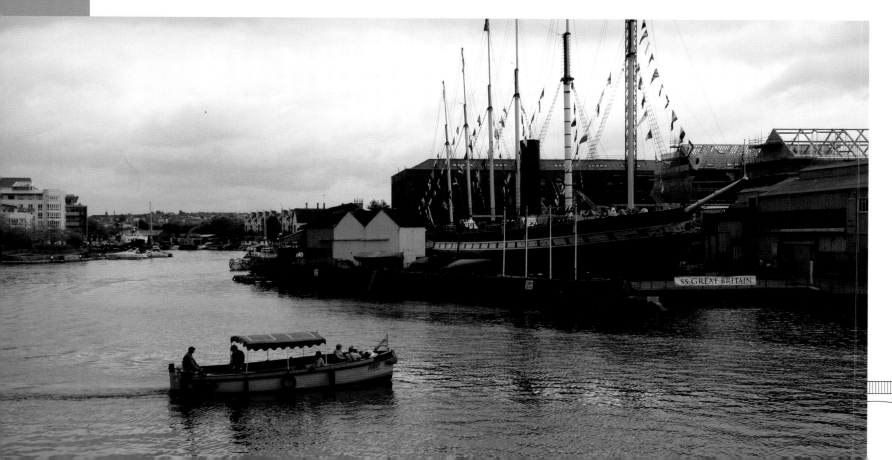

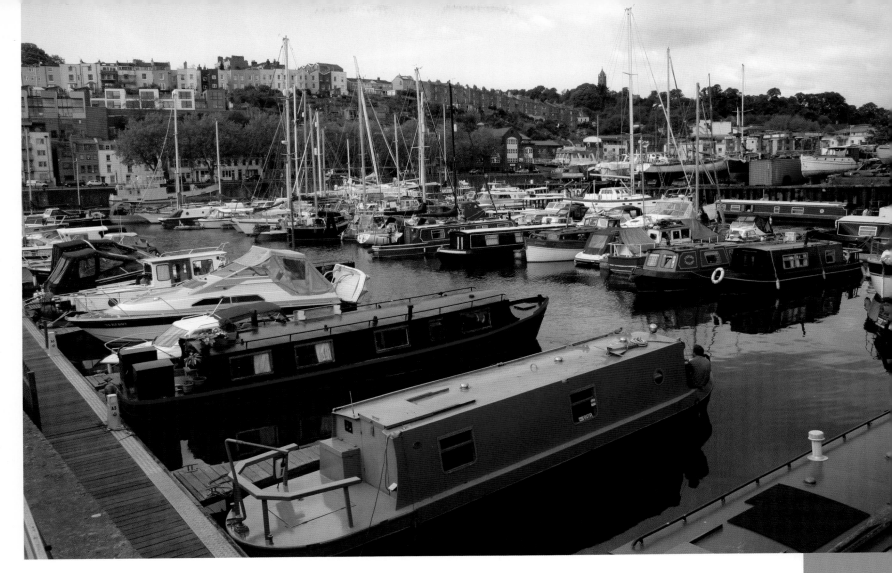

The Arnolfini Art Gallery in St Augustine's Reach is situated in a former tea warehouse. It derives its name from the 15th-century painting *The Arnolfini Portrait* by Jan van Eyck, which can be seen in the National Gallery in London.

Bristol Marina was built on the site of the former Albion Dockyard. It can be seen adjacent to the SS *Great Britain*.

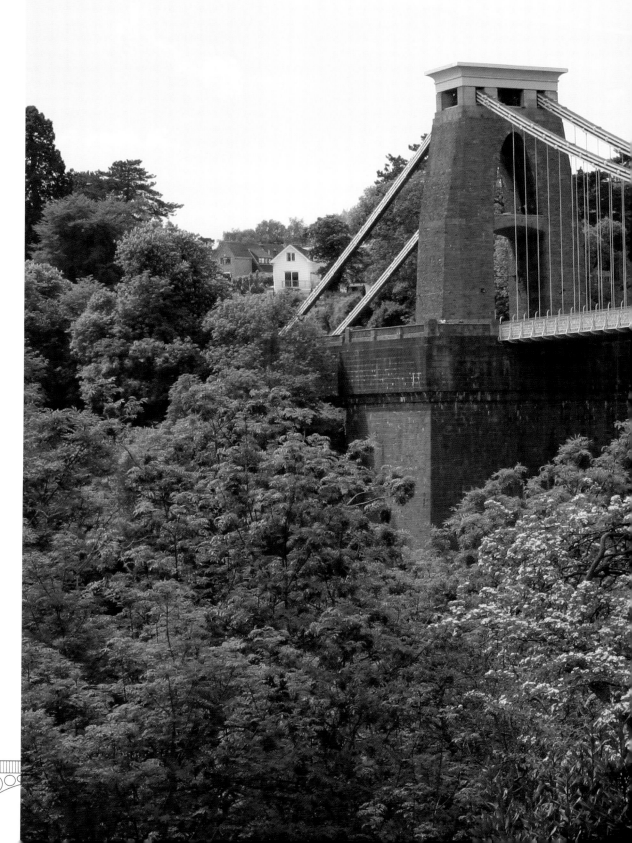

A section of the Clifton Suspension Bridge which spans the wooded Avon Gorge. The bridge was built to a design by Brunel, but was only completed in 1864, five years after his death.

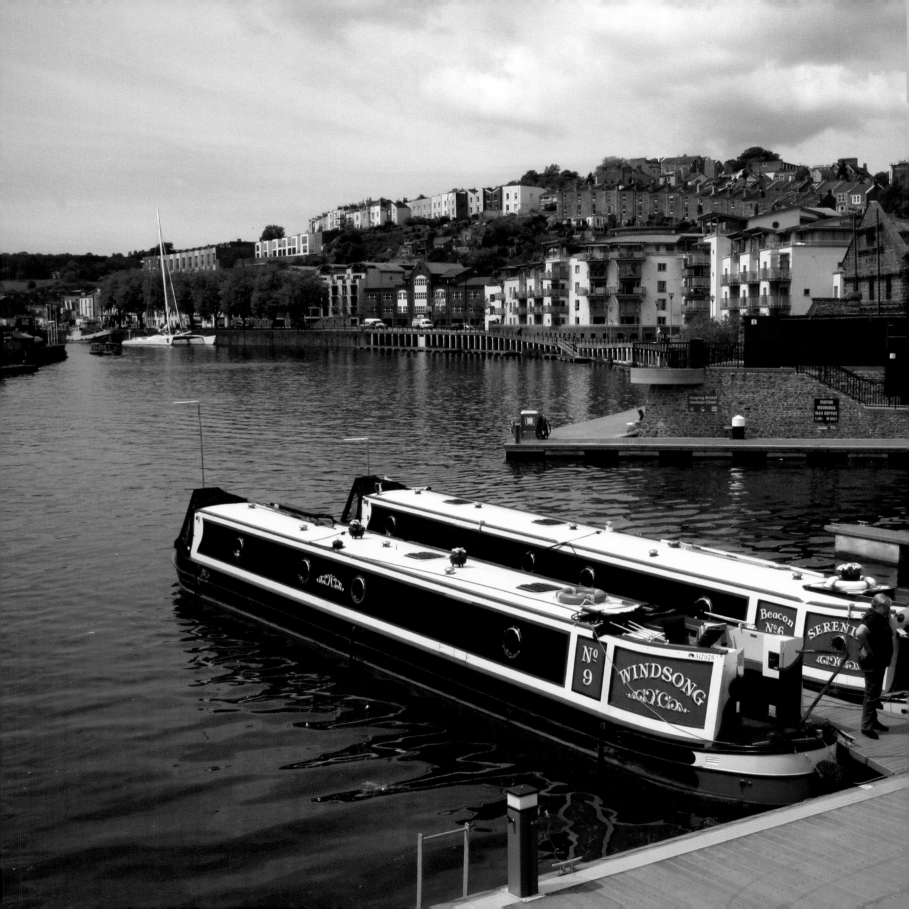

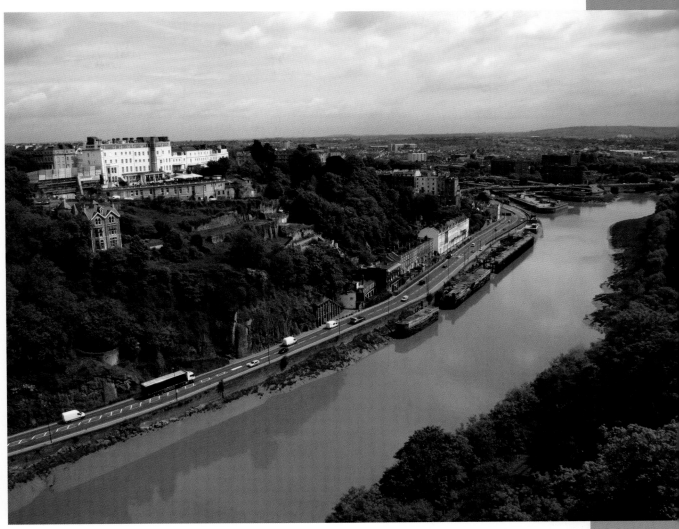

▲ The view from Clifton Suspension Bridge along the River Avon towards the entrance to the Floating Harbour.

◄ A section of the Floating Harbour viewed from Brandon Wharf towards Hotwells. Constant water levels in the harbour allow safe mooring for inland waterway craft.

Published by Adlard Coles Nautical
an imprint of Bloomsbury Publishing Plc
50 Bedford Square, London WC1B 3DP
www.adlardcoles.com

Copyright © Derek Pratt 2012

First edition published 2012

ISBN 978-1-4081-4027-7

A CIP catalogue record for this book is
available from the British Library.

This book is produced using paper that
is made from wood grown in managed,
sustainable forests. It is natural,
renewable and recyclable. The logging
and manufacturing processes conform
to the environmental regulations of the
country of origin.

Typeset in 12pt Helvetica Neue Light

Printed and bound in China by
C&C Offset

Acknowledgements

To Peter Ludwell for his invaluable help
when compiling information and photos
for the Yorkshire section

To Claire Ludwell and the Royal Armouries
at Leeds

To Ed Fox at British Waterways

To the Ragged School Museum in Mile
End, London

To the Black Country Living Museum,
Dudley, West Midlands

To my wife Janet who accompanied me
on many of my journeys

And finally to Liz Multon at Adlard Coles
Nautical who has been an absolute
pleasure to work with on this book.

Index

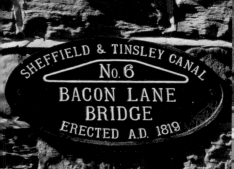

SHEFFIELD & TINSLEY CANAL
No. 6
BACON LANE
BRIDGE
ERECTED A.D. 1819

BLACKCOUNTRY
BLACKCOUNTRY
...eaistered at Watford → 60

NARROWBOAT WAY
DY2

THE FOUNTAIN INN, TIPTON
FROM
1835 TO 1851
THE
HEADQUARTERS OF
WILLIAM PERRY
'THE TIPTON SLASHER'
CHAMPION PRIZEFIGHTER
OF ENGLAND
1850–1857
THE BLACK COUNTRY SOCIETY

BACK IN THE "OLD DAYS"
WHEN ALL CONTESTS WERE
FOUGHT BAREFIST AND OFTEN
IN THE OPEN AIR. IT WAS ONLY
THE TOUGHEST WHO SURVIVED
TO TAKE PRIZEMONEY.
WILLIAM PERRY WAS SUCH
FIGHTER, BORN IN PARK LANE
TIPTON 1819 HE BEGAN HIS
CARREER IN ABOUT 1835.
SOME TIME LATER HE DEFEATED
AN OPPONENT IN NEARBY
CLBURY WITH SUCH
"TERRIFIC HITTING", THAT FROM
THEN ON HE WAS KNOWN AS
"THE SLASHER"
MANY FIGHTS FOLLOWED, SOME
WITH AS MANY AS 100 ROUNDS
OR MORE AND WITH VARYING
AMOUNTS OF PRIZEMONEY
"THE SLASHER" FOUGHT FOR
THE NEXT 20 YEARS OR SO AND
FINALLY THREW THE TOWEL IN,
CHRISTMAS EVE 1880
AGED 61

Grand Union Canal
53A

BCN

CANALSIDE WA...
CAMBRIAN WHA...

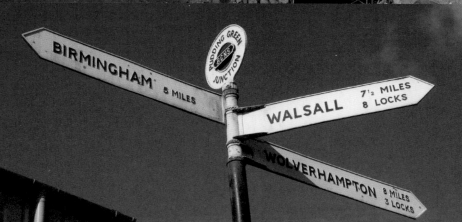

BIRMINGHAM 5 MILES
PUDDING GREEN JUNCTION
WALSALL 7½ MILES 8 LOCKS
WOLVERHAMPTON 8 MILES 3 LOCKS

BULLFINCH
RUFFORD

Cadbury
WORLD

G.J.C.Cº
BRAUNSTON
93
MILES

BLACKBURN
WATERSIDE
LEEDS & LIVERPOOL
CANAL